Thirty Florida Shipwrecks

KEVIN M. MCCARTHY

PAINTINGS BY
WILLIAM L. TROTTER

MAPS BY STEVE ROGUSKI

D1412003

PINEAPPLE PRESS, INC.
SARASOTA, FLORIDA

Inquires should be addressed to:
Pineapple Press, Inc.
Sarasota, Florida

LIBRARY OF CONGRESS
CATALOGING-IN-PUBLICATION DATA
McCarthy, Kevin.
 Thirty Florida shipwrecks/Kevin M. McCarthy; paintings by William L. Trotter; maps by Steve Roguski.--1st ed. p. cm.
 Includes bibliographical references.
 ISBN 1-56164-007-7; $17.95
 1. Shipwrecks--Florida. I. Trotter, William L. II. Title. III. Title: 30 Florida shipwrecks.
G525.M388 1992
383.12'3'0916348--dc20 91-47020
 CIP

First Edition
 10 9 8 7 6 5 4 3 2

Design by Frank Cochrane Associates
Composition by Millicent Hampton-Shepherd

Printed in Hong Kong

ACKNOWLEDGMENTS

Among the many people who have helped to make this book possible, I would like to thank Duncan Mathewson III (*Atocha*), David Moore (*Henrietta Marie*), Billy Causey and Ed Davidson (*Loo*), Dena Snodgrass (*America*), Ed Mueller and Howard Tower, Jr. (*Columbine*), Keith Holland (*Maple Leaf*), Elizabeth Friedmann and Don Serbousek (*Commodore*), Janet Hutchinson (*Georges Valentine*), Mike McCaskill and Ed Mueller (*City of Hawkinsville*), Townsend Hawkes and Michael Gannon (*Gulfamerica*), Henry McDowell (*Cecil Anne*), Steve Sommerville (*Mercedes I*), Joe Clark, and Barbara Robinson (*Bibb*). Also Elizabeth Alexander, Muriel Burks, Bruce Chappell, Joan Crawford, Melanie Davis, Yakenya DeBose, Dionne Hughes, George Kingson, John Knaub, Marjorie Niblack, Rosa Piedra, Virginia Seacrist, Louise Stephenson, Mike Summers, and Kathy Williams. Finally we dedicate this book to the thousands of men and women shipwrecked in the waters in and around Florida.

CONTENTS

FOREWORD

With one of the nation's longest continuous coastlines and miles of rivers and lakes, Florida has a unique and broad range of submerged historical and archaeological resources. From prehistoric dugout canoes to modern steel freighters, Florida's waters have accumulated a significant number of sunken ships through storms, human error, naval actions, and other causes. The exact number of shipwrecks is, of course, unknown, but there are at least 2,000 documented ship losses in the waters of Florida. Undoubtedly many more undocumented wrecks exist.

Of course, many of these shipwrecks are relatively modern and of limited historical and archaeological interest today. Yet they are routinely visited by divers and fishermen for their recreational value and the marine life they harbor. Some, as you will learn from this book, have been purposely sunk for artificial reefs. Perhaps years in the future, they will have historical and archaeological value as well. But the most significant of Florida's shipwrecks are those that sank between the sixteenth and nineteenth centuries. They represent the cultural remains of several colonial maritime nations, including the United States. Florida was (and still is) a crossroads of the Americas, as well as the Atlantic Ocean, and a natural magnet for shipping.

These wreck sites are time capsules that were left behind, however inadvertently, by those who came before us. They contain the remnants of the cultures that shaped our past, and they constitute a priceless but extremely fragile record of more than three centuries of exploration, settlement, colonization, and commerce. Some of these cultural resources, like the *Maple Leaf*, are surprisingly well preserved in Florida's warm, shallow waters. Others, like HMS *Loo*, have deteriorated over the years, as nature took its toll. Only a small fraction contained cargoes of precious metals or "treasure," yet media and public preoccupation with those few Spanish galleons, like the *Atocha*, have overshadowed and distorted the real picture of Florida's unique maritime heritage.

Since the advent of scuba diving in the 1950s, many of Florida's shipwrecks have been discovered by sport divers and explored by both amateurs and professionals. But over the years historic wreck sites have come under increasing pressure by treasure hunters searching for gold and silver who view the remains of sunken vessels as opportunities for private, short-term profit. Too often, discovery of a colonial vessel starts a destructive cycle of speculation, investment, and exploitation, based on the hope of finding "treasure." Now, as more and more of Florida's citizens and visitors enter its underwater world, they are recognizing the importance of conserving and protecting our natural resources, such as coral, manatees, and other marine life. They also are learning to respect Florida's cultural resources since, unlike the natural environment of which they have become a part, the sites of shipwrecks do not grow back again once they are damaged or destroyed.

The diving public is encouraged to visit Florida's sunken historical sites with the understanding that these sites are protected by legislation that prohibits any disturbance or removal of objects on publicly owned submerged bottomlands without written authorization. Adoption of the modern sport diving motto, "take only pictures, leave only bubbles," will help to ensure that Florida's vast underwater storehouse of history is preserved for future generations to enjoy.

In the following pages, Professor McCarthy tells the stories of thirty Florida shipwrecks of various nationalities spanning four hundred years. A color illustration of each ship by William Trotter accompanies the narratives. Some shipwrecks, like *San Pedro* and *Duane* have become popular diving destinations. Others, like *Reformation*, have not yet been identified. Some, like *City of Hawkinsville*, were simply abandoned when they fell into disuse. Others, like SS *Gulfamerica*, were victims of warfare resulting in tragic loss of life. Each represents a fascinating chapter in the continuing saga of Florida's maritime history.

Dr. Roger C. Smith
State Underwater Archaeologist
Florida Division of Historical Resources

INTRODUCTION

"Wreck ashore!" Those words or some version of them, whether spoken by wreckers in the Keys, the Spanish in St. Augustine, the Ais Indians near Cape Canaveral, the Calusa Indians near Charlotte Harbor, or the U.S. Coast Guard in St. Petersburg, have echoed hundreds if not thousands of times in the history of Florida. What happened to the shipwreck survivors, the cargo, and the ships themselves is the subject of this book. Shipwrecks have continued to hold their fascination for those interested in the sea, and the development of scuba diving gear has enabled countless swimmers to visit the remains of sunken ships. Florida is one of the best places in the world for such diving since the ocean surrounds it on three sides, and reefs, sandbars, and shallow channels have wreaked havoc on unsuspecting ships. Hurricanes, Confederate mines, enemy submarines, lightning, and dynamite have all taken a heavy toll on all kinds of vessels for almost 500 years.

My own interest in shipwrecks began 40 years ago when I was growing up on New Jersey's Long Beach Island. My parents, brother, and I lived near a town called Ship Bottom, so called because it had in the sand the remnants of a beached ship. One afternoon while digging in the sand, my brother and I discovered a wooden plank about five feet down. We quickly gathered our other teenage friends and spent a long, exciting night, aided by hurricane lamps and sandwiches from our parents, unearthing the 20-foot-long plank. By the time morning came and the incoming tide covered over the plank with sand, we had learned nothing much about the plank, but our imaginations had transformed it into the side of a pirate ship that had foundered off shore after Blackbeard or Captain Kidd had buried treasure on the island.

When I moved to Florida in 1969, I discovered a peninsula rich in history, including maritime stories about hundreds of shipwrecks. Having learned from librarians about the insatiable desire of patrons for anything concerning sunken treasure or hearing map collectors queried by the naive ("Can you show me maps of hidden treasure in Florida?"), I too became

curious about shipwrecks. Not having been bitten by the treasure bug, I became more interested in those shipwrecks that gave a glimpse into our fabled past, whether 16th-century Spanish galleons or Civil War baggage boats or tankers torpedoed by German submarines. Would-be treasure finders, take heed! You will not find in these pages maps to sunken treasure waiting for you to don a scuba mask and slip beneath the waves. Instead the following 30 shipwrecks represent part of the rich nautical history of our country's earliest-settled European colony.

Treasure hunting has reached new heights of popularity in this country. Witness the large numbers of beach-goers after a hurricane, armed with the latest metal detectors, scouring the sands for coins and jewelry washed ashore from offshore wrecks. Many have dreams of becoming another Mel Fisher and finding another *Atocha*, preferably close to shore and in shallow water. Some experts estimate that 40,000 vessels lie submerged in waters around our country, with several thousand in Florida waters alone, although most of those do not have the kind of treasure most people would like to find.

This book grew out of a fondness for the sea that painter William Trotter and I have had for many years. We have chosen 30 important, significant shipwrecks from the waters around and in Florida that represent the major periods in the state's history. The wrecks represent over 400 years of seafaring, from 16th-century Spanish and French explorers to 20th-century freighters. Some of the wrecks have long since been removed either by local authorities or by salvagers or by the tides and worms. Does treasure still remain below the surface? Of course. But that treasure is not always silver and gold. It may be a 16th-century ship's wheel or a 20th-century freighter's bell, Civil War baggage or armaments from a gun-runner. Most importantly the wrecks represent time capsules that let us better understand the men and women who sailed our waters for the past 400 years.

The following chapters will give details of 30 of those wrecks, some of which are valuable to the

treasure seeker and others to the historian/archaeologist. We will discuss methods of finding shipwrecks and examining them with the least damage to the surroundings and with the utmost regard for the law. When you have done your homework and pinpointed a wreck site and don your mask and scuba tank and slip beneath the surface to the depths below, you will enter a world that has mysteries and dangers, but also breathtaking beauty and great excitement. Keep in mind that you are also entering a realm where thousands and thousands of seafarers have perished; treat their final resting place with respect. As marine scientist Dr. Sylvia Earle, the chief scientist for the National Oceanic & Atmospheric Administration (NOAA), has said, divers are more and more developing an enthusiasm for conservation that is forming the basis for wise resource management policies. "Those of us who have our faces in the water have a special role to play; we have something valuable to share. We have the opportunity now to set in motion policies that will be legacies for all time. . . . Divers should stand tall and appreciate how special they are. They should share what they know and get others to go see for themselves."

<div align="right">

Kevin M. McCarthy
4008 Turlington Hall
University of Florida
Gainesville, Florida 32611

</div>

SUGGESTED READING ON SHIPWRECKS

Bass, George F. *Ships and Shipwrecks of the Americas.* London: Thames and Hudson, 1988.

Dictionary of American Naval Fighting Ships. Washington: Naval History Division, 1959-81.

Douglas, Marjory Stoneman. *Hurricane.* New York: Rinehart, 1958.

Green, Jeremy. *Maritime Archaeology.* San Diego, CA: Academic Press, 1990.

Jenney, Jim. *In Search of Shipwrecks.* New York: A.S. Barnes, 1980.

Lockery, Andy. *Marine Archaeology and the Diver.* Toronto: Atlantis Publishing Co., 1985.

Marx, Robert F. *Shipwrecks in Florida Waters.* Chuluota, Florida: Mickler House, 1985.

McKee, Alexander. *History Under the Sea.* New York: E. P. Dutton, 1969.

Muckelroy, Keith (ed). *Archeology Under Water: An Atlas of the World's Submerged Sites.* New York: McGraw-Hill, 1980.

Muckelroy, Keith. *Maritime Archaeology.* New York: Cambridge U. Press, 1978.

Narratives of Shipwrecks and Disasters, 1586-1860. Edited by Keith Huntress. Ames: Iowa State University Press, 1974.

Pearcy, Arthur. *A History of U.S. Coast Guard Aviation.* Annapolis, Md.: Naval Institute Press, 1989.

Rackl, Hanns-Wolf. *Diving Into the Past.* New York: Scribner's, 1968. Translated by Ronald J. Floyd.

The Sea Remembers: Shipwrecks and Archaeology. Edited by Peter Throckmorton. New York: Weidenfeld & Nicolson, 1987.

Skin Diver. A monthly magazine. P.O. Box 51473, Boulder, CO 80323-1473.

Stabelfeldt, Kimm A. *Wreckdiver's Handbook.* Milwaukee, WI: Rowe, 1981.

Throckmorton, Peter (ed). *The Sea Remembers: Shipwrecks and Archaeology.* New York: Weidenfeld & Nicholson, 1987.

Underwater USA. A monthly newspaper. P.O. Box 705, Bloomsburg, PA 17815-9933.

ᴛHIRTY

ℱLORIDA

ᴤHIPWRECKS

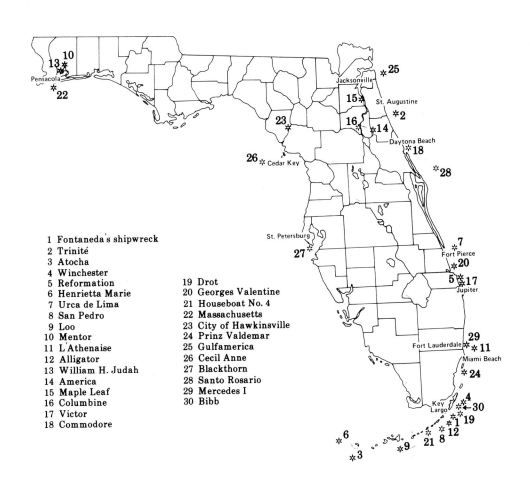

1 Fontaneda's shipwreck
2 Trinité
3 Atocha
4 Winchester
5 Reformation
6 Henrietta Marie
7 Urca de Lima
8 San Pedro
9 Loo
10 Mentor
11 L'Athenaise
12 Alligator
13 William H. Judah
14 America
15 Maple Leaf
16 Columbine
17 Victor
18 Commodore

19 Drot
20 Georges Valentine
21 Houseboat No. 4
22 Massachusetts
23 City of Hawkinsville
24 Prinz Valdemar
25 Gulfamerica
26 Cecil Anne
27 Blackthorn
28 Santo Rosario
29 Mercedes I
30 Bibb

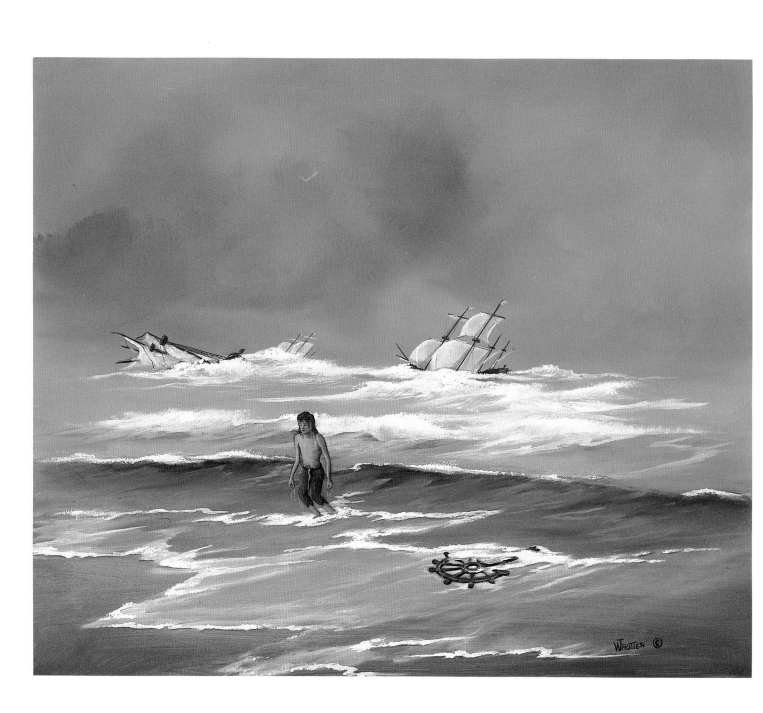

ƒONTANEDA'S SHIPWRECK, 1545

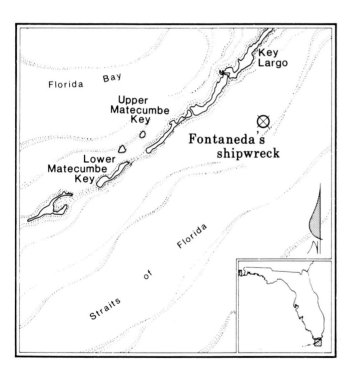

Location: No trace of Fontaneda's ship has been definitely identified.

Early Spanish explorers of Florida looked on *La Florida* with very mixed feelings. For some it represented a new beginning, a place where gold might exist, maybe even a place where a fountain of youth could turn back the years. But for others it represented a desolate outpost, one whose geographical location in the Caribbean and along the Gulf Stream made it important for guarding the semiannual treasure fleets to Spain.

The Spanish who sailed along its coast risked their lives in ways hard to comprehend in this day of sonar, radar, loran, and depth finders. Relying on sketchy maps or guesswork as to where underwater dangers lay, they sometimes wrecked their ships on sandbars or coral reefs. If they made it to shore, they faced great dangers: starvation, disease, injury, or capture by hostile Indians. Capture by the Indians meant either death or slavery, especially if the sailors were British. The Indians had much less respect for the British than they did for the Spanish, possibly out of fear for the latter, who could be brutal toward the indigenous population. The attitude of the Indians to shipwrecked sailors is understandable in light of how the Spanish treated the Indians. For example, when Spanish forces landed near Charlotte Harbor and met the Calusa Indians, the Spanish soldiers killed their chief, Carlos, installed a new chief for the tribe, and later killed him and 14 of his tribe. Spain's great explorer, Pedro Menéndez de Avilés, the man who founded St. Augustine in 1565, drove the French from Fort Caroline, and established missions and settlements throughout Flor-

ida, lost his only son to a shipwreck and spent much time unsuccessfully looking for him along the coast and in different Indian villages. In doing so, Menéndez found and released more than 30 captives of the Indians.

Of the many Spanish who were shipwrecked on Florida shores and lived to tell about it, 13-year-old Hernando de Escalante Fontaneda ranks as one of the most important because of the details of Indian life and customs he later wrote about. His first-person narrative is the most complete for the 16th century. His description of Florida's geography, animals, and plants, as well as the Indian languages, customs, clothing, and food, while sometimes questioned by historians, has been invaluable in reconstructing that century's history of the peninsula. For 17 years, from age 13 until age 30, he lived among the Indians after having been shipwrecked en route from South America, where he had been born to Spanish parents, to Spain to complete his education.

By the mid-1500s Florida Indians had had enough experience with Spanish explorers to know what to expect when the latter landed along the coast. Beginning with Ponce de León's trips to the St. Augustine area in 1513 and the Charlotte Harbor area in 1521, Spanish seamen explored both coasts of Florida and often did battle with the tribes they met. When Hernando de Soto began his famous march from Tampa Bay to Tallahassee and the Mississippi River in 1539, he and his troops burned Indian villages, enslaved Indians they captured, and mutilated or killed those who resisted them. Fontaneda quotes the Indians as having said that they once considered the Spaniards to be "gods come down from the sky," but the Indians soon changed their opinion when they saw how the Spaniards treated them, for example in cutting off the nose of an Indian chief and throwing his mother to the dogs.

Spanish explorers were very reluctant to go ashore unless accompanied by a large force. Sailors had watched from their ships as Indians attacked single missionaries who had insisted on going ashore without protection. When the ship Hernando de Escalante Fontaneda was on wrecked in the Florida Keys around 1545, he knew he was in trouble. The Keys were a dangerous place to be shipwrecked since they offered little or no means of survival, and the Indians there were fierce. The name of Key West derives from Spanish *Cayo Hueso* "Bone Island" from all the human bones found there. Ponce de León called the Keys *Los Martires* "The Martyred," possibly because of all the people who had died there. And Upper and Lower Matecumbe keys may have had their names from Spanish *mata hombre* "kill man," again possibly from all the shipwrecked sailors who had been killed in the area.

For some reason, when the Indians there found Fontaneda, they spared his life, possibly because he was so young and because they had plans to make him a slave. He slowly became acclimated to the new life he was forced to live, traveled with the Indians throughout a good part of Florida, and learned the customs, languages, and beliefs of his captors. The Indians, whom he described as having "no gold, less silver, and less clothing," ate fish, turtle, snails, whales, crayfish, and "sea-wolves," the latter probably referring to manatee. He noted that the Keys had deer and bears and an animal he described as looking "like a fox, yet is not, but a different thing from it. It is fat and good to eat" — probably a raccoon.

Fontaneda mentioned the idea that Ponce de León may have gone to Florida in search of the fabled Fountain of Youth. Fontaneda wrote that, while "I was a captive there, I bathed in many streams, but to my misfortune I never came upon the river." He wrote that many Indians came from Cuba in search of that river and bathed in as many lakes, ponds, and brooks as they could find.

Among the recommendations made by Fontaneda for Florida were that the Spanish should fight the Indians and deport them or enslave them, strong words from a young man but understandable in light of his negative impressions of them. Another recommendation and one that presaged the 20th-century's Cross Florida Barge Canal was that Spain use Florida's rivers to transport goods across the state rather than around the Keys; Menéndez also supported such an idea and attempted to use the St. Johns River to reach Lake Okeechobee, with plans to head west to the Gulf from there. Fontaneda also suggested using Florida as a cattle-raising site, that the Spanish build forts along its east coast to protect the Bahama Channel, and that searchers look for pearls.

One reason the Indians killed shipwrecked sailors, according to Fontaneda, was that the Indians would order newly captured sailors to dance and sing; the

sailors, not understanding the words of the Indians, would not do as the latter ordered, which angered the captors and led to the killing of their prisoners. The Indians seemed to look forward to shipwrecks since they could salvage gold, silver, and jewels from the wrecks, as well as provisions.

Shipwreck survivors like Fontaneda who were freed from the Indians either escaped or were ransomed by Spanish commanders, or were rescued when the Spanish attacked an Indian village. The freed Spaniards were very helpful in acting as translators for European troops since the former had often learned one or more of the local languages. Fontaneda's account of Florida may have discouraged other Spanish explorers from looking for gold and silver mines, since the land had none; the Indians actually had great amounts of gold, silver, pearls, and jewelry, not from any mines there, but from the many shipwrecks they plundered. Fontaneda was fortunate to have survived the loss of his ship and his 17-year captivity; his descriptions of the land and its people have made us much more knowledgeable about the 16th-century peninsula that 12 million people today call their home.

REFERENCE

Memoir of Do. d'Escalante Fontaneda Respecting Florida. Ed. David O. True. Coral Gables: Glade House, 1945.

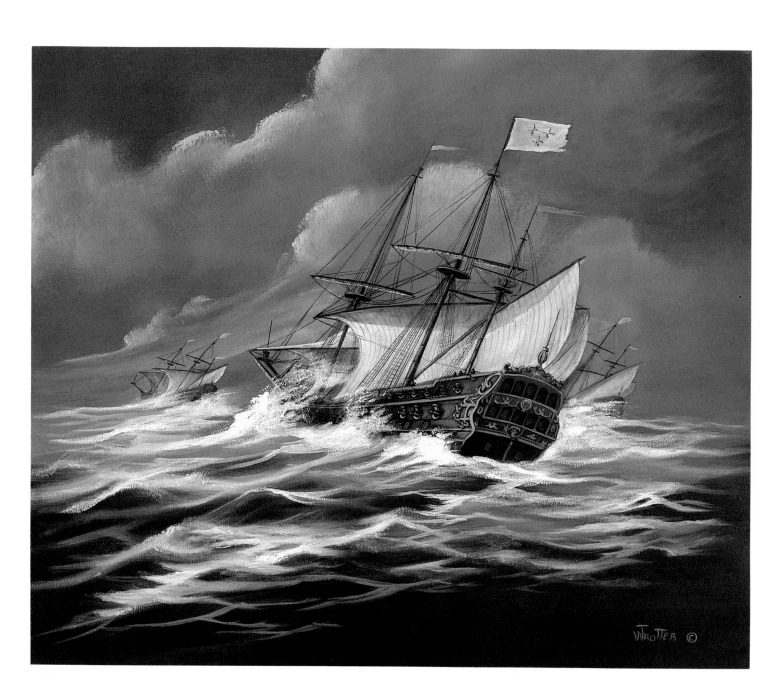

\mathscr{T}RINITÉ, 1565

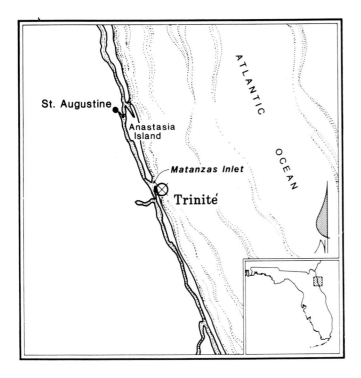

Location: Matanzas is four miles south of Crescent Beach. A marker 200 feet south of Matanzas Inlet Bridge on the west side of A1A notes the massacre of the French, but nothing remains of the shipwrecks. Fort Matanzas National Monument north of the inlet has a display about the Spanish slaughter of the French.

S torms off the Florida coast have often meant trouble for those caught in them. One particular storm in 1565 caused the French much grief and anguish, but enabled their rivals, the Spanish, to claim *La Florida* for themselves. One can only speculate how the history of the Western Hemisphere might have been different if it had not been for that sudden squall from the north, how France and not Spain would have controlled Florida and the offshore route to Europe. That mini-hurricane led to a confrontation between two daring men who faced each other, first over a small body of water at the mouth of St. Augustine harbor and later at a sandy spit south of the settlement; only one of them lived to tell the tale.

After Columbus had come to the New World for the first time in 1492, Spanish explorers followed him, including Ponce de León, whom historians credit as the one who discovered Florida in 1513. Other Spanish explorers followed, men like Pánfilo de Narváez in 1528, Hernando de Soto in 1539, and Tristán de Luna y Arellano in 1559, but they did not succeed in establishing permanent settlements in Florida.

King Philip II of Spain may have been contemplating abandoning his claims to Florida in the early 1560s when he learned that the French had sent an expeditionary force to lay claim to the land. Jean Ribault, a French Protestant, had first come to north Florida in 1562 but did not stay long. After returning to Europe, he came back to Florida three years later with seven ships and 500 soldiers, artisans, and women. He took

them to a newly established French colony, Fort Caroline, along the St. Johns River about five miles from its mouth. When King Philip II heard about the French colony, he sent Pedro Menéndez de Avilés to reclaim the land and settle some 1,000 workers, farmers, and their families in north Florida. Menéndez settled them in a site he called St. Augustine, so named because he sighted Florida on August 28, the feast day of Saint Augustine, Bishop of Hippo. The Spanish wanted settlements along the Florida coast, not so much for the natural resources the land might offer, but as further proof of the legality of Spanish claims to the New World and as ports from which they could protect the treasure galleons returning to Spain from Peru and Mexico.

When the French learned about the new Spanish settlement, Ribault sailed from Fort Caroline with 200 sailors and 400 soldiers ready to battle the Spanish for control of Florida. At St. Augustine Ribault's forces almost captured Menéndez, who was unloading supplies and ferrying them across the harbor, but the Spanish leader beat a hasty retreat to his new town. Ribault's forces, unable to cross the shallow bar at St. Augustine with their large ships, decided to wait for a higher tide and stronger wind. At that point a severe storm, possibly a hurricane so common in the early fall around Florida, arose out of the north and swept Ribault's flagship, *Trinité*, and the other French ships south until they wrecked along the beaches between present-day Matanzas and Cape Canaveral.

Meanwhile Menéndez, guessing that the French had left few soldiers to guard their Fort Caroline, marched his troops overland to the fort, seized the structure, and killed over 100 Frenchmen left behind by Ribault to guard the site. Menéndez renamed the fort San Mateo, left 300 soldiers to hold it, and hastened back to St. Augustine, where he learned from friendly Indians that Ribault's ships had wrecked along the coast. The French troops, barely alive from the harrowing shipwrecks, were walking north along the coast trying to reach Fort Caroline. When Menéndez found them 15 miles below St. Augustine, they were waiting on the south side of Matanzas Inlet for some means to cross the inlet.

Menéndez, using one of his French captives to act as an interpreter, had the French soldiers lay down their arms and then ferried small groups of the Frenchmen across the inlet, questioned each one as to his religious preference, and killed the 300+ who were Protestant, including Jean Ribault himself. One witness to the execution quoted Ribault as saying: "Twenty years more or less are of little account." Among those Menéndez spared were carpenters and caulkers he could use, seamen kidnapped by the French, several musicians (a drummer, a fifer, and a trumpeter), and those who claimed to be Catholics.

Menéndez and his followers, when later asked to justify the slaughter of so many people, argued that the slain were pirates, not soldiers; that they were Protestants, not Catholics; and that he could not provide for so many more mouths to feed. The action at Matanzas, a word that means "slaughters" in Spanish, ended the French presence in Florida and secured for the Spanish a firm foothold in the area. Even when a French force attacked San Mateo three years later and killed any Spaniards they found there, the French did not remain to establish another colony.

One of Ribault's ships ended up near Cape Canaveral in that September storm of 1565. There the shipwrecked survivors built a fort to protect themselves from the Spaniards, hostile Indians, and the elements. When Indians informed Menéndez about the fort, he had 100 of his men sail slowly down the coast, while he led another 150 along the beaches. When they came upon the French fort, the shipwrecked survivors were too weak from hunger and exposure to offer much resistance. Menéndez sent one of his prisoners, the trumpeter, to the fort to demand their surrender, and most of the weary Frenchmen gave up, but others escaped into the woods to take their chances with the Indians.

Realizing he did not have enough supplies for his own men and the prisoners, Menéndez left a garrison of 200 of his soldiers and some of the French captives in the area and sailed to Cuba for supplies. It took Menéndez so long to return that those left behind became desperately hungry. The contingent split up into small groups that frantically foraged for sustenance. When an Indian chief whom the Spaniards had thought was loyal to them attacked the soldiers, they fled several miles south where they built a makeshift blockhouse that they called Santa Lucia, but not before the Indians there had killed 16 more Spaniards. One survivor from that blockhouse later claimed that the desperate Spaniards had resorted to cannibalism, killing the French prisoners and eating them.

Local historians have called those Frenchmen who escaped into the woods or who might have escaped the slaughter at Matanzas Inlet the Ribaults after their slain leader. Stories about those escapees have persisted, kept alive by rumors of 16th-century French coins found near Cape Canaveral. Researchers from such groups as the National Park Service's Southeast Archaeological Center in Tallahassee have dug and sifted through Indian "garbage piles" along Indian River Lagoon below New Smyrna Beach for any signs of European encampments to corroborate those stories, but have found nothing definitive. Those researchers tend to conduct their investigations discreetly so as not to encourage local scavengers who would ruin a site in their search for relics. Officials point out that persons disturbing valuable historical sites face a two-year prison term and a $250,000 fine for violating the Archaeological Resource Protection Act. The stiff penalty is meant to dissuade all would-be looters.

REFERENCES

Lyon, Eugene. "The Captives of Florida." *Florida Historical Quarterly*. July 1971: 1-24.

Tebeau, Charlton W. *A History of Florida*. Coral Gables: University of Miami Press, 1971: 29-36.

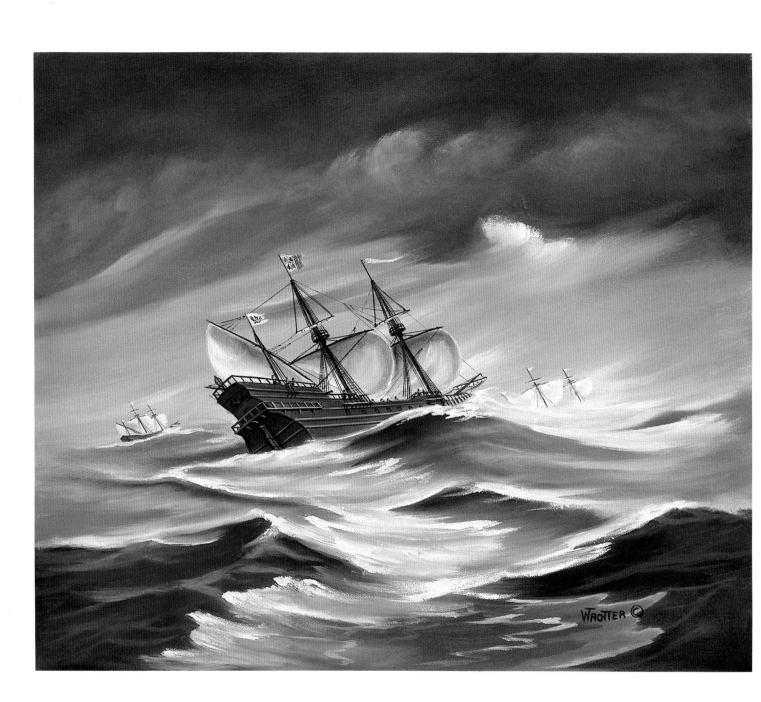

ATOCHA, 1622

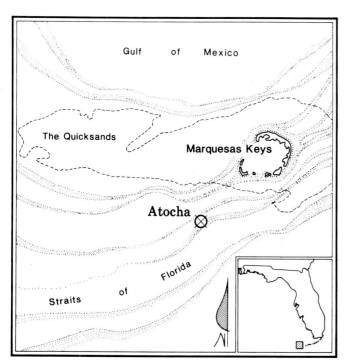

Location: Visitors to Key West can visit Mel Fisher's Treasure Exhibit at 200 Greene Street and actually handle some of the treasure that he and his Treasure Salvors have brought up from the Atocha. *The site of the Atocha wreck is 40 miles west of Key West in the Marquesas just south of the Quicksands and north of the Outer Reef. The site is under contract to a salvage company and is not open to other divers. Passengers flying out to Fort Jefferson can see the site from the low-flying planes.*

The discovery of the *Atocha* exemplifies what treasure-seeking entails: persistence, solid research, the use of high technology, and the ability to overcome immense personal tragedy. To some the price may be too high in terms of lives lost and years spent without any tangible results. But to Melvin Fisher, the person who symbolizes the modern treasure-seeker, the man who began every dive day with the cheer, "Today's the day," it all came together July 20, 1985. What that man with *febris auris*, "gold fever," sought and found that day was one of the richest treasures ever found by a shipwreck diver and one that has inspired many would-be divers to don the latest scuba gear and plunge into the ocean. The story began 363 years before in a country to the south of Florida.

The fleet that assembled in Havana, Cuba, in September 1622 was loaded down with a vast amount of gold, silver, and jewelry. The treasure fleet consisted of eight galleons and 20 merchant ships. The flagship of the fleet, the three-masted *Nuestra Señora de Atocha*, had a crew of 115, a contingent of 100 soldiers, and 48 rich passengers eager to return to Spain with the wealth they had accumulated in South America. In the hold were some 47 tons of gold and silver, as well as much unregistered bullion being smuggled back to Spain by merchants and corrupt officials.

The fleet had silver from the mines of Potosi, Bolivia, which ships had brought to Panama and pack animals had carried across the isthmus to Portobelo on the Caribbean. One Spanish fleet collected all of

that and transported it to Cuba for a rendezvous with a second fleet, which had gone to Vera Cruz, Mexico, to collect gold and silver, as well as the proceeds of the Pacific trade. The two fleets met in Cuba and made plans to return to Spain accompanied by warships for protection against pirates and foreign raiders. The plan was to sail together to the Florida Keys, catch the Gulf Stream up to Cape Canaveral, and then cross the Atlantic to Europe.

Because of unforeseen delays the fleet had to postpone their departure from Cuba until September, the height of the hurricane season. On September 5, 1622, as the ships approached the Florida Keys, an enormous hurricane struck and scattered the fleet. While some of the ships managed to weather the storm, the heavily laden *Atocha* and *Santa Margarita* hit a reef and foundered ten miles southwest of the Marquesas Atolls, 40 miles west of present-day Key West. Hundreds of seamen and passengers lost their lives in the storm, and the rich treasure sank to the ocean floor, soon to be covered by the shifting sands. The other ships made their way back to Havana, where the survivors informed authorities of the tragedy. Officials sent out salvage crews to try to recover some of the treasure, which they did, but fresh storms drove the salvors away before they could work on the *Atocha* and *Santa Margarita*.

And there the treasure remained for the next three centuries, until Mel Fisher, former chicken farmer and shop operator, set his mind to finding it. He and his partners had already discovered part of the 1715 Spanish treasure fleet between Vero Beach and Fort Pierce, Florida, and recovered more than $2 million in gold and silver. He helped develop such innovative technology as the "mailbox" or blower, which enabled crews to force the powerful prop wash from the boat's propellers down to the sea bottom to sweep away sand from sites. He also had the good fortune to have on his team of Treasure Salvors a scholar of immense prestige, Eugene Lyon, a man who had grown up in Miami and knew the Keys well and a researcher who knew how to decipher the old Spanish handwriting on documents in Spain's General Archives of the Indies in Seville.

What had first thrown off searchers was the fact that the Spanish used the term "Matecumbe" for all of the Florida Keys, not just the two islands, Upper Matecumbe and Lower Matecumbe, that map makers today use for two islands between Key Largo and Marathon; as a result of using modern geographical names instead of the 17th-century names, salvors were looking for the *Atocha* 100 miles away from where she lay. Unlike many researchers, who rely on documents written at the time of the shipwreck, Lyon used documents written decades after the sinking of the *Atocha*, reasoning that the records of the Spanish salvors who searched for the ship long after it sank would have valuable information. While Lyon was researching material about Florida explorer Pedro Menéndez, he found some 1626 salvage information concerning the *Atocha*'s sister ship, the *Santa Margarita*, that mentioned the "Cayo de Marquesas." That led him to suggest that Fisher move his operation to the Marquesas west of Key West.

Another problem arose from the fact that most salvors had relied on one Spanish woman to do the translation of the old Spanish documents; in working with those documents about the wreck, she had mistakenly translated the site of the *Atocha* wreck, "veste del ultimo cayo," as "east of the last key," whereas she should have translated it "west of the last key." Lyon realized the mistake and had Fisher move his operation to the west of the Marquesas, and there Fisher's divers found the "mother lode." Such painstaking work with the original documents is often necessary to pinpoint the wreck site. The few scholars of Lyon's caliber who can use the old handwritten Spanish documents are obviously in great demand.

Before that final discovery, tragedy struck Fisher's family. In 1975, Fisher's son Dirk, Dirk's wife, and another diver were drowned when the salvage ship they were on capsized suddenly and sank. Despite his overwhelming grief, Fisher kept on with the search. Strangers' boats began prowling around the area he and his crew were searching, even firing a pistol at one of his boats. Finally, on July 20, 1985, ten years after Dirk Fisher had drowned and 19 years after Mel Fisher had begun his search, his divers found the "mother lode" of the *Atocha*. But his troubles were not over.

First of all, the State of Florida had claimed the wreck as its own property, and that took years for Fisher to clear up. In 1982, the United States District Court finally concluded that Fisher owned the treasure, not Florida or the United States. Secondly, the value of the *Atocha*'s cargo, originally estimated

at $400 million, decreased to $100 million as numismatists took a closer look at the find and as auctions around the country began to flood the market with coins and jewelry. Despite claims that he is interested only in looting shipwreck sites to reach the gold and silver, Fisher has shown a great interest in marine archaeology and preserving such sites for future generations. He has used the services of such people as R. Duncan Mathewson III as archaeological director of the search for the *Atocha*; Mathewson is a dedicated professional who has done much to train future divers in carefully preserving shipwreck sites, especially in the Florida Keys. Since then Fisher has moved on to other searches, not content to rest on his well-deserved laurels.

REFERENCES

Burgess, Robert. F. *They Found Treasure.* New York: Dodd, Mead & Co., 1977: 51-75.

Cardone, Bonnie J. "Atocha Treasure Auction." *Skin Diver.* Jan. 1988: 28-29+.

Lucas, Steve. "Atocha Treasure Found." *Skin Diver.* Oct. 1985: 28-32.

Lyon, Eugene. *The Search for the Atocha.* Port Salerno, Florida: Florida Classics Library, 1985.

Lyon, Eugene. *Search for the Motherlode of the Atocha.* Port Salerno, Florida: Florida Classics Library, 1989.

Lyon, Eugene. "The Trouble With Treasure." *National Geographic.* June 1976: 787-809.

Mathewson, R. Duncan III. *Treasure of the Atocha.* New York: Dutton, 1986.

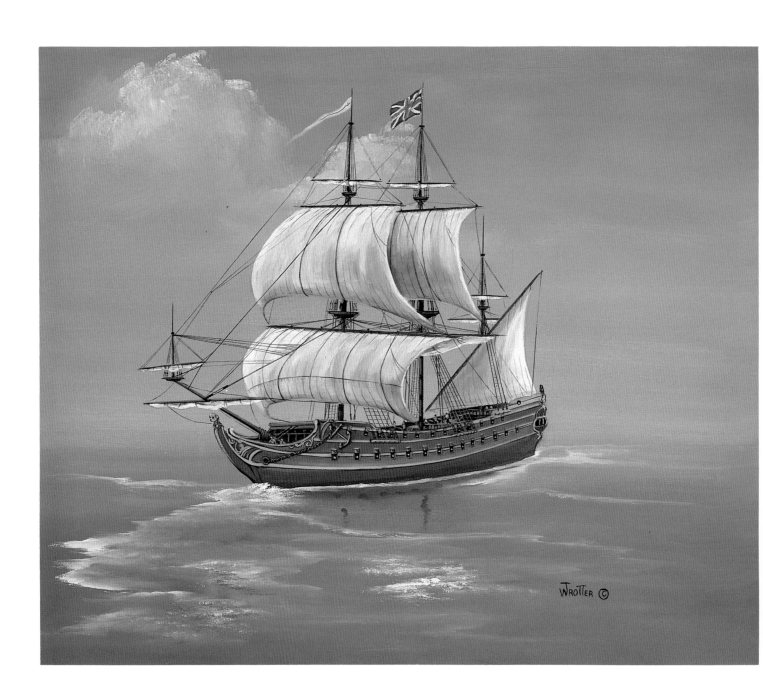

WINCHESTER, 1695

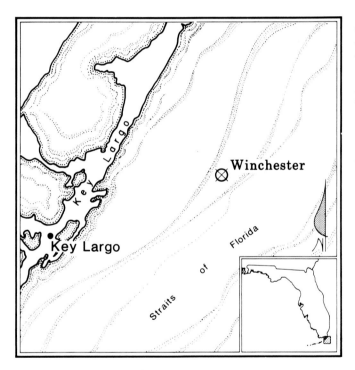

Location: Remains of the Winchester *are in 28 feet of water at the northern end of Pennekamp Park southeast of Carysfort Lighthouse on a direct line between the light house and the Elbow formation.*

Sailors passing along the Florida Keys in the daytime will see a distinct contrast between the white breakers along the shore and the Gulf Stream's ultramarine color. What they won't see is what lies just below the surface: the Florida Reef, a breathtakingly beautiful coral reef to the diver but a deadly menace to careless ships and the reason behind the place's nickname: Graveyard of Ships. The reef off Key Largo, part of a living coral reef and the only one of its kind in the continental United States, is now part of America's first undersea park, established in 1960 and named after Miami newspaperman/conservationist John Pennekamp. Also nearby are Carysfort Reef Lighthouse and Alligator Reef Lighthouse, both of which took their names from ships that grounded on the reef over 170 years ago; the lighthouses have warned passing ships about the dangerous reef for many decades, but no lighthouse or lightship was there in 1695 when a disease-ridden warship crashed on the reef.

For a ship to pass along the Florida Reef during the summer hurricane season was taking a chance. For a ship with a sickly crew and a new commander, who had replaced one who had recently died of disease, was courting disaster, but that is precisely what the British man-of-war *Winchester* did. The square-rigged ship was sailing to England after having attacked the French colony in what is now Haiti in January 1695. From the time the ship weighed anchor at Port Royal, Jamaica, on September 3, 1695, until she wrecked on September 24, some 140 men on

board died from sickness. What that sickness was has been the subject of debate among people associated with the shipwreck.

Records from the British Admiralty indicate that the 934-ton *Winchester* had 60 guns and was therefore a fourth-rate ship-of-the-line. Launched in April 1693, the ship was 146 feet long, had a beam of 38 feet, and housed a crew of 285. The *Winchester* was part of the West India Squadron that set sail from England on January 23, 1695, and escorted 19 ships to Madeira Island, off Africa's west coast, and the Lesser Antilles. After dropping off the escort ships, the squadron sailed for Santo Domingo in April and landed 150 soldiers who went to Haiti to fight the French. In July the squadron sailed to Port Royal, Jamaica, where it remained until September 3.

The ship's log had been recording sickness among the men, but very few deaths up to that time. In Jamaica the death toll began, with at least one man, sometimes more, dying each day, finally reaching a total of 35 for the six weeks the *Winchester* remained at Port Royal. On September 3, the squadron set sail for England and headed for the Straits of Florida, where they hoped to catch the Gulf Stream. The death toll began rising and reached 25 on September 16 alone. During the three weeks it took for the ship to sail from Port Royal to Key Largo, Florida, 140 more sailors died.

The two-year-old ship became separated from the rest of the convoy and wrecked along the outer reef a mile-and-a-half south of where Carysfort Reef Light-house stands today. And there she rested for 243 years, until two fishermen discovered her cannons in December 1938. They kept their find secret until one day they told Charles Brookfield, a resident on Elliott Key 20 miles south of Miami. As is typical of many people who think they have found a sunken treasure ship and because the two men feared that someone might overhear their tale of finding a sunken wreck and then beat them out to the site, they whispered their tale to Brookfield away from his house. All they wanted was to be fairly compensated for their discovery if any treasure might be found.

They then took along another neighbor and a young diver who would go down to the site and determine if the cannons were brass (which they thought would indicate a Spanish wreck) or iron (which they thought would indicate a British wreck).

On their way out to the reef they remembered that a home-builder had found buried treasure 40 years before on Elliott Key, perhaps somehow part of a treasure trove related to the sunken ship they were on their way to see.

When they reached the spot and looked down into the crystal-clear water, they could see cannons lying on the ocean floor — a thrilling sight that excited the men on board the boat. The spread of the cannons over 200 feet in a north-south line indicated that the ship must have hit the jagged reef, began breaking up from the force of the collision, and started spilling her big guns through their ports. The upper tiers of guns must have come crashing through the ship's sides and landed over and near the cannons already spread out on the seabed.

In those days before sophisticated scuba equipment, the diver donned his heavy suit and large helmet while another man began pumping air into the suit, and the diver went over the side and down a tight line to the bottom. He soon determined that the cannons were made of iron. Eventually the small group of men brought a derrick to the site and retrieved some of the guns and coins which later identified the wreck as the *Winchester*. One of the cannons made its way to a resting place at the Historical Museum of Southern Florida, two to the lawn of the Biscayne Bay Yacht Club in Coconut Grove, Florida, several to Lignum Vitae Key State Park, and two to the campus of the University of Miami. One of the objects found was part of a prayer book with Latin words still discernible, preserved for 245 years by the weight of a cannon pressing it into the reef and sand.

Brookfield described the salvage operation in a 1941 *National Geographic* article, to be followed 21 years later by an article in the same magazine that speculated that scurvy was the sickness that weakened and killed off most of the crew. While the cause of death could have been scurvy, malaria, typhus, or dysentery, a medical doctor who examined the records of the ship concluded that the culprit was yellow fever, what sailors called the "Scourge of the West Indies," a disease that could kill a man 12 hours after he contracted it. The doctor came to that conclusion because of the fact that yellow fever was common in the West Indies, where the *Winchester* had stopped, and because a Royal Navy historian noted that when its squadron left Jamaica, "the fever went with them."

Today the remains of the *Winchester* lie in John Pennekamp Coral Reef State Park, a popular site that over 200,000 divers visit annually. Snorkelers often remain close to shore, while more experienced divers boat out to the reef four to seven miles from shore. The clear waters of the nearby Gulf Stream, dramatic coral structures, and abundant fish make the 45-minute boat trip well worth it. Boat operators are careful to preserve the fragile coral reef and warn divers that spearfishing and shell collecting within the park boundaries are forbidden, as is the possession of spear guns, gigs, and bangsticks. Seeing other wrecks in the park like the freighter *Benwood*, which a German submarine torpedoed in World War II, and photographing the elkhorn and staghorn coral throughout the 73,000 acres of the marine preserve usually require several trips, which is why Pennekamp is such a popular dive destination. The picturesque setting offers a stark contrast to that day in 1695 when disease-ravaged men tried unsuccessfully to reach shore from the wrecked *Winchester*.

REFERENCES

Brookfield, Charles M. "Cannon on Florida Reefs Solve Mystery of Sunken Ship." *National Geographic.* Dec. 1941: 807-24.

Le Guin, Charles A. "Sea Life in Seventeenth-Century England." *American Neptune.* 27 (1967): 111-34.

Straight, William M. "The Bilging of the *Winchester.*" Tequesta [Journal of the Historical Association of Southern Florida], 48 (1988): 25-35.

Straight, William M. "The Yellow Jack." *The Journal of the Florida Medical Association.* 57 (Aug. 1971): 31-47.

Weller, Bob "Frogfoot." *Famous Shipwrecks of the Florida Keys.* Birmingham, AL: EBSCO Media, 1990: 29-40.

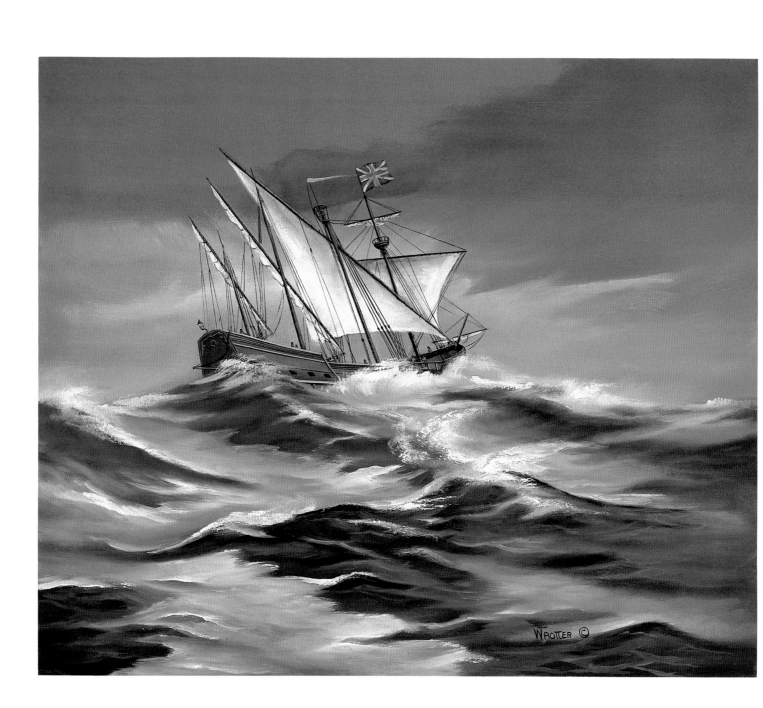

CHAPTER 5

CREFORMATION, 1696

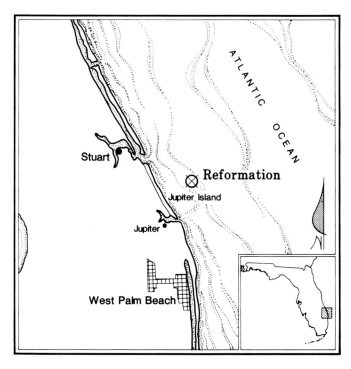

Location: No remains of Dickinson's ship have been identified. The Indians seemed to have burned the vessel to keep the captives from attempting to use it to escape. Jonathan Dickinson State Park, on U.S. 1 13 miles south of Stuart, commemorates the leader of the Quakers who were shipwrecked three miles east of this site.

When the barkentine *Reformation* grounded off Florida's east coast during a heavy storm in 1696, her survivors began an ordeal that ranks among the most harrowing of Florida shipwreck stories. Not only did the small band have to contend with several different tribes of Indians intent on their slaughter, but they also had to deal with mosquitoes, sand flies, freezing cold, and starvation. How they survived and trudged some 230 miles to St. Augustine is a testimony to their deep religious faith and a doggedness that surmounted overwhelming odds. We know much about that shipwreck, the trek along the coast to St. Augustine, and the customs of Indians along the way from Jonathan Dickinson's Journal, a work with a long title: *God's Protecting Providence, Man's Surest Help and Defence, in Times of Greatest Difficulty, and most Eminent Danger: Evidenced In the Remarkable Deliverance of Robert Barrow, with divers other Persons, from the Devouring Waves of the Sea; amongst which they Suffered Shipwrack: And also, From the cruel Devouring Jaws of the Inhuman Canibals of Florida.*

The young Quaker merchant Jonathan Dickinson was on his way from Port Royal, Jamaica, to Philadelphia in September 1696 when a storm forced his ship, the *Reformation*, onto the beach north of present-day Palm Beach. Dickinson describes the horrible feeling the passengers must have felt when they hit land: "About one o'clock in the morning we felt our vessel strike some few strokes, and then she floated again for five or six minutes before she ran fast aground,

where she beat violently at first. The wind was violent and it was very dark, that our mariners could see no land; the seas broke over us that we were in a quarter of an hour floating in the cabin: we endeavored to get a candle lighted, which in a little time was accomplished."

The 24 men, women, and children on board scampered ashore only to meet two fierce Indians rushing at them "foaming at the mouth" and brandishing their knives. The Indians soon left, but later returned with a large group of their comrades who demanded to know if the shipwrecked survivors were English or Spanish. Dickinson knew that the Indians liked the Spanish, or at least were in awe of them, but that the Indians despised the English and probably would kill his group if they suspected that they were English. When the Indians descended on them and started yelling "Nickaleer, Nickaleer," their term for the English, Dickinson's followers shouted back, "No, Espainia." One of the group, a Quaker missionary named Robert Barrow, who was known for telling the truth, admitted that they were English, which seemed to confuse the Indians enough that they did not kill Dickinson's group.

The Indians plundered the shipwreck for most of its cargo, but would not touch the rum, sugar, or molasses. They also rejected the beef and pork from the ship, indicating they did not eat meat. They then stripped most of the clothes off the captives and made them walk barefooted to a village where the group spent much time praying and reading the Bible, actions which calmed the watchful Indians. The captives ate very little, convinced that the Indians were cannibals and "would feed us to feed themselves." At one point Dickinson heard the Indians say "English son of a bitch" and concluded that they had had other English prisoners at one time and had heard their captives use "son of a bitch" frequently.

For some reason the Indians let the Quakers continue on their way and even gave them some provisions. Dressed in canvas patches from the ship's sail, the healthier ones walked along the coast while the sicker ones went in the salvaged longboat. The sand flies and mosquitoes added to their misery. Near St. Lucie the ferocious Ais Indians descended on them shouting "Nickaleer" and kicked and pushed them into a nearby village. Once again the Indians threatened to kill the hapless band, but their good fortune

prevailed. An Indian mother took Dickinson's six-month-old son and suckled him since the baby's mother could no longer provide milk to the baby.

The Indians sent the Quakers on to the Vero Beach area, where they met up with other shipwrecked survivors. While they all waited for help to get them to St. Augustine, a storm washed away their huts and stranded them on a shell mound for several days with no food and little water. They finally found some palm berries and fish which they devoured. When the Indian chief suspected that they were "Nickaleer," he kept them there longer. In mid-October the Indians agreed to take one of the group to St. Augustine for help, but those left behind had a hard time surviving on the scraps of food the Indians provided them.

On November 2, eleven Spanish soldiers arrived from St. Augustine to rescue the group. When the Indians learned that their captives were in fact English, they raged at them, but their fear of the Spanish prevented their harming the Quakers. The situation looked very bad as the group headed north since the Spanish had no extra provisions or clothing for the Quakers. The freezing cold that set in soon killed six of the group, but the others, despite being barefoot, endured storms, rough seas, marsh, and sand, all the while surviving on palm berries and fish. Several of the group froze to death, but the baby somehow survived, "so black with cold and shaking that it was admirable how it lived."

On November 15, they finally reached St. Augustine, where the inhabitants tended to their injuries before helping them reach Charles Town (Charleston) and their home port of Philadelphia. Dickinson went on to become a prosperous merchant and his son, Jonathan, Jr., grew into a healthy young man. The journal that Dickinson wrote, God's Protecting Providence, testified to the courage and faith that the group had and also became one of the primary sources for information on 18th-century Florida Indians. The Indians he came in contact with lived along the eastern coast and on islands rather than in the more marshy, tangled interior, and so they might have been more distrustful of strangers because of their contact with the Spanish and English.

Dickinson noted that the Indians had canoes that were capable of carrying up to 30 passengers and could go far out to sea with two masts and two sails so that they could obtain a sufficient fish supply. The Indians that

Dickinson encountered near Jupiter Inlet depended on fish, oysters, clams, crabs, and berries rather than crops tilled in the soil.

In the subtitle of his journal Dickinson characterized the Indians as *the Inhuman Canibals of Florida*, which may have been more of a fear than a reality. The Indians Dickinson's party met along the way threatened the captives with instant death and continually harassed them, for example in stripping off the few remnants of clothing the men had, but they did allow them to continue on their way, and some of them, especially the chiefs and the chiefs' wives, showed them kindness. All in all, Dickinson's shipwreck and trek north were frightening experiences that most of his group managed to survive.

REFERENCES

Burnett, Gene. "A 230 Mile Gamut of Death." *Florida Trend*. 18 (Feb. 1976): 82-86.

Cabell, James Branch and A. J. Hanna. *The St. Johns: A Parade of Diversities*. New York: Rinehart, 1943: 61-66.

Johnathan Dickinson's Journal or, God's Protecting Providence. Edited by Evangeline Walker Andrews and Charles McLean Andrews. New Haven: Yale University Press, 1945.

Matter, Robert Allen. "Mission Life in Seventeenth-Century Florida." *The Catholic Historical Review*. 67 (July 1981): 401-20.

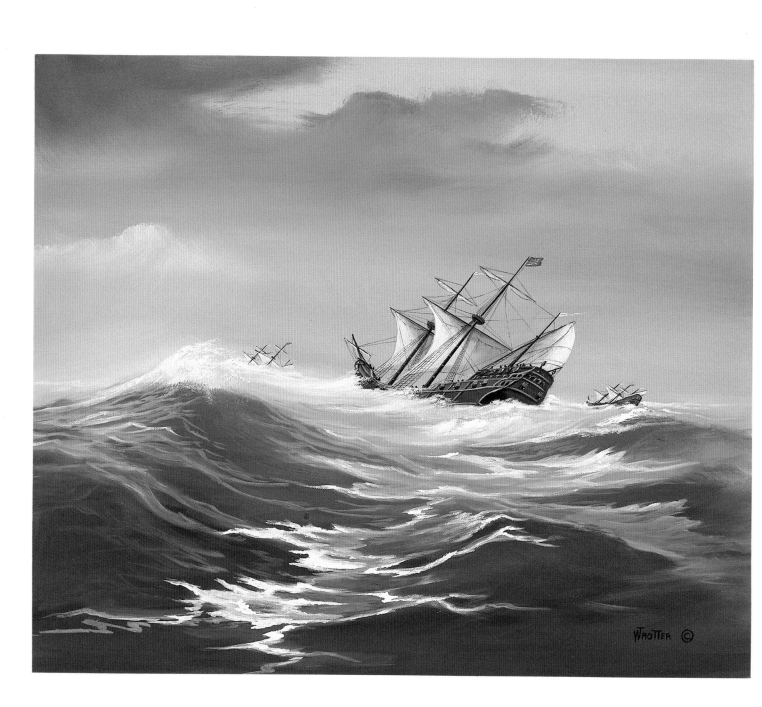

CHAPTER 6

\mathcal{H}ENRIETTA MARIE, 1701

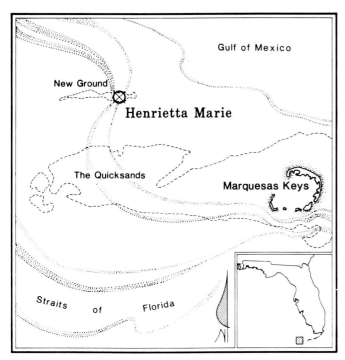

Location: The remains of the slaver are on New Ground Reef about 13 miles west-northwest of the Marquesas about 36 miles west of Key West.

W ithout doubt the most tragic shipwrecks anywhere in the world were the slave ships. Whether transporting captured Indians to work in the Spanish colonies in Hispaniola and Cuba or ferrying African slaves to work in Brazil and the West Indies, those ships of death had some of the worst conditions ever imposed on human beings by other human beings.

Slaves who managed to survive the transatlantic crossing had one more danger to contend with before they reached shore: shipwreck. When the slave ships hit a reef or struggled with a hurricane or simply came apart in heavy seas, the desperate crews scampered overboard and tried to make it to shore, completely oblivious of the screaming slaves manacled together under the decks. The leg irons and wrist shackles on slave ships bear mute testimony to the horrible deaths those slaves must have experienced.

In 1972, treasure hunters found the remains of a small merchant-slave ship that had wrecked on New Ground Reef about 36 miles west of Key West. Pewterware, including large bowls, bottles, tankards, and spoons with their makers' touchmarks stamped on them, enabled researchers to date them back to English artisans between 1694 and 1702. Ivory tusks, trade beads, and sets of leg and wrist shackles confirmed what the researchers had suspected: the ship had been involved in the African slave trade. They concluded that the pewterware had been intended as barter for slaves on Africa's Guinea coast. The ship's bronze bell with the words *"The Henrietta Marie* 1699"

and further research enabled the searchers to identify the ship as a slaver that had left London in September 1699, went to Africa where she traded her cargo for slaves, sailed to Jamaica to unload the slaves in time for the sugar harvesting season, and began her trip home to London in June 1700 or 1701 before the height of the hurricane season, with a load of sugar, indigo, cotton, and logwood. The 120-ton, square-sterned ship must have been hit by a storm as it approached the Marquesas and ended up on New Ground Reef. What happened to her captain and crew of approximately 20 men is unknown.

The artifacts on the ship clearly showed each of the three parts of the triangular transatlantic trade system such slave ships were engaged in. The pewter, trade beads, and guns represented the first leg, London to Africa, and were to be traded for slaves. So much pewterware was left over from that part of the trip and discovered on the wreck site in the Florida Keys because the African natives no longer wanted that particular type of cargo, preferring instead the brass and copper rings that their owners wore around their arms and legs. The swords and firearms found on the shipwreck site would have been used for trading and for defense on board the ship. Captains of slavers were well aware of slave uprisings on the long crossings.

The second part of the trip, the infamous Middle Passage from Africa to the New World, was the one that packed hundreds of slaves below decks for the transatlantic crossing. Searchers found many sets of iron leg and wrist shackles on the *Henrietta Marie* that confirmed the use of the ship. Although South America was the destination of almost 50 percent of all slaves brought to the New World, Jamaica was a popular destination of ships like the *Henrietta Marie* because by 1700 it had become the largest sugar producer in the world and had a slave community of some 45,000. The ship probably stopped in Barbados after the Atlantic crossing in order to replenish her provisions and fresh water supply and then headed on to Jamaica. The ivory found on the ship attested to the fact that the crew was taking "elephant teeth" back to England for the high profits it usually brought there.

The third leg of the trip, from the West Indies to England, was represented by a great quantity of dyewood or logwood, which workers used to make purple dye stuff. Merchants bought the dyewood for the trip home to England after it had been grown in Mexico's Yucatan region and was transported to Jamaica and other islands. Divers also found parts of a bilge pump which the crew had probably used to take out the water that wooden sailing ships like the *Henrietta Marie* collected through its seams. Like many ships leaving Jamaica, the *Henrietta Marie* probably headed for the Dry Tortugas with the idea of proceeding along the Florida coast until she could head for Europe. A 1971 survey of shipwrecks in the Dry Tortugas by the National Park Service turned up 195 wrecks in the area, attesting to the difficulty of navigating the waters there, especially during a storm or at night. For example, another slaver, the *Tyrant*, a New York brig, wrecked on the Marquesas in 1859, a month or so after she may have unloaded 367 Africans in Cuba in February 1859.

While the transporting of slaves from Africa to the New World was bad enough, the conditions on the slave ships were horrendous. The crews packed as many slaves as possible below decks, although occasionally they would allow women and children to make the passage on the main deck under protecting tarpaulins. For the vast majority of slaves, workers would build a slave deck between the main deck, where the crew would work the sails, and the hold, the unventilated bottom of the ship that held food and water. The slave deck might have only about four feet from top to bottom, a distance that did not allow much ventilation; bad weather occasionally forced the crew to shut the scuttles, which aggravated the situation and led to fevers spreading among the slaves. Each slave would have a space of about 16 inches width and five-and-a-half feet length, which forced them to lie on their sides. The stench from urination, defecation, sea sickness, disease, and rotting corpses made the inhumane conditions difficult for the public to imagine. The heat from the tropical sun and the small amount of rations took their toll, especially when the Africa-to-West Indies trip took more than 40 days. Experts estimate that one out of five Africans on such ships died during the Middle Passage. The *Henrietta Marie* could have transported as many as 400 slaves each trip across the Atlantic.

The international slave trade continued through the 18th century into the 1860s despite the laws of civilized nations that outlawed it. Why? Profit. The immense profits slave merchants could earn from the slave trade encouraged them to flout the laws of

European and American nations. A slave that a merchant would buy in Africa for $50 might bring $200 or more in Brazil, Cuba, or the United States. Multiply that figure by the 300 or 400 a slave ship could hold and one can see what profits were available to unscrupulous men.

Until the United States took control of Florida from Spain in 1821, smugglers used the many unguarded bays and inlets of north Florida to bring in slaves before smuggling them into places like Georgia. The United States had outlawed the foreign slave trade around 1807, and so slave smugglers simply shifted their operations south to the territory of Florida. The *Henrietta Marie* is a time capsule of one of the worst segments of our history. That it had probably unloaded its cargo of slaves in Jamaica before wrecking in the Marquesas does not diminish its despicable history.

REFERENCES

Howard, Warren S. *American Slavers and the Federal Law, 1837-1862*. Univ. of California Press, 1963.

Klein, Herbert S. *The Middle Passage: Comparative Studies in the Atlantic Slave Trade*. Princeton Univ. Press, 1978.

Mannix, Daniel P. *Black Cargoes: A History of the Atlantic Slave Trade, 1518-1865*. Viking, 1962.

Moore, David D. *Anatomy of a 17th Century Slave Ship: Historical and Archaeological Investigations of "The Henrietta Marie 1699."* Thesis. East Carolina University, 1989.

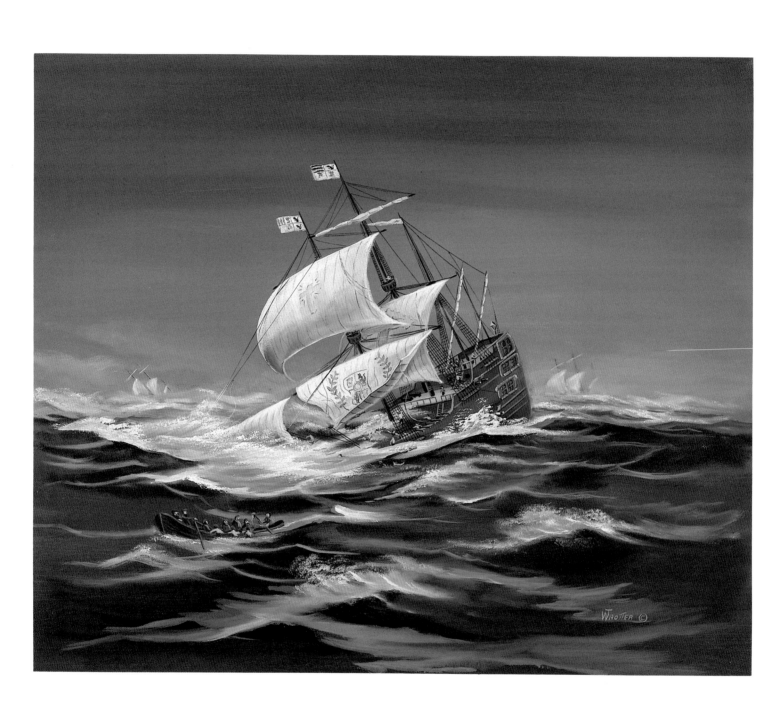

CHAPTER 7

\mathcal{U}RCA DE LIMA, 1715

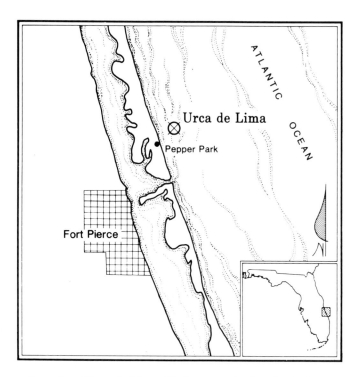

Location: Urca de Lima Underwater Archaeological Preserve is located in 10-15 feet of water, some 200 yards off Pepper Park, north of the Fort Pierce Inlet. Visitors are encouraged to explore the galleon's remains, but it is against the law to disturb or remove anything from the site.

In an effort to encourage more divers to experience the thrill of diving on historic shipwrecks without damaging them and to interpret the significance of such wrecks in Florida's history, the Florida Department of State through its Division of Historical Resources, Bureau of Archaeological Research, has established several underwater archaeological preserves on historic shipwrecks. Such parks, passively managed with the help of local citizens and waterfront groups, allow thousands of divers the chance to explore a sunken shipwreck and witness history frozen in time. The first such park, established in 1987, contains the remains of *Urca de Lima*, a Spanish ship sunk in 1715 off Fort Pierce.

One should not expect to find many remnants of the wooden ships that sank off Florida. Unlike wrecks in the cold waters of the Baltic, where the absence of worms and violent wave motion will sometimes allow wooden hulks to remain intact under the water, the warm waters and turbulent wave motion along Florida's east coast will seldom allow wooden wrecks to remain intact. Also, wooden ships sunk more than 100 years ago were usually subject to the voracious teredo shipworm.

Soon after a ship sinks to the bottom, sea water will penetrate the timbers, and worms, fungi, and bacteria will begin to destroy the wood. The weakened material will break apart and fall to the sea floor where currents and the motion of the water will spread them further. If mud or sand covers the timbers, they may be safe from the worms, but may disappear from sight

forever.

When a ship sinks to the bottom, she does not remain upright, masts erect, sails fluttering in the gentle currents, maybe a skeleton manning the wheel. Instead many a ship began her descent by being buffeted by hurricane-force winds and huge waves. As she slips beneath the surface, everything not attached, including human beings, is swept away. Those divers below the surface who have witnessed the death of a ship claim that she made eerie sounds on her final descent, sounds that the water conducted five times more clearly and efficiently than air.

If the ship turns turtle on the way down, cannons and other loose structures will fall away so that the keel and anchors may be some distance away from the big guns. The "mother lode" and bulk of the ship's cargo will usually be with the keel, if it is still intact. In the warm waters off Florida, living coral will cover any exposed metal. Deeper wrecks will be less subject to storm surges and currents than will those closer to the surface. The wreck becomes a time capsule, freezing forever the last moments of the ship's life on the surface, stopping timepieces at the moment of sinking. Coins washed ashore by storms are what led one of Florida's most famous shipwreck seekers to find a rich treasure offshore.

Like many residents along Florida's east coast near Sebastian Inlet, Kip Wagner, a house builder in Sebastian, knew that Spanish galleons had sailed along the Florida coast in earlier centuries and that some of them had wrecked. He spent many an afternoon in the late 1940s and 1950s combing the sands along the beach near his home and found hundreds of coins. A friend of his, Dr. Kip Kelso, began doing research in local libraries and in the Library of Congress to try to find information about shipwrecks in the vicinity. He finally found what he wanted on p. 273 in *A Concise Natural History of East and West Florida* (1775) by English cartographer Bernard Romans: "Directly opposite [the mouth of San Sebastian River] happened the shipwreck of the Spanish Admiral, who was the northermost wreck of [the] galleons,...all laden with specie and plate." That work, written just 60 years after the shipwreck, contained a detailed map that told Kelso and Wagner they had rediscovered the 1715 Spanish Treasure Fleet wreck.

In July 1715 the Spanish treasure fleet set sail from Havana for the long trip home along the Florida coast.

The 11 ships carrying tons of treasure from Mexico and Colombia as well as goods from the Orient that came by way of the Philippines planned to travel the usual course home: north from Havana along Florida's east coast to St. Augustine and then east to Spain. Forty miles south of Cape Canaveral a hurricane wrecked ten of the 11 ships. 1,500 survivors reached the beach and immediately began trying to salvage the ships. An English pirate, Henry Jennings, arrived on the scene with a group of 300 brigands, who seized a large quantity of the salvaged coins and fled. Spanish salvors continued working the site and recovered about $4 million of the treasure, leaving some $10 million for future divers.

In doing research in the General Archives of the Indies, a rich storehouse of Spanish documents in Seville, Spain, Wagner and Kelso found information about the 1715 fleet and also about the salvage camps the Spanish set up along the beach near the shipwreck site. Wagner began using an inexpensive Army-surplus mine detector to comb the sands, but did not find much. He eventually discovered the campsites of the salvors and found a gold ring, which hooked him on treasure seeking.

Not having had much success at ground level, Wagner next examined the offshore area from a slow, low-flying airplane and found a dark object 20 feet below on the sandy ocean floor, as well as what looked like logs lying about — what turned out to be ballast stones and cannons. After doing some cursory snorkeling over the site and realizing he was on to something big, Wagner organized the Real Eight Salvage Company, named for *ocho reales*, the Spanish term for pieces of eight, and obtained a salvage search lease from the state of Florida that gave him exclusive searching rights to specific wreck sites he had found. He bought a 40-foot U.S. Navy launch, convinced others to donate time or money to the operation, and began in earnest in April 1960.

After two-and-a-half centuries little remained of the ship's structure, but after patient searching the divers found much silver, gold, coins, and artifacts, including an 11-foot-long gold chain that brought in $50,000 at an auction. The divers spent much time cleaning in hydrochloric acid the silver pieces of eight, called "cobs," which had been cut from a lump or bar of silver. The Real Eight Company, which eventually salvaged over $4 million worth of treasure, consisted

of dedicated divers, including a crew led by Mel Fisher, who would later find the *Atocha* in the Florida Keys. Fisher's crew had developed a magnetometer, a sensitive underwater metal detector that could distinguish between different types of metal. Fisher also developed what he called a "mailbox," a large metal pipe bent downward at right angles and resembling a mailbox, that can direct strong water surges from the propeller down to the bottom to wash away deep sand over a site. Wagner died in 1972 after doing much to stir the fantasies of many would-be divers. The museum Wagner's company founded in Cape Canaveral showed thousands what the sea can reveal to skilled divers.

Even today, major beach erosion that occurs after a storm will often reveal hundreds of the silver and gold cobs that have been hidden since 1715. For example, the Thanksgiving Day storm of 1986 unearthed some $100,000 worth of treasure to those walking the beaches. The 1715 wreck has helped give the area the name of Gold Coast or Treasure Coast.

REFERENCES

Burgess, Robert F. *They Found Treasure*. New York: Dodd, Mead & Co., 1977: Chap. 2: "Kip Wagner: Dragon on the Beach," pp. 26-50.

Burgess, Robert F., and Carl J. Clausen, *Florida's Golden Galleons: The Search for the 1715 Spanish Treasure Fleet*. Port Salerno, Florida: Florida Classics Library, 1982; formerly *Gold, Galleons, and Archaeology* (1976).

Link, Marion Clayton. "The Spanish Camp Site and the 1715 Plate Fleet Wreck." *Tequesta* [Journal of the Historical Association of Southern Florida], 26 (1966): 21-30.

Wagner, Kip. "Drowned Galleons Yield Spanish Gold." *National Geographic*. Jan. 1965: 1-37.

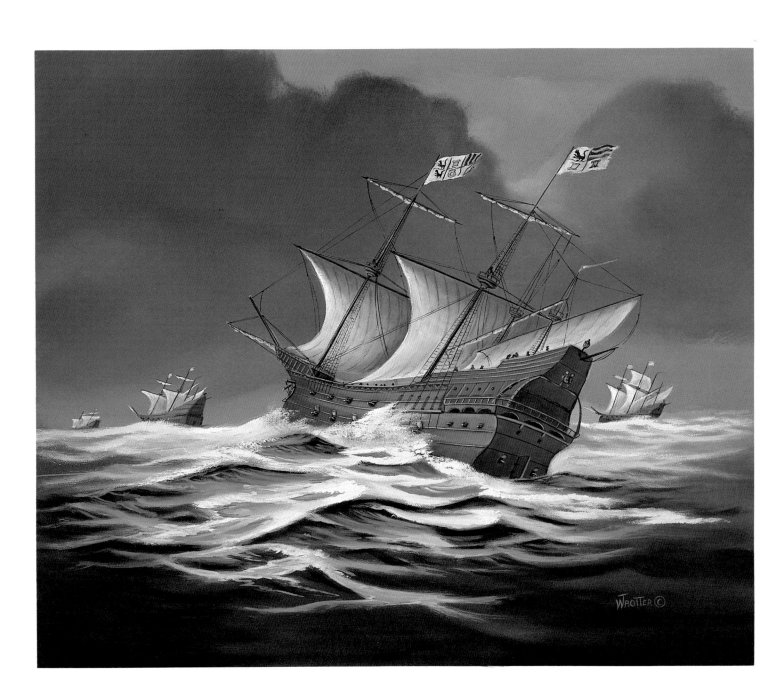

SAN PEDRO, 1733

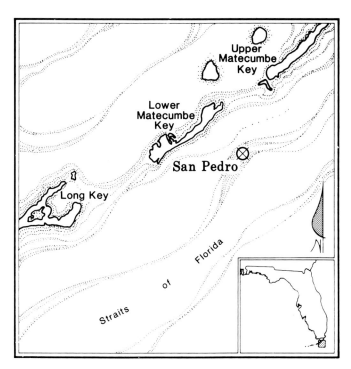

Location: The San Pedro *lies about 1.5 miles south of Indian Key in 20 feet of water.*

The Florida Department of State established an underwater shipwreck park here in Indian Key State Park in 1989 to allow divers to dive on a historic shipwreck, but with enough controls to preserve it for future generations. The San Pedro State Underwater Archaeological Preserve allows divers to see a Spanish ship sunk off Islamorada in 1733. Nearby wrecks from the 1733 fleet include the *Herrera, El Infante,* and *Tres Puentes.*

On Friday July 13, 1733, a dozen Spanish ships in the New Spain fleet headed off from Havana, Cuba, for Cadiz, Spain. Under the command of Don Rodrigo de Torres aboard his flagship, *El Rubi Segundo,* the convoy had four armed galleons and 18 merchant ships carrying treasure from Asia and Spain's colonies in the Philippines and Mexico. On Sunday, July 15, 1733, a fierce hurricane caught them unawares, scattered them along 80 miles of the Keys, and grounded all but one of them, including the 287-ton, Dutch-built *San Pedro.* The one surviving ship, *Nuestra Señora de Rosario,* returned to Cuba with the news of what had happened. Survivors of the wrecked ships huddled on shore and built crude shelters from the debris washed ashore. Spanish salvage crews arrived on the scene in the following weeks, tended to the survivors, and recovered much of the ships' cargo and treasure, which amounted to more than was listed on the official manifests and thus was part of contraband being smuggled back to Spain. The crews refloated some of the less-damaged ships

and towed them back to Havana. They burned the others down to the waterline so as to let divers descend into their holds and to hide the wrecks from roaming scavengers. They managed to retrieve much of the ships' silver, China porcelain, ceramics, and art from Spain's colonies. And there the wrecks lay for 200 years, forgotten by the ages.

In 1937, a professional helmet diver, Art McKee, learned from a local fisherman that some cannons and ballast lay in 27 feet of water off Plantation Key. A transplanted New Jerseyite who had come to Florida to be able to swim a lot to heal an injured knee, McKee worked as the chief diver on the Navy underwater pipeline that ran from Homestead to Key West. When he found a 1721 gold coin in the wreckage off Plantation Key, he wrote to the Archives of the Indies in Seville for more information and received a Spanish salvor's chart that pointed out the wreck sites of the 1733 fleet, including *Capitana El Rubi*, the flagship of the sunken fleet and the ship that McKee had found. In those days, before scuba equipment was invented, McKee started taking tourists out to the site in a glass-bottom boat to watch divers working the wreck and allowed those willing to pay $10 to wear his diving helmet and dive on the wreck themselves. In 1949, he opened on Plantation Key the world's first museum devoted to sunken treasure and shipwrecks, McKee's Museum of Sunken Treasure. Despite the fact that the 18th-century Spanish salvors recovered most of the treasure, illegal scavengers have ransacked the wrecks in a futile attempt to find treasure and have ruined the wrecks for other divers.

In the 1980s biologists surveyed the sea life around the wreck, and archaeologists examined the area to see if any of the shipwrecks might be a good candidate for Florida's new program of establishing a living museum in the sea. Students from Florida State University and Indiana University joined officials with Florida's Bureau of Archaeological Research to survey 11 shipwrecks from the 1733 fleet in an attempt to judge each wreck site for public accessibility, natural beauty, and closeness to other state parks. Officials chose the *San Pedro* for the underwater shipwreck park because of its proximity to parks on Indian Key and Lignum Vitae Key. The Islamorada Chamber of Commerce successfully encouraged local businesses to donate money and services to help establish the park. PADI, the Professional Association of Diving

Instructors, also helped in the project. Workers placed concrete mooring blocks at the site that will allow boaters to tie up for diving. An Islamorada gravel company built seven concrete replicas of the Spanish cannons, and divers used huge air-filled flotation devices to place the big guns around the site. They also installed a 700-pound limestone plaque which identifies the site and thanks supporters of the park.

Divers and snorkelers can see the vessel's wooden hull, ballast rock, and several replicas of the cannons that once served the ship. The wreck lies in a picturesque white sand pocket in the midst of turtle grass and rich marine life that have had two centuries to grow on one of Florida's oldest artificial reefs. As at most wreck sites, the *San Pedro* has its resident barracuda as well as countless moray eels, stingrays, groupers, parrotfish, and angelfish. Visitors must not disturb the ship's remains, must not use spearguns or metal detectors, and should tie their boats to permanent mooring buoys and display the "diver down" flag. They should follow the new credo of "take only pictures, leave only bubbles" in order to preserve the state's rich maritime heritage for generations to come.

The ship lies in 20 feet of water about a mile off tiny Indian Key, the first county seat of Dade County and the home of one of the Keys' most infamous wreckers, Jacob Housman, a man who tried unsuccessfully to make Indian Key a major wrecking center in 1830. Located near Alligator and Carysfort reefs, the island gave him quick access to the wrecks that occurred on those reefs. He finally lost his wrecking license when witnesses testified how he illegally removed cargo from wrecks and stored it on Indian Key. That island also became the scene of an Indian attack in 1840. Housman died the next year when he was crushed between a wrecking vessel and a stranded boat; his body was buried on Indian Key.

The coral encrustation and sea life offshore testify to the age of one of Florida's oldest artificial reefs. The idea of having underwater archaeological parks, something that places like Michigan and Vermont also have, provides a living museum in the sea. Many of the thousands of yearly visitors to Florida come because of its water resources, including the ocean, lakes, rivers, and seashores. They are becoming more aware of how seriously the state looks on its underwa-

ter relics, including shipwrecks. Since the Abandoned Shipwreck Act of 1987, the state has taken more interest in preserving its wrecks for future generations. Among the groups in Florida that divers can join for more information are the Paleontological and Archeological Research Team (PART), the Marine Diving Archeological Divers Association (MADA), and the Washington, D.C.-based Maritime Archeological and Historical Society (MAHS); such groups insist that they will excavate historical sites only if a trained archaeologist accompanies them. The state issues very few salvage contracts, which earlier treasure hunters used in Florida. Officials point out that Spanish treasure galleons such as the *Atocha* represent less than one percent of total shipwrecks.

REFERENCES

Burgess, Robert. F. *They Found Treasure.* New York: Dodd, Mead & Co., 1977: 3-25.

Key West Citizen. March 31, 1989: 3B.

Palm Beach Post. March 29, 1989: 1D, 8D.

San Pedro Underwater Archaeological Preserve. Tallahassee, FL: Florida Dept. of State, 1989. Brochure.

Underwater USA. May 1989: 11; Feb. 1990: 40.

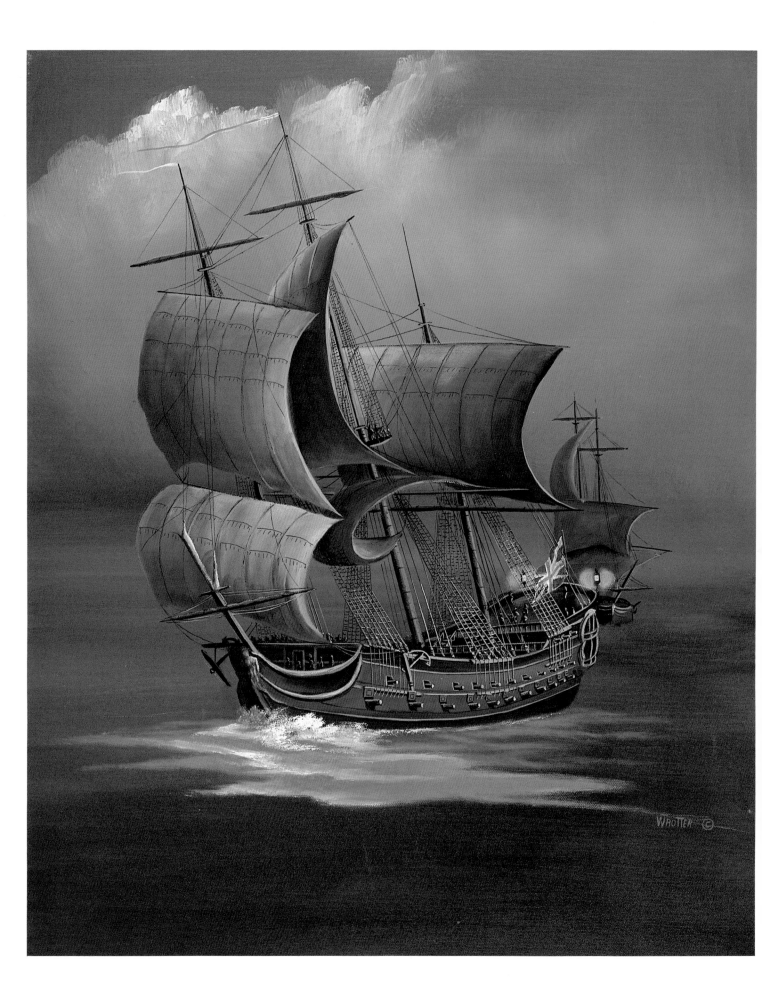

CHAPTER 9

$\mathcal{L}oo$, 1744

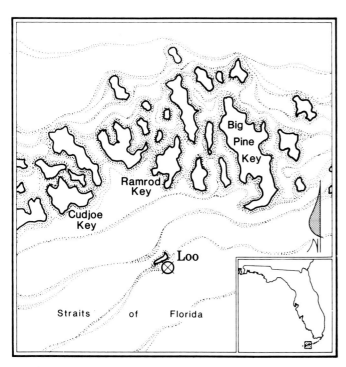

Location: Looe Key Reef is bounded on the north by Hawk Channel and on the south by the Florida Straits. The remains of the frigate Loo *lie in 12 to 30 feet of water southwest of the marker post.*

Wreck divers use any evidence at hand to identify a ship's remains: coins, guns, ballast found at the site; official records of the U.S. Coast Guard and shipping companies; manifests, letters, diaries of those on board or in the area; place names; charts; contemporary newspaper accounts for more recent wrecks; and reports from those living in the vicinity. Researchers on modern wrecks sometimes have success in libraries of towns near the wreck sites since those libraries often have vertical files of local interest, including shipwrecks, and old local newspapers.

Many shipwreck sites have coins, cannons, ceramic materials, and bottles that can date the wreck with a high degree of accuracy. Coins can indicate the date after which the wreck took place and possibly the nationality of the ship. Cannons found at a site will often have a date stamped on them that can identify the wreck; dates expressed in two ciphers were probably used for cannons cast in the last two decades of the 17th century or the first eight decades of the 18th. Charts identifying the class of ship, numbers of batteries on each deck, weight of cannon, and dates cast are available to serious divers, for example in Mendel Peterson's *History Under the Sea*. Such charts will also furnish information on anchors, for example the weight, type, and length for different types of ships and for different countries. Even the type of ballast, whether cast iron or large stones or coarse gravel, can help identify the ship.

Evidence such as coins helped identify the frigate *Loo* (sometimes spelled *Looe*) on a small reef 25 miles southwest of Marathon in the Florida Keys. The fact that the reef there was called Looe, a tradition that commemorated the name of a ship sunk there, suggested that it might have been the site of the final resting place of the 44-gun English frigate lost on February 5, 1744, and subsequent evidence confirmed that. A letter written nine days after the sinking by the ship's captain, Ashby Utting, that researchers discovered in London's Public Record Office gave details of the ship's last days.

The *Loo*, a frigate built around 1706, spent her first few cruises around Newfoundland, Holland, and Russia. She served as a hospital ship, as an intercepter of smugglers and pirates, and as a convoy ship. In 1743, because Great Britain and Spain were at war, the British colonies in North America, especially Georgia and South Carolina, worried about Spanish forces from Florida invading their territories. Those Spanish forces had invaded Georgia the year before, but had been repulsed by Georgia's General Oglethorpe. Authorities in London ordered Captain Ashby Utting to take His Majesty's Frigate *Loo* to Charleston to help defend the coastline from the Spanish. During the winter he was to cruise the Florida Straits to intercept Spanish ships between St. Augustine and Havana.

On February 4, 1744, while Captain Utting and his crew were sailing near Cuba, they saw a suspicious vessel and gave chase. When they caught up with the ship, they found it was flying the French flag; at that time Great Britain and France were at peace. However, Captain Utting saw a suspicious-looking man on the deck of the captured vessel throwing a packet into the sea; when Utting's crew retrieved the packet, they found that the papers indicated the vessel was in the service of Spain. Utting decided to take the vessel to Charleston for further investigation, and the two ships started heading north up the Florida Straits.

As the ships were passing along the Florida Keys, carefully using a lead-line to determine the depth of the water every half-hour, the crews misjudged where they were and ran the ships onto a reef in the middle of the night. Captain Utting ordered the crews to cut away the masts and throw the heavy guns overboard in order to lighten the ships in hopes of freeing them from the reef, but heavy seas pushed the vessels further onto the reef and crushed them. The crews did manage to get off the ships and onto the island and also to save some of the supplies and food.

At dawn the sailors found themselves on a small island about five miles from the main line of Florida Keys. The situation of the 274 who comprised the two crews was desperate. If the Calusa Indians on one of the nearby Keys discovered them, the Indians would probably kill them; the Calusas tended to spare captured Spaniards in hopes of receiving a ransom, but usually killed English captives. The crews also realized that any large wave would completely wash over the island and drown them. At one point they spotted a small Spanish sloop approaching the island. Utting sent a longboat after it, and both vessels disappeared in the distance. The next morning the sloop returned with the longboat in tow; the Spanish crew had abandoned the sloop rather than face capture and headed off in a smaller boat, probably for Havana, where they would tell authorities there about the shipwrecked Englishmen. The stranded seamen knew they had little time to waste in making their escape. To add to his problems, Utting discovered that many of the seamen were mutinous, having rejected the authority of the officers once their ship was wrecked.

The crews loaded supplies into the sloop and increased the capacity of the longboat by adding planks to the gunwales. The next day Utting blew up what remained of the HMS *Loo*, fearing that the Spaniards who had fled his longboat would alert Cuban authorities to their plight and that Cubans would soon arrive to try to salvage the *Loo*'s guns and anchors. Utting put 184 men in the sloop, 60 in the longboat, 20 in another boat, and 10 in a yawl and set sail for the Bahamas. The lighter boats separated from Utting's overloaded sloop during the night and headed across the Gulf Stream for the Bahamas. A strong breeze forced Utting north, and he landed in South Carolina on February 13.

In May 1744, authorities in Great Britain court-martialed Utting for having lost his ship but had to acquit him when evidence indicated that an unnatural current, rather than Utting's negligence or incompetence, had swept the *Loo* off her course. Utting received another commission in July of that year, but his repeated requests to return to the Carolinas, where his wife was, were turned down. Finally, in the spring of 1745, he was ordered to escort a convoy to America, where he was to assume his former com-

mand as senior officer at Charleston. There he had much difficulty patrolling the coast with his small fleet and contending with the enemy privateers along the Georgia and Carolina coasts. In January 1746, Utting died on board his ship at Charleston after returning from a coastal patrol.

Today Looe Key is more of a small coral reef than an island since a hurricane washed away the sand over 100 years ago. The site is about eight miles southwest of Big Pine Key in the Middle Keys, about 25 minutes by boat from sites between Sugarloaf Key and Marathon. In 1981, federal authorities designated the area the Looe Key National Marine Sanctuary in order to protect the fragile coral reef. Unlike other places in the Keys, which attract the majority of their visitors in the winter months of December through April, Looe Key attracts its share during the summer, when the calm waters and high water temperature result in excellent diving conditions. How surprised Captain Utting and his terrified men would be today if they could see the many snorkelers and divers flocking to the reef that brought the British crew such anguish.

REFERENCES

Barada, Bill. "Little Looe Key." *Skin Diver*. March 1979: 60-67.

Colledge, J.J. *Ships of the Royal Navy*. Vol. 1. New York: Augustus M. Kelley, 1969: 328.

Peterson, Mendel. *History Under the Sea*. Washington, D.C.:Smithsonian Institution, 1965: 5-9.

Peterson, Mendel L. *The Last Cruise of H.M.S. "Loo."* Washington, D.C.: Smithsonian Institution, 1955.

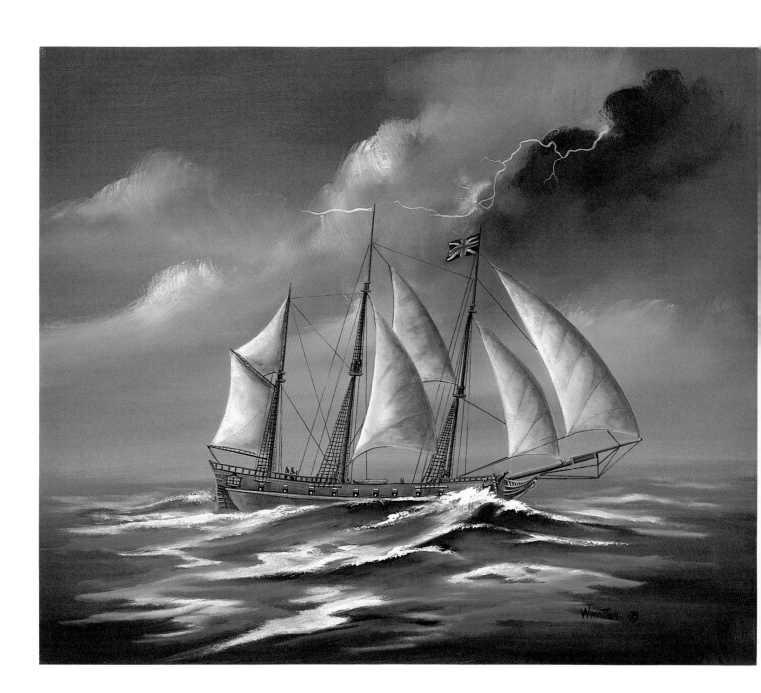

ℳENTOR, 1781

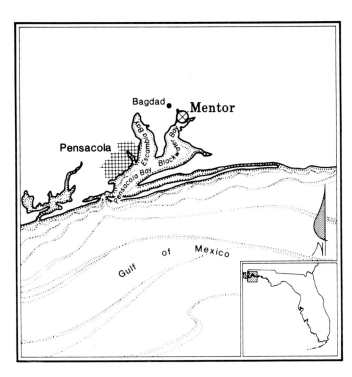

Location: The remains of the Mentor, *while not definitively identified yet, probably lie in the Blackwater River near present-day Bagdad, Florida.*

To all the dangers that ships faced in Florida waters (worms, hurricanes, groundings, submarines, pirates) we need to add one more: lightning. The tall masts of ships offer an inviting target for the lightning that often strikes Florida sites. Such was the case for a robust little frigate, HMS *Mentor*, that served well in the unsuccessful defense of Pensacola when the Spanish attacked it in 1781.

Spanish control of West Florida dated back to 1559, when Tristán de Luna y Arellano led 500 soldiers and 1,000 civilians to settle near Pensacola, but a storm destroyed many of his ships and followers, and Spain abandoned her efforts to settle the area for another 150 years. Various shifting European alliances resulted in French and Spanish conflicts over Pensacola, but the Spanish held it most of the time. In a 1763 treaty Spain traded Florida to England for the return of Havana since the Spanish considered the busy port of Havana far more important than the isolated Florida peninsula that seemed to be full of vengeful Indians and devoid of gold, silver, or any Fountain of Youth. While the English controlled Florida (1763-1783), they set up East Florida and West Florida, the latter extending from the Apalachicola River to the Mississippi.

The small settlement at Pensacola, the seat of government for West Florida, engaged in trade and farming and depended on England's Royal Navy and troops sent by the king for defense. When the 13 colonies to the north rebelled against English rule and

set off the American Revolutionary War, England concentrated her forces along the Atlantic coast, which made the West Floridians fear for their safety, especially from the Spanish in New Orleans. As part of the defense of West Florida England's Admiral Sir Peter Parker, stationed at Port Royal in the British West Indies, purchased a privateer, *Who's Afraid*, and commissioned her in March 1780 as HMS *Mentor*. The sloop-rigged ship of 220 tons and a draught of 14 feet had been built in Maryland in 1778, captured by the British, redesigned to carry 18 12-pound and six 4-pound guns, and then sent out as a privateer against American, French, and Spanish ships. Of great importance for her longevity in the Gulf of Mexico was the copper sheathing that increased her speed and protected her bottom from the sea worms that preyed on many ships there. Admiral Parker ordered her to Pensacola under the command of Captain Robert Deans.

On the trip north to Pensacola Deans captured three enemy vessels and then traded the captive seamen for a like number of English seamen whom the Spanish had captured and sent to New Orleans. That fall of 1780 Deans sailed the *Mentor* west along the coast looking for Spanish ships, one of which he captured out of Mobile. In October a hurricane hit a large Spanish expedition sent from Havana to attack the English and dispersed the Spanish ships.

In a January thunderstorm lightning struck the *Mentor*'s mizzenmast and smashed the main topmast. Deans spent valuable time having his crew replace the mast although the ship would not leave Pensacola harbor again. Deans sent a convoy of nine other ships out of West Florida and back to England before the Spanish arrived. On their way southeastward the convoy came upon a fleet of 38 ships flying the Dutch colors, but confusedly flying them upside down. The English convoy realized the fleet was actually the long-awaited Spanish fleet on its way to attack Pensacola. The Spanish ships arrived near Pensacola in early March, forcing Deans to retreat inside the harbor rather than take on the overpowering guns of the Spanish. Deans then had his men take the *Mentor*'s powder and shot off the ship and on to Pensacola for use at Fort George. While English Navy officials later criticized Deans for not standing and fighting on his ship, his decision to have his men and ammunition deployed at Fort George made more sense and

strengthened the defenses of the city. The Spanish had amassed some 7,000 troops, partly with the help of the French, to fight against the 2,500 defenders of Pensacola, including Loyalists from Pennsylvania and Virginia, and another 1,000 Indians.

On March 20, 1781, Deans ordered all but 12 of his crew ashore to help defend Pensacola. To keep the *Mentor* out of Spanish range the remaining crew members sailed her up Middle River and then up into the more shallow river known today as Blackwater River. Several days later a sudden squall capsized the *Mentor*, and her crew set fire to the little ship to keep her out of Spanish hands. Deans and his crew joined in defending Pensacola, but an unlucky shot from the Spanish exploded the powder magazine and led to the defeat of the English. They surrendered the city on May 10 and thus allowed Spain to control West Florida several years before the English ceded both East and West Florida to Spain in the 1783 Treaty of Paris. The 20-year English rule of Florida had little effect on the place as a whole in terms of history, religion, or customs, and to this day Floridians look more to Central and South America for trade and tourists than to distant England.

When Spanish troops took over Pensacola, they transported most of the surrendering troops to English ports, but would not allow Deans and two other officers to go, partly out of anger at an English revolt against the Spanish at Natchez just before the fall of Pensacola. The Spanish sent Deans to Cuba, where he remained for seven months, before sending him to Spain. Spanish authorities would not allow him to return to England for another 18 months. There he faced a court martial on the loss of the *Mentor*, but the board of judges, including Horatio Nelson, who sat in judgment of him concluded that "the landing the officers & crew and taking them to the Battery was the best expedient in the power of Captain Deans..., that the destroying the Ship was proper & necessary, and that the whole of Captain Deans Conduct was officerlike and meritorious."

Captain Deans went on to command another ship, HMS *Monmouth*, in the North Sea and helped blockade the Dutch fleet before retiring to a quiet life with his family. When he died in 1815, he left behind, somewhere in the quiet of the Blackwater River, a feisty little frigate that did its part in maintaining an English presence in West Florida in the late 18th

century. Since that time two other ships of the Royal Navy have taken the name *Mentor*: a 16-gun American sloop captured by the English in 1781 and wrecked two years later; and an M-class destroyer during World War I.

Because her crew had removed her guns, ammunition, and other equipment for the defense of Fort George, divers these days will probably only find the *Mentor*'s keel, ribs, ballast, sheathing, and metal fittings. Professionals using the latest in remote metal sensing devices and pulse induction detectors may have luck in discovering the site of the wrecked ship, or maybe weekend snorkelers may come upon something that will lead them on to the remains of the ship.

Since the Blackwater River offers more protection than the storm-tossed waters around the Florida Keys, the remains of the *Mentor* might be in a more confined space than a shipwreck subject to hurricanes and violent wave action. The *Mentor* site contains no treasure, but divers who find the site should contact the state's Bureau of Archaeological Research in Tallahassee (904-487-2299) so that experts can map the site and maybe consider it for another underwater archaeological park.

REFERENCE
The Log of H.M.S. Mentor, 1780-1781. Ed. James A. Servies. University Presses of Florida, 1982.

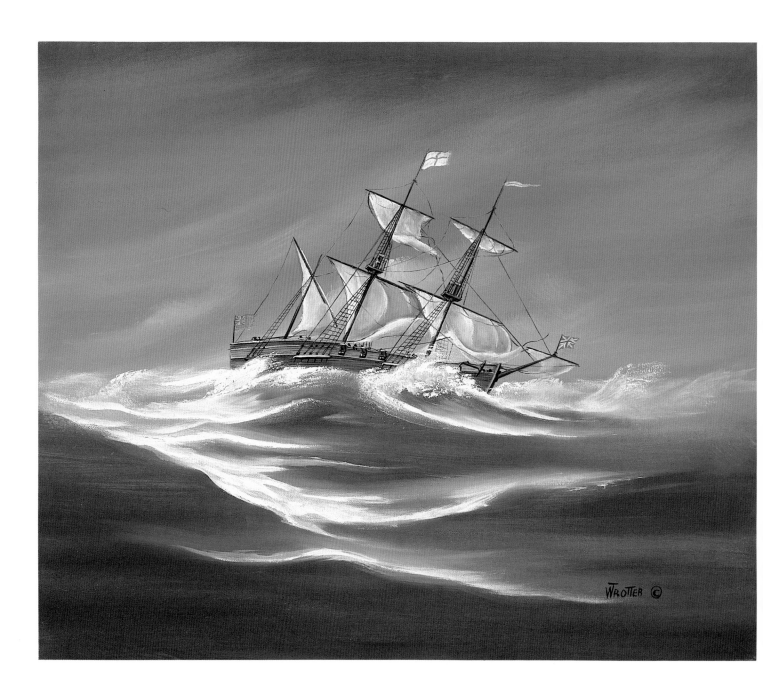

ATHENAISE, 1804

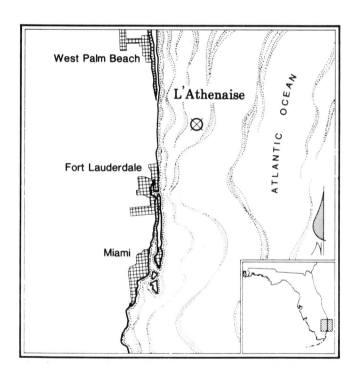

Location: The ship wrecked near Fort Lauderdale, but most likely divers would have difficulty identifying this particular wreck, if in fact anything is left of it.

Some ships courted shipwreck. Imagine sailing on a ship in which no one on board knew the ocean currents, a small canoe was the single lifeboat, the captain was continually drunk, the coastal charts were incorrect, and most of the seamen were incompetent. The *Athenaise*, a copper-bottomed, 350-ton vessel built in Normandy, France, was just such a ship as it attempted to transport a large group of prisoners from Jamaica to England in 1804. That it wrecked off Florida was no surprise to those who knew the treacherous reefs lying in wait for the unsuspecting pilot.

The British-controlled ship set out from Port Royal, Jamaica, with 182 French prisoners and a crew of 34 seamen, only five of whom were able to go aloft. The crew was made up of sick men from other ships, invalids that captains were glad to get rid of, even if it meant manning the *Athenaise* with a decrepit crew. Authorities told the French prisoners that the *Athenaise* was to sail to France in an exchange of prisoners, but the British actually planned on taking the ship to England to imprison the French prisoners there. Her 14-month inactivity at Port Royal had diminished the seaworthiness of the ship and definitely contributed to her breaking up on the reef off Florida. The ship's only boat, whose deficiencies were hidden by a new paint job, was too rotten to be of use, but the crew was able to replace it with a tiny canoe that they later used to bathe fever-ridden sailors in. After the ship set out from Port Royal, the sick men began dying at such

a rate that the prisoners figured they would soon be the only ones left on board. The captain was forced to use several of the French prisoners as crew members and gave them full rations instead of the two-thirds usually given to prisoners.

As the ship approached the Florida coast, the captain was too drunk to notice that they were approaching a dangerous reef. The wind, which increased to gale strength, split the foresail, but the crew was too weak to replace it. The only sail left, the main topsail, was not strong enough to prevent the ship from drifting toward the reef. When the ship struck the reef at around four in the morning, the situation on board was desperate, as later described by one of the survivors:

"There were upwards of two hundred men crouching on the deck, naked, and mostly praying and confessing their sins, whilst the sea broke over her mast heads, and to heighten the confusion the mizzen mast fell across the deck, breaking one man's ankle and maiming several others."

Fortunately the strong sea drove the ship over the reef into deep water and onto the beach instead of wrecking it on the reef and drowning the men too weak to swim to shore in the pitch dark of the early morning.

When dawn broke, the sailors found themselves near a sandy, barren beach. Before the onrushing sea destroyed the provisions below decks, the men saved half a cask of pork and four turtles they had obtained as presents for friends at home. When the survivors reached shore, they angrily turned on the derelict captain and blamed him for their plight. The French prisoners decided to hang him and picked out a tree, but the British convinced them not to do it.

Most of the survivors agreed that making the 270-mile trek overland to St. Augustine was their only viable alternative, but several decided to remain with the wreck in hopes of attracting a passing ship. One of those deciding to remain behind had in fact been shipwrecked twice before on that coast and had been rescued by a wrecker. Despite the bad press that wreckers received over the years, they performed many heroic deeds in rescuing shipwrecked sailors along the Florida coast.

The trip north was very difficult. The weary travelers subsisted on what they found along the way, including an occasional rattlesnake that they made into a soup and two parrots that had been brought from the ship. They found no shelter along the way from the rain that drenched them or the hot beach that scorched their bare feet in the day or the cold that beset them at night. Stragglers were left to face death alone, but the others were too exhausted to pay them much mind. They once sighted a schooner that came in close to examine the band, but it was scared off at the sight of 160 desperate men. The able ones spent time capturing the crabs that ventured forth from their holes in the sand around sunset. The men continued walking north, although their feet had swelled to twice their normal size and were ulcerated. Mosquitoes and sand flies made their lives even more miserable.

When the stragglers came upon an American sloop which had also been shipwrecked, they divided the cargo of flour, apples, potatoes, and onions among themselves. Many of the men ate and drank so much that convulsions and delirium set in. One sailor noted that "this coast is very little known and most erroneously laid down on the English charts." They came upon an isolated settler who was trying to raise coffee, and he helped them on their way by ferrying them across an inlet in his boat. Sharks and alligators in the inlet followed the boat, but everyone made it safely across.

Along the way they found cabbage palm, berries, snakes, even a dead alligator. By the time the group reached New Smyrna Inlet, only 140 remained, and many of those were near death. When they found another 18-foot-long alligator, 20 of the men attacked it and succeeded in disabling it by throwing stones and sticks into its mouth when it opened it to charge them. As they approached St. Augustine, they came upon some very reclusive settlers, who might have been deserters from the British army during the American Revolutionary War.

When the weary group, reduced to 131, reached St. Augustine after two weeks of walking along the beach, the Spanish governor was not very happy to see them since he could barely provide for his own soldiers. He was particularly contemptuous of British who were shipwrecked on the Florida coast and refused to send either a small schooner south along the coast to search for more survivors or men on horseback along the beach to bring food to those lagging behind. After recuperating for about three weeks in

St. Augustine, the British sailors among the survivors sailed for Charleston and home. Eighty-one had perished from fever or starvation from the time the ship left Jamaica until the shipwreck survivors reached St. Augustine.

If someone were to find the remains of this shipwreck, they should keep in mind that new rules for shipwrecks are in effect. The Abandoned Shipwreck Act of 1987, which President Reagan signed into law in April 1988, gives states control over historic shipwrecks lying within three miles of the Atlantic Coast and 10 miles of the Gulf Coast. Before that law, modern salvors could make claims to their finds under federal admiralty law. In Florida divers are encouraged to visit shipwrecks, but not to disturb or remove anything from them. The rationale behind such laws is to preserve shipwrecks for future generations and to discourage the destruction of submerged cultural resources that constitute part of our rich maritime heritage.

REFERENCE

"The Wreck of the Athenaise." *El Escribano*. 4 (Jan. 1967): 5-16.

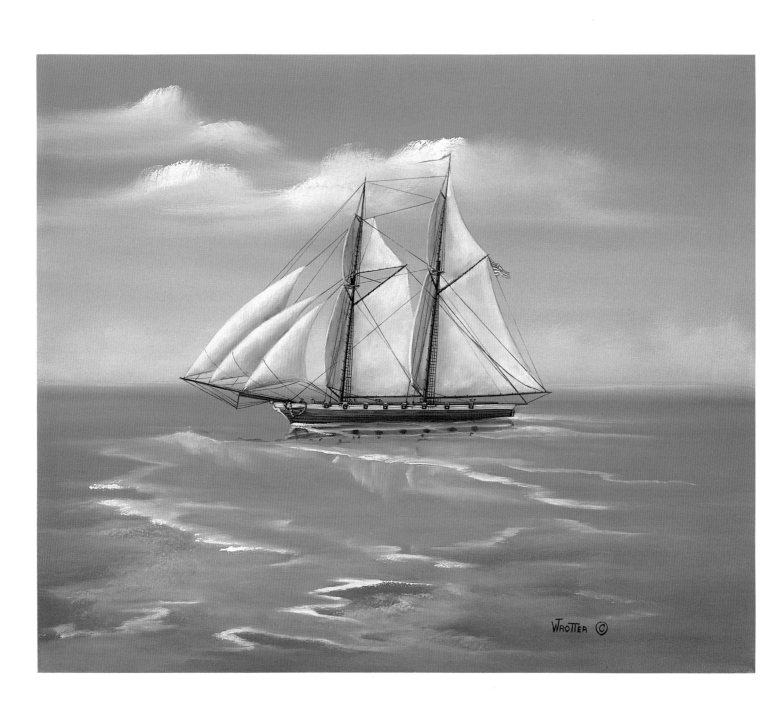

CHAPTER 12

ALLIGATOR, 1822

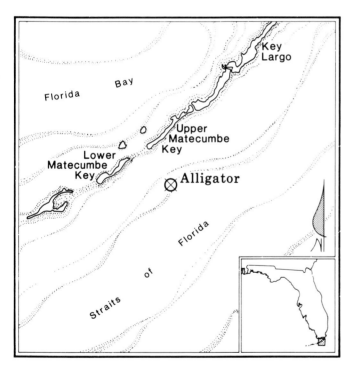

Location: The remains of the Alligator *lie on Alligator Reef, close to the lighthouse in shallow, clear water. Her coral-encrusted ballast piles mark the grave of one of Florida's oldest American warships.*

Pirates and slave traders working in the West Indies from 1818 to 1850 forced American and British navies to spend much time there. The pirates, some of whom had been privateers during the Napoleonic Wars (1802-1815), liked the remoteness and climate of the West Indies and wreaked much havoc on commercial shipping there. At the end of the War of 1812 the U.S. Navy had very few small men-of-war it could use for the suppression of pirates and slavers and so, in 1820, decided to build several small, fast ten-gun schooners of about 175 tons to work in the West Indies. The first one built, the *Dolphin*, was diverted to the Pacific instead of the Caribbean and spent her career (1821-1835) on the northwest coast. The second schooner built was the *Alligator*. The third one, the *Shark*, had a long career (1821-1846) in the West Indies, Africa, the northwest coast, and the Mediterranean. The fourth one, the *Porpoise*, spent her career (1821-1823) in the West Indies. For guns the designers outfitted the vessels with ten short six-pounders and two eighteen-pounders. These small schooners were fast enough to capture many pirates and slavers and brought fame to American shipbuilders.

The *Alligator* that grounded off Indian Key in 1822 was the third of four American naval fighting ships with that name. The first was an 1809 gunboat that protected cities and commerce along the Carolina coast. The second was an 1813 tender out of New Orleans that the British captured in 1814. The fourth

was an 1862 hand-propelled submarine that saw service in the American Civil War.

The third *Alligator* and the one built to fight the pirates in the West Indies weighed about 175 tons, was 86 feet long, and had a speed of eight knots. After being launched at the Boston Navy Yard in 1820 and commissioned in 1821, she made two trips to the west coast of Africa that year and captured several slave ships as the U.S. Navy tried to curtail the lucrative Africa-to-America slave trade. That same year, 1821, after the United States acquired the Territory of Florida from Spain, the federal government resolved to rid its waters of the pirates operating in the Caribbean and West Indies. From June until November 1822 the USS *Alligator* hunted pirates off the southern coast of Florida, but did not find any. Then on November 9, she seized a pirate schooner near Matanzas, Cuba, after a fierce fight during which her commander, Lieutenant William H. Allen, was killed.

Ten days later the ship ran aground on the reef off Indian Key. Its captain, Lt. John M. Dale, later noted that, "after remaining by her three days, using every exertion to get her off, but to no purpose, and expecting any moment that she would go to pieces, I was forced...to come to the resolution of abandoning her and making an encampment on one of the Keys." The American brig *Ann Maria* came along at that time on its way to New York and waited offshore in case it were needed for assistance. Lt. Dale then had his crew transfer the *Alligator*'s cannons and other government property to the *Ann Maria* and ordered his men to blow up his ship in order to keep it out of the hands of pirates. Officials later named the reef for the *Alligator*, a custom followed in the naming of other reefs like the nearby Carysfort Reef, named after HMS *Carysford* that ran aground there in 1770.

A month after the loss of the *Alligator* President Monroe requested the formation of a special naval force to wipe out the pirates still operating off the Florida Keys. The Navy sent Commodore David Porter to Key West to command the force, and he formed the West India Squadron with eight schooners, five barges, and a ferry boat. The barges, which had names like *Mosquito*, *Gnat*, and *Sandfly*

to indicate their persistence and annoying nature (to the pirates), were able to sail in shallow waters and seek out the pirate ships hidden in the mangroves. The barges and schooners did much to end the threat of piracy in the area.

It would be another 51 years before the government would build Alligator Reef Lighthouse, named after the USS *Alligator*, to join other spindly lighthouse structures that follow the Keys down to Key West. They have stood up well to hurricanes and tidal swells, primarily because they are anchored into the reef and because their small mass offers little resistance; the wind and waves pass through the structure. Alligator Reef Lighthouse withstood one of the most powerful hurricanes to hit Florida this century: the 1935 Labor Day hurricane. Winds of 200 miles per hour and a 20-foot storm wave swept over nearby Indian Key, killing more than 400 people, but the lighthouse remained standing. Today the unmanned lighthouses are powered by the sun.

Besides pirates, wreckers used the Florida Keys to make a living from the misfortunes of others. They made their headquarters near such dangerous reefs so as to be able to dash out to ships grounded offshore. The elkhorn and staghorn corals that grow along the upper Keys form a dangerous wave-resistant reef that has torn out the bottom of many an unsuspecting ship. From the days of the Calusa Indians before the time of Columbus, wreckers have had a lucrative business in the northern Keys. Up until the early 1820s the headquarters for wreckers involved in salvaging ships below Miami was in the Bahamas and Cuba. Seven years after the United States acquired Florida from Spain in 1821, the government designated Key West the center of jurisdiction for ships wrecked in the Keys.

At the first cry of "Wreck Ashore!" salvagers would race out in their boats to the site of the wreck. The first one to reach the ship could claim the right to be "wreck master" and would direct the wrecking operation. The wreckers would try to free the grounded vessel before too much damage was done. When they had saved the ship and cargo, wreckers would bring the salvage to Key West, where a court would determine who would receive compensation and how much for the salvage oper-

ation. Wrecking, along with sponging and cigar making, helped make Key West the richest city per capita in the United States, and many of the fine homes in that town owe their elegance and building materials to the wreckers of old. Some of the passengers whom wreckers saved from stranded vessels settled in the Keys, vowing never to risk their lives in a ship again.

Some of the wreckers had a bad reputation of luring ships onto the reef with false lights or of being more interested in salvaging the cargo than in rescuing those on board a stranded ship, but most of the wreckers were honest and solicitous for the well-being of the crews and passengers of the ships. Once the United States government began building lighthouses along the Keys to warn ships of the offshore reef, fewer ships wrecked along the coast, and eventually the wreckers went out of business.

REFERENCES

Brothers, Betty Miller. *Wreckers & Workers of Old Key West*. Big Pine Key, Fl.: Brothers, 1972.

Chapelle, H. I. "Naval Schooners, 1820: Alligator - Dolphin - Porpoise - Shark." *The Mariner*. Vol. 8 (1934): 3-10.

Cheetham, Joseph M. "Wreck on the Reef." *Tequesta*. 18 (1958): 3-5.

Dean, Love. *Reef Lights: Seaswept Lighthouses of the Florida Keys*. Key West: Historic Key West Preservation Board, 1982.

Schene, Michael G. "The Early Florida Salvage Industry." *The American Neptune*. 38 (Oct. 1978): 262-71.

Weller. *Shipwrecks*. pp. 81-89.

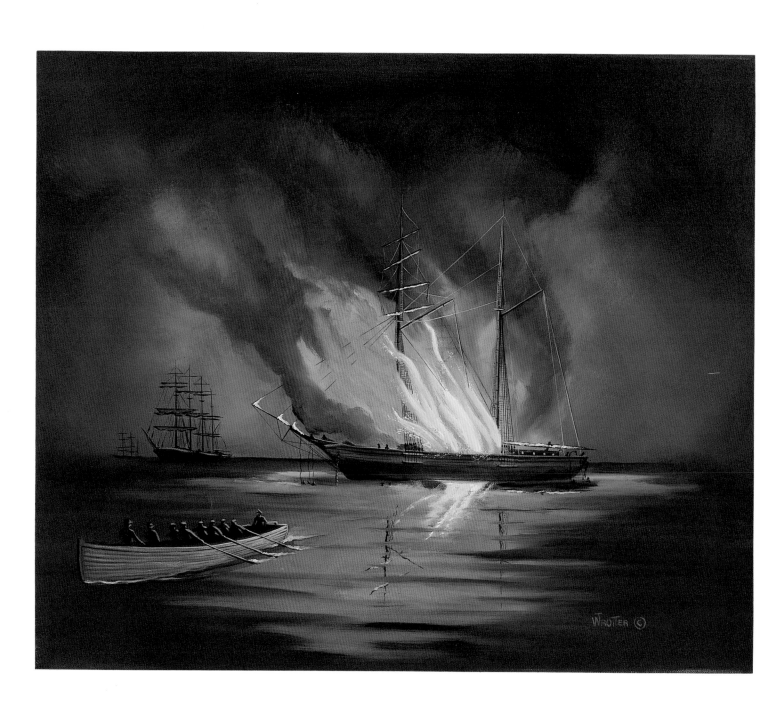

WILLIAM H. JUDAH, 1861

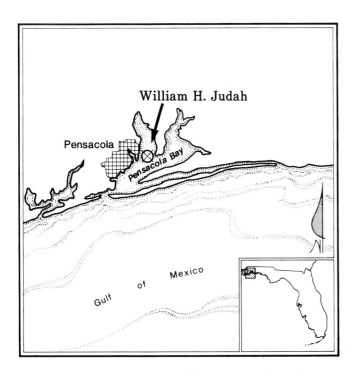

Location: remains of the Judah lie in 21 feet of water near the mouth of Pensacola Bay opposite Fort Barrancas. Most of the wreck lies under several feet of sand.

Pensacola has one of the longest maritime histories of any site in North America, beginning in 1559, when Spanish explorer Tristán de Luna y Arellano led 500 soldiers and 1,000 civilians from Mexico to establish a colony in the Bay of Ochuse (Pensacola); the colony did not survive after a storm wrecked some of the ships and convinced the survivors to give up, but it was the start of a long maritime history. The French and Spanish fought over the city in the early 1700s, and the Spanish settled there until the English took over West Florida in 1763. The Spanish regained control in 1781 and kept it until the United States took control of the whole territory in 1821. Pensacola prospered for the next 40 years, becoming one of the most important cities in Florida and vying with St. Augustine on the east coast to become the most important economic, political, and cultural center of the territory/state. Then the Civil War broke out in the early 1860s. Although Pensacola did not see too much action during the Civil War, one incident happened that surprised the Confederate forces and resulted in the loss of the schooner, *William H. Judah*, as well as the first loss of life in Florida during the war.

Abraham Lincoln's election to the Presidency in November 1860 set the stage for South Carolina's state convention, which passed its ordinance of secession in December 1860. On January 10, 1861, Florida left the Union to join the Confederacy. In February 1861, delegates from the seceded states met in Mont-

gomery, Alabama, and established a new government, the Confederate States of America. Besides an army to fight the Union soldiers, the Confederacy needed a navy to fight on the high seas, protect southern ports and ships, and prey on northern ships. On April 17, 1861, President Jefferson Davis of the Confederacy invited "all those who may desire, by service in private-armed vessels on the high seas, to aid this Government in resisting so wanton and wicked an aggression, to make application for commissions or letters of marque and reprisal to be issued under the seal of these Confederate States." The regulations passed by the Confederate Congress had few restrictions for those interested in pursuing the dangerous but potentially lucrative practice of sending privateers after enemy ships. Those who were attracted to privateering had motives of patriotism for the southern cause as well as making a handsome profit on the captured ships.

In September 1861, Confederate forces contracted with the Judah and LeBaron Company for the use of their 250-ton, two-masted schooner, *William H. Judah*. They then sailed it from St. John, New Brunswick, with a supply of mercury, tin, and lead for the southern forces. Two pilots successfully ran the ship through the Union blockade into the Pensacola harbor. Workers at the Navy Yard then began the process of converting the schooner into a privateer for use by Confederate forces; the workers began installing four broadside guns and a pivot gun amidships on the *Judah*. To protect the vessel from raiders the Confederates placed her at the southeast end of the Navy Yard, mounted several large guns on the battery overlooking the ship, and stationed more than 1,000 soldiers around the Navy Yard.

Commodore William Mervin, the commander of the Union's Gulf Blockading Squadron, considered the danger worth it if his forces could destroy the *Judah* before it headed out to sea. Captain Theodorus Bailey of the USS *Colorado*, a 3,425-ton frigate with 46 guns and a crew of 525, set out to destroy the *Judah* and to spike the guns at the gunnery. Early on September 14, 1861, four boats set out from the *Colorado*: two boats to attack the battery and spike its guns and two boats to destroy the *Judah*. The Union soldiers were to wear white caps to distinguish themselves from the Confederate soldiers. The sailors and marines who set out to spike the guns succeeded in their

task and returned to the ship.

At around 3:30 a.m., a sentry on duty discovered the approaching Union boats and aroused the soldiers at the Navy Yard by firing his gun. The 75 Confederate sailors stationed on the *Judah*'s deck began firing at the approaching Union soldiers, while other Confederates scampered up into the ship's rigging to fire down upon the approaching soldiers. The Union soldiers clambered on board the *Judah* and drove off the Confederates with heavy firing. The first Union soldier to reach the *Judah*, marine John Smith, died when he lost his white cap, which was meant to identify the Union forces from the Confederates; in the confusion one of his own comrades killed him with a bayonet stab to the abdomen. When the Union soldiers found that the Confederates had chained the *Judah* to the wharf, the Union soldiers set her afire and retreated to their boats. The battle was over in 15 minutes.

Unable to douse the flames on the *Judah*, the Confederates watched as she burned to the water's edge and finally drifted free of the wharf and down opposite Fort Barrancas, where she sank. The casualties included three Union marines killed and 15 wounded, as well as three Confederate soldiers killed and numerous wounded. One near-casualty among the Union soldiers was Lieutenant Blake, who had placed a liquor flask — to be used to ease the pain of the wounded — in his left coat pocket over his chest; in the battle that flask stopped a bullet aimed at his heart. And so ended the brief privateering career of the *William H. Judah*. The sinking of the ship probably had little effect on the outcome of the Civil War, but it showed how daring Union commanders could inflict such stinging defeats on the enemy and also demonstrated how vulnerable Florida was to enemy attack.

When authorities can pinpoint the exact location of the *Judah*, they will add it to their map of shipwrecks in the Pensacola area. Local divers in cooperation with the state's Bureau of Archaeological Research are attempting to document wrecks like the *Judah* in an attempt to better preserve such important glimpses into our past. Pensacola's University of West Florida has joined other schools like Florida State University, the University of Miami, Fort Lauderdale's Nova University, Pasco Hernando Community College, and Florida Keys Community College in offering

courses in underwater archaeology and related fields so that skilled divers can add to our knowledge of our maritime past.

When they find artifacts from shipwrecks, like the *Judah*, they may send them to the Florida Research and Conservation Laboratory in Tallahassee, which is part of the state's Archaeological Research Bureau and possibly the world's largest facility for electrolysis on historic artifacts. The laboratory in the state's archives building has large tanks in which workers place metal objects for up to three years, during which time electric currents running through the liquid draw corrosive salt from the metal before workers paint them with preservation materials. Workers place wooden artifacts from shipwrecks in large vats of heated sugar water to bulk up and restore the wood. Elsewhere in the lab others are photographing, cleaning, processing, and illustrating gold and silver coins from shipwrecks and making exact epoxy replicas of swords, pistols, and tools that have corroded away but whose shape has been preserved in calcium carbonate deposits on the sea bottom. Visitors to the Florida Museum of History, to the archives building, and to museums throughout the state can see such items on display.

REFERENCES

Broussard, Larry W. "The Judah." *Skin Diver*. July 1988: 164-68.

Maclay, Edgar Stanton. *A History of the United States Navy From 1775 to 1901*. New York: Appleton, 1906. Vol. 2, pp. 169-70.

Official Records of the Union and Confederate Navies in the War of the Rebellion. Washington: Government Printing Office, 1903. Vol. 16, pp. 670-73.

Pearce, George F. *The U.S. Navy in Pensacola*. Pensacola: University Presses of Florida, 1980: 65-89.

Robinson, William Morrison, Jr. *The Confederate Privateers*. New Haven: Yale University Press, 1928: 231-32.

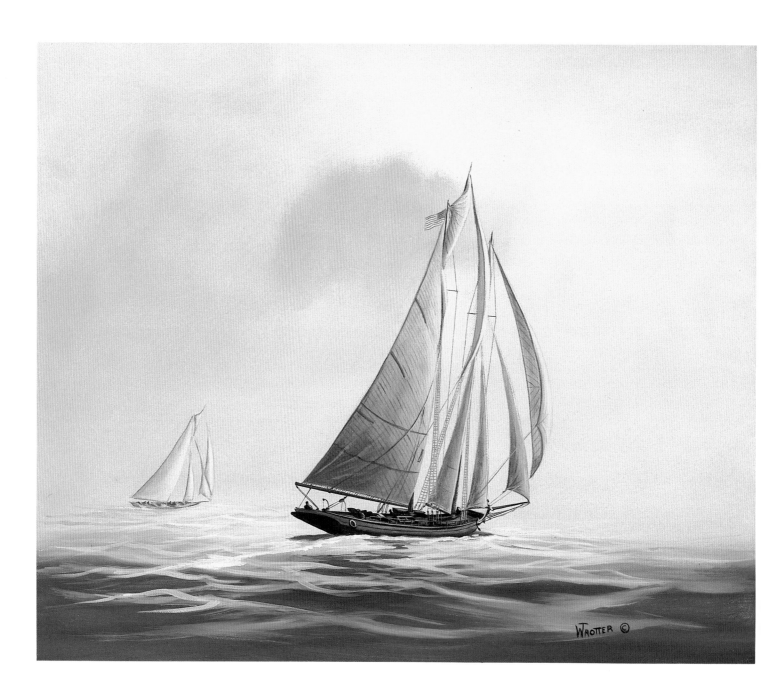

CHAPTER 14

AMERICA, 1862

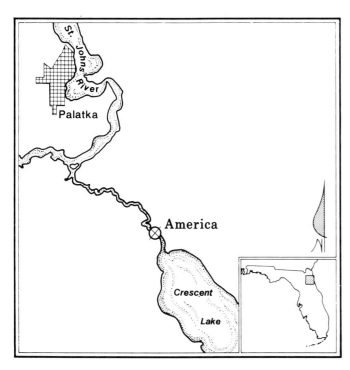

Location: Dunn's Creek, where Confederate forces sank the America, *connects the St. Johns River with Crescent Lake southeast of Palatka.*

The boat lying at the bottom of Dunn's Creek in 1862 had come a long way from her moment of glory 11 years before. Nearby residents might have been surprised to learn that that sunken vessel had excited Americans and stirred patriotic emotions the way very few ships in our history have ever done. Workers would soon raise the sunken ship from the brackish St. Johns to let her continue her 90-year history as this nation's best-known yacht, one that is still commemorated in the world's most famous yachting race.

Eleven years before that, in 1851, a 31-year-old naval architect, George Steers, had helped build a schooner yacht in New York City under the supervision of Commodore John Stevens and the New York Yacht Club. Steers's purpose was to show the world in general and the English in particular that American designers could build the fastest boats on the ocean. When finished, she looked like no other boat of the time. She measured 170 tons, was 101 feet long, and had a beam of 23 feet. Her huge spars stretched 79 and 81 feet, and her main boom 58 feet. Besides four staterooms she had a large fore cabin with 14 berths. More amazing was her long bow and her ability to carry a tall rig, and the small wake she left behind made onlookers disbelieve her speed, until they saw her pass the competition.

Soon after her May launch the *America* sailed for England to enter a yacht race in conjunction with the 1851 Crystal Palace exposition, becoming the first

vessel to ever cross an ocean for international competition. After she arrived in England, workmen covered her dull gray paint with a glossy black coat. She entered an open regatta held by the Royal Yacht Squadron, not for money (no one would bet against her once they saw how fast she was) but for an ornate bottomless ewer known as the Royal Yacht Squadron 100 Guineas Cup, so named for what it cost to have it made. The 53-mile race for the 17 British yachts and one American entry was to be around the Isle of Wight through treacherous waters. *Punch* magazine printed a parody of a famous American ditty that summed up the race; its first two verses are as follows:

Yankee Doodle sent to Town
His goods for exhibition;
Everybody ran him down,
And laughed at his position;
They thought him all the world behind,
A goney, muff or noodle;
Laugh on, good people — never mind
Says quiet Yankee Doodle.

Yankee Doodle had a craft,
A rather tidy clipper,
And he challenged, while they laughed,
The Britishers to whip her.
Their whole yacht squadron she outsped,
And that on their own water;
Of all the lot she went ahead
And they came nowhere arter.

Toward the end of the race, legend has it that Queen Victoria asked those around her which boat was leading and which was second. The answer: "Your Majesty, there is no second." After the race one Maryland family named their newborn daughter America in honor of the most popular heroine of the day. The young upstart American yacht had far outstripped her competitors and laid claim to the cup, renamed the America's Cup, that would remain in American hands until the Australians won it in 1983, only to lose it back to the United States four years later.

After the race, the boat's owners sold the *America* for $25,000 to an Englishman. With a change of name to *Camilla* and several British owners, she eventually wound up in the American Civil War on the side of the Confederacy with yet another name change, to *Memphis*. Southern forces used the speedy yacht as a blockade runner to Nassau and Bermuda, but even she could not continue to outrun the ever-tightening blockade of the Union's South Atlantic Squadron.

In January 1862 the yacht made a final entry into Jacksonville. Charles Boswell's book, *The America*, quoted an eyewitness description of that dash (p. 158):

One moonlight night at Mayport, when the Federal gunboats were just far enough outside for their black hulls to be faintly visible, there came up out of the east on a wholesale sailing breeze a yacht with every stitch of canvas set and drawing. The foam was cut from her bows like a knife would do it and was thrown high over her deck and on her sails. There came a flash and a boom from a gunboat and a shot crossed her bow, followed by more flashes and shots; but on the gallant craft came, spar and rigging untouched, heeling over now and then and righting herself gracefully. She passed inside the bar safely and when she went by the point seemed to be flying. She went up to Jacksonville.

She remained at Jacksonville until mid-March, when the Confederate troops stationed there burned seven sawmills and some four million feet of lumber, confiscated whatever metal they could find for use in making armor, and left hurriedly at the approach of enemy troops. Union forces were about to enter the city by the St. Johns, and the Confederates did not want to meet them. On March 11, 1862, Confederate forces took the yacht up the river beyond Palatka to Dunn's Creek and sank the proud vessel in order to keep her out of the hands of the enemy. When local officials told the Union forces about the disappearance of the yacht, Lt. Thomas Stevens searched the river and finally found her in the creek. After a week of hard labor Union forces raised her and returned her to Jacksonville. She was renamed *America* and joined the Union blockade off the southern coast where she captured one prize. Her service on both sides of that conflict was appropriate since much of the nation had applauded her when she beat the best of the English ships in 1851.

After the war she served as a training ship at the Naval Academy in Annapolis. In 1870, in the first defense of the cup she had won in 1851, a Naval Academy crew sailed her in the race but could finish

no better than fourth, a respectable showing for the 19-year-old vessel. She spent the next 19 years as a private yacht for General Benjamin F. Butler, who entered her in numerous New England regattas. After he died in 1893, some yachtsmen established the America Restoration Fund Committee, bought the boat, repaired her for being towed to Annapolis, and returned her in 1921 to the Naval Academy as a gift of gratitude for the fame she had brought America on that windy day in 1851. Authorities exhibited her at the Academy until the start of World War II, when financial constraints relegated her to storage. On March 29, 1942, a blizzard at the Annapolis Yacht Yard collapsed the shed that housed the yacht, destroying her beyond repair.

In 1857, the *America*'s original owners deeded the America's Cup to the New York Yacht Club and asked that it be an international challenge trophy. In order to ensure that only seaworthy yachts compete for the cup, the original owners required any challenger to cross the ocean under sail on her own bottom, a condition that was rescinded in 1958 to allow smaller yachts to compete and not have to sail across the ocean. The world's most famous yachting race continues to commemorate this nation's best-known yacht.

REFERENCES

Boswell, Charles. *The America*. New York: David McKay, 1967.

Bruzek, Joseph C. "The U.S. Schooner Yacht AMERICA." *U.S. Naval Institute Proceedings*. Sept. 1967: 159-73.

Robinson, Bill. "America," *Legendary Yachts*. New York: David McKay, 1971. pp. 29-45.

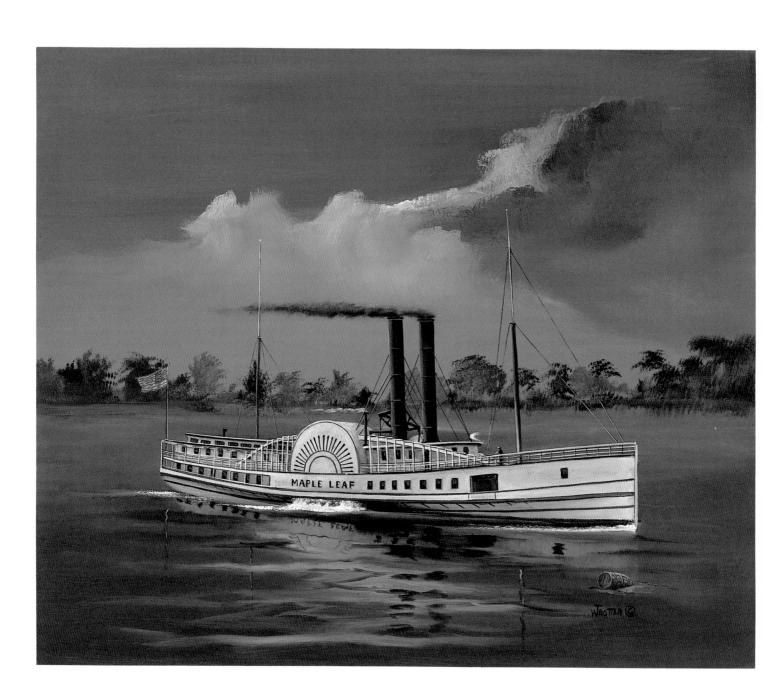

MAPLE LEAF, 1864

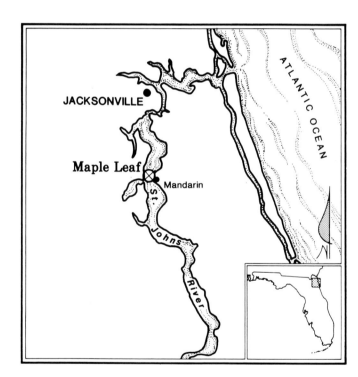

Location: The remains of the Maple Leaf *lie on the eastern side of the river channel off Mandarin Point in the St. Johns River.*

When you read about Florida shipwrecks, you might conjure up precious jewels, silver bars, and vast quantities of gold. However, experts believe that sunken shipwrecks can yield treasures even more valuable than that. To the historian and archaeologist, a ship encased in mud or sand is a time capsule, preserving for decades and centuries the artifacts and everyday utensils from a distant past. The shaving kits, clothing, daguerreotypes, and personal belongings from the depths can educate new generations about life in a former time. Such is the case with the *Maple Leaf*, a Union Transport Steamship which historians and archaeologists have discovered contains a surprising quantity and variety of cultural material in an unusual state of underwater preservation.

The ship, which began life as a luxury passenger and freight vessel in Kingston, Ontario, in 1851, had three decks, was approximately 173 feet long, 24 feet wide, and had a hold depth of 10.5 feet. When the Civil War began, American businessmen bought her for a troop transport. In September 1862 the federal government chartered the double-stacked, sidewheel steamer for transporting army troops. In the spring of 1864, she was sent to Folly Island, S.C., near Charleston and loaded with 400 tons of baggage for a trip to Jacksonville, Florida, where Union troops were to reinforce Union forces against an expected Confederate attack. Confederate troops had defeated Union troops at the Battle of Olustee on February 20,

1864, west of Jacksonville and might have been planning to recapture Jacksonville. It would take the camp quartermasters five weeks to load the 400 tons of personal belongings onto the *Maple Leaf* for the trip south.

When the *Maple Leaf* arrived in Jacksonville on March 30, 1864, local authorities ordered her to transport some 90 cavalrymen and their horses 60 miles south to Palatka. She was to proceed immediately, even before she had time to unload her cargo from South Carolina. In Palatka the ship unloaded the cavalrymen and their horses, picked up three Confederate prisoners and a small group of Union sympathizers fleeing the area, and headed north back to Jacksonville. Meanwhile Capt. E. Pliny Bryan and his Confederate squad of Florida's 2nd Regiment were busy placing beer-keg mines, each with 70 pounds of explosive powder, in the St. Johns River near Mandarin Point 12 miles south of Jacksonville. On April 1, at 4 a.m., the *Maple Leaf* hit one of the mines and exploded. Four deck hands who were sleeping on the ship's bow died when the ship hit the mine, but the other passengers survived. The ship sank within seven minutes in 24 feet of water, but part of the structure remained above water.

The crew found themselves in a desperate situation. The captain later explained, "I expected to see the enemy's small boats put off after us and thought it the better part of valor to get away as soon as possible with the passengers." Because Confederate troops controlled the river's west bank, the crew tried to steer the wounded ship toward the east bank, where Union forces were in control. When the ship sank, the crew abandoned the Confederate prisoners on the ship, piled into lifeboats, and headed for Jacksonville. Later that day the Union gunboat *Norwich* arrived on the scene to retrieve the Confederate prisoners, but declared the ship and its cargo a total loss and not worth the danger of salvaging the cargo in the midst of hostilities. Confederate troops arrived some time later and set the ship on fire, but decided not to try to retrieve the cargo. As time passed, the ship slowly sank into the bottom of the river until some seven feet of mud covered the wreck 20 feet below the surface of the water. And there it remained for 121 years, forgotten by most people but carefully preserved in the river's fresh water and thick mud from the damage oxygen would cause. A freshwater spring near the wreck site may also have prevented the river's brackish water from destroying the ship's more fragile items.

Mandarin Point was a particularly dangerous site on the river because of mines. Two weeks after the *Maple Leaf* incident, the 470-ton Union steamship *General Hunter* also hit a torpedo there, but was not as badly damaged as the former ship and was later raised. In the 1880s, the Army Corps of Engineers dynamited part of the *Maple Leaf* in order to clear the river channel of the wreck's superstructure.

In the early 1980s Jacksonville dentist Keith Holland, the great-great-grandson of an Alabama Confederate soldier, began researching records in libraries, the National Archives, and the Department of Justice and examined 19th-century maps and infrared photographs of the river before he was able to pinpoint the site of the *Maple Leaf*. In a remote-sensing survey of the river bottom, engineers used a highly sensitive magnetometer, which can measure the presence of metals under water and mud. Dr. Holland has spent some $40,000 of his own money as well as state and local grants and funds from private individuals to excavate the ship and formed St. Johns Archaeological Expeditions Inc. of historians, divers, engineers, and admiralty lawyers. In Jacksonville's U.S. Admiralty Court he successfully sued the U.S. Army for the right to excavate the ship.

Holland, who served as president of the Jacksonville Historical Society, has spent countless hours giving illustrated talks to schools and civic groups hoping to find others to carry on the work of the excavation. Holland's group of divers, who are working closely with state archaeologists in Tallahassee to conserve and preserve the artifacts, have retrieved 1,100 pounds of artifacts from the 400-ton cargo, but much remains to be done. Divers have to work in poor visibility conditions caused by the tannic acid of the river. Experts from East Carolina University in Greenville, N.C., have worked with Holland on the *Maple Leaf* and have used the ship in their study of Civil War wrecksites. Holland's careful research into the shipwreck and his working with state governmental bodies (the Department of Natural Resources, the Department of Environmental Regulation, the Division of Historical Resources) and federal agencies (the U.S. Corps of Engineers, the U.S. Coast Guard, the U.S. Environmental Protection Agency, and particularly

the Department of Army — museum branch) have enabled him to identify the shipwreck and obtain the necessary permits to excavate the site.

Workers have been careful in preserving the thousands of articles recovered from the *Maple Leaf*, many of which will be displayed in Jacksonville's Museum of Science and History. They have cleaned the porcelain items, have used electrolysis on the metal ones, and have even freeze-dried the brittle wooden ones. Those artifacts, which have given us an unparalleled view into a military world long gone, will add to the information collected in the Army's Center of Military History in Washington, D.C. One way in which the *Maple Leaf*'s artifacts have changed the ideas of military historians is in what the latter thought the ordinary soldier carried with him from place to place. Before the discovery of the *Maple Leaf* historians thought that soldiers carried with them only the barest necessities and that, when something wore out, the soldiers simply threw it away. The many artifacts from the *Maple Leaf* indicate that soldiers carried many everyday items with them, including sewing utensils and repair kits to fix worn-out items like shoes and clothing. The ship is telling us much about the everyday life of the foot soldier and therefore adding information to our military past.

REFERENCES

The Florida Times-Union [Jacksonville]. Jan. 18, 1988: B1; Aug. 1, 1988: B1; June 28, 1988: A1; April 23, 1989: B1; June 18, 1989: B1; Sept. 15, 1989: B1; Jan. 22, 1990: B1; Sept. 24, 1990: B6.

Perry, Milton F. *Infernal Machines: The Story of Confederate Submarine and Mine Warfare*. Baton Rouge: Louisiana State University Press, 1965: 114-15.

Stewart, Charles W. *Official Records of the Union and Confederate Navies in the War of the Rebellion*. Washington: Government Printing Office, 1902. Series 1, vol. 15: 307, 316.

The Tampa Tribune. Dec. 23, 1990: 10H.

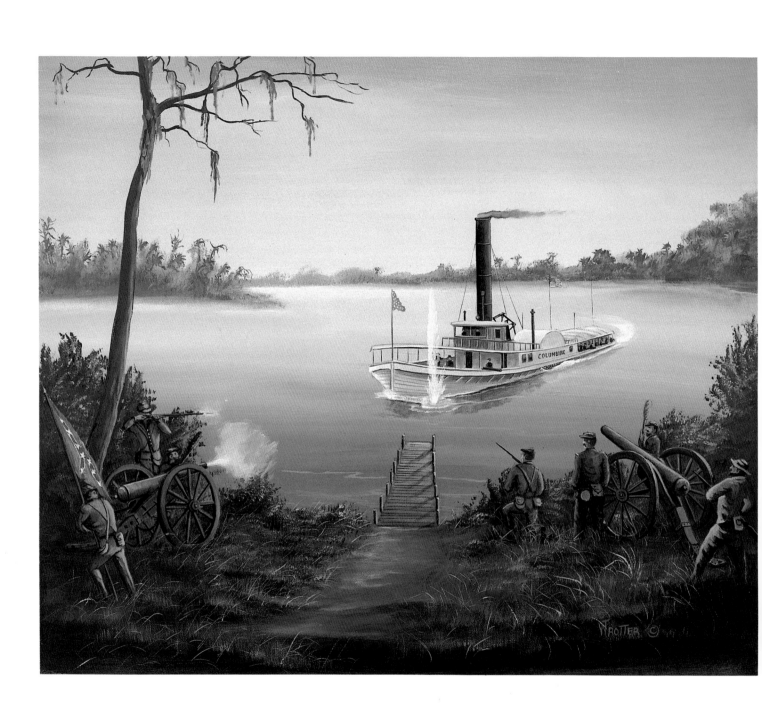

COLUMBINE, 1864

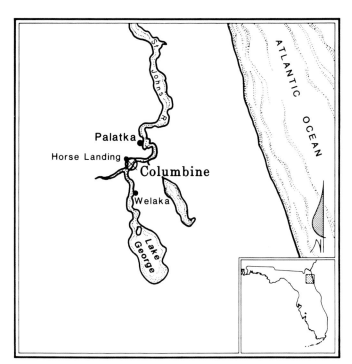

Location: Horse Landing is three miles north of Welaka. The St. Johns is 350 yards wide at that point.

For a ship to be captured by the enemy is not unusual in the annals of naval history. For that enemy to be cavalry is highly unusual; for that cavalry to be dismounted is quite rare and very embarrassing to the ship's crew. But that is what happened along the banks of the St. Johns River below Palatka in May 1864 in what some historians call "the major Confederate naval victory in Florida." That incident rallied Confederate troops throughout Florida and brought fame to Captain J. J. Dickison and his guerilla fighters at a time when Confederate defeats elsewhere were sapping morale and making the end seem inevitable.

When the Civil War began in 1861, the Confederates did not expect much from Florida. The state had relatively few people (only 140,424), farms, and industries, and only several hundred miles of railways. When the Confederate leaders ordered Florida's soldiers to other states in 1862, the state had few left to defend her from Union incursions. In 1864, Florida was doing its part in the conflict by supplying the South with meat from her 660,000 head of cattle and thousands of razorback hogs. The only real pitched battle that took place in Florida was the Battle of Olustee, in which southern troops routed Union forces in February 1864, west of Jacksonville.

Both sides had numerous skirmishes in Florida during the war, and Union troops occupied several important towns like St. Augustine and Key West. The man who did much to keep Union forces at bay and

who inspired many stories and songs about his exploits was Captain John J. Dickison (1816?-1902) of Ocala. A brave man in battle, he had a well-deserved reputation of being ready to protect women and children throughout his territory and of being fair to the enemy he captured. For three years after he helped form the Second Florida Cavalry in 1862 and became its captain, his troops guarded wide areas of north central Florida and waged guerilla warfare on Union forces. One of their most daring and successful exploits occurred on the St. Johns River in May 1864.

In order to prevent ships from leaving or entering Confederate ports, Union ships blockaded the southern coast and raided coastal installations at will. While successfully maintaining that blockade for the last part of the war, federal authorities realized that they had to cruise the inland waters of the southern states in order to prevent or at least harass the movement of supplies and troops. Because the rivers were often shallow, Union forces needed shallow-draft vessels to cruise those rivers, bays, and lakes inaccessible to the large vessels that cruised the Atlantic and Gulf.

In December 1862, the U.S. Navy bought a side-wheel tug, the *A.H. Schultz*, which they renamed the *Columbine* and which they armed with two 20-pounder Parrott rifles before sending her south to join the South Atlantic Blockading Squadron. The 1850 wooden tug, which had been built and used in New York harbor, was 117 feet long, 20.7 feet wide, and drew six feet of water. In 1863 and the beginning of 1864, the *Columbine* patrolled the south Atlantic off South Carolina before she arrived in Jacksonville, Florida, to perform such duties as towing coal vessels, patrolling the St. Johns River, attacking Confederate ships in the river, and transporting goods and people.

In May 1864, the *Columbine* joined the *Ottawa* and the transport ship, *Charles Houghton*, in patrolling the St. Johns near Palatka. The commander of the *Columbine*, Acting Ensign Francis W. Sanborn, notified the *Ottawa*'s skipper that he would fire a rocket if he needed help with any enemy force, but that artillery fire which the soldiers on board the *Columbine* would direct toward the forest along the river would not necessitate help from the *Ottawa*. After leaving Welaka on the afternoon of May 23, he approached Horse Landing around 4 p.m., began firing artillery at suspected Confederates near the landing, and lowered traps in the water to intercept underwater torpedoes.

After Captain Dickison had been notified of the approach of the *Columbine* by scouts along the river, he placed two 12-pounder Napoleon field pieces in the woods on the river's east bank and had his 16 sharpshooters secure their horses and wait in the woods along the bank of the St. Johns. When the *Columbine* came within 60 feet of where they were, Dickison gave the order to open fire. The shots slammed into the vessel and disabled it, causing it to drift onto a sandbar 200 yards from the bank. At that point the *Columbine*'s pilot left his post and jumped into the river to save himself. Another shot pierced the main steam pipe, causing the ship to lose steam. Enemy sharpshooters sprayed the deck with bullets, killing many of the crew. The ship's two 32-pounders proved almost useless before the accurate fire of the sharpshooters behind the trees along the bank. The *Columbine*'s commander realized the futility of his situation and, after consulting with his remaining officers, decided to surrender after the 45-minute battle. As he reported later in the *Official Records of the Union and Confederate Navies in the War of the Rebellion* (series I, vol. 15, p. 452):

> I was spared the mortification of hauling down the flag, it having been shot away in the early part of the action. It now became my humiliating duty to hoist a white flag to prevent the further useless expenditure of human life. A boat from the enemy immediately boarded me, demanding the surrender of the vessel. I refused to surrender to the officer in the boat, but lowering my own boat went on shore and asked to see the commanding officer. I was immediately presented to Captain Dickison, C.S. Army, from whom I demanded, in case of an unconditional surrender, personal safety to the officers and colored men on board, which was immediately guaranteed, whereupon I surrendered myself, officers, and crew as prisoners of war, and my vessel a prize to the so-called Confederate States of America.

The toll of the battle was heavy for the Union forces. Over half of the 148 men on board the *Columbine* were killed or wounded, several of whom drowned when they tried to escape by swimming across the St. Johns. All of the officers except the commander were killed or wounded during the battle.

None of the Confederates were killed. Dickison's men took the Union survivors as prisoners, seized many rifles and rounds of ammunition, and then burned the ship to the water's edge as they feared the *Ottawa* would soon arrive. The scuttling of the *Columbine* did not have much effect on the outcome of the war, but it did rally Floridians behind Dickison and gave his troops a much-needed psychological lift in the weary months at the end of the war.

Dickison took the *Columbine*'s lifeboat and later sank it in a lake near Palatka to keep it away from Union forces. In 1865, after the end of the war, John S. Breckinridge, formerly the vice-president of the United States before joining the Confederacy and becoming the Confederate Secretary of War, fled south and met up with Dickison in Gainesville. Dickison had three of his men raise the lifeboat from the lake and made it available to Breckinridge, who used it to go up the St. Johns. Confederate sympathizers then hauled the boat overland to the Indian River, and Breckinridge sailed down the Indian River to Jupiter Inlet, the Atlantic Ocean, and eventually Cuba. The remains of the *Columbine* itself rested for over 100 years in the St. Johns until divers chanced upon her in the 1970s, but very little is now left of the ship. Many recovered artifacts are on display in local museums.

REFERENCES

Dickison, Mary Elizabeth. *Dickison and His Men*. A facsimile reproduction of the 1890 edition. Gainesville: University of Florida Press, 1962: 62-74.

Mueller, Edward A. "Six Weeks of Glory - One Day of Defeat." *St. Johns River Steamboats*. Jacksonville: Mueller, 1986: 43-52.

Stewart, Charles W. *Official Records of the Union and Confederate Navies in the War of the Rebellion*. Washington, D.C.: Government Printing Office, 1902. Series I, Vol. 15, pp. 446-54.

Tower, Howard B., Jr. "U.S.S. Columbine." *Skin Diver*. Jan. 1985: 54-55+.

Tower, Howard B., Jr. "The U.S.S. Columbine - Florida's Blackwater Civil War Wreck." *Western & Eastern Treasures*. Sept. 1988: 41-43.

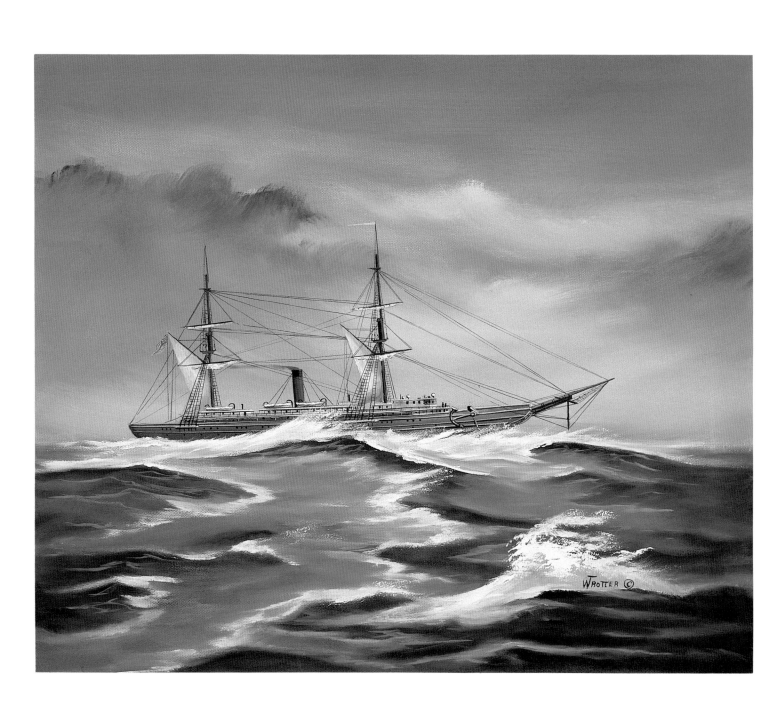

CHAPTER 17

\mathcal{V}ICTOR, 1872

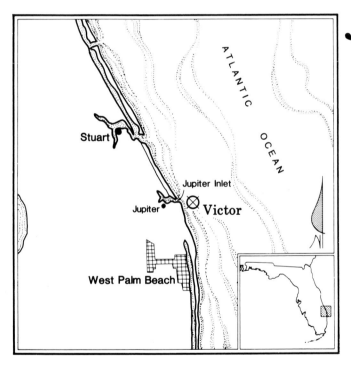

Location: The remains of the shipwreck lie in 20 feet of water about 300 yards off the Jupiter Civic Center.

Jupiter Inlet, which offers a break in the long Florida coastline, has had an erratic geologic history. Drifting sands have sometimes closed the inlet until fall floods or human exertion opened it again. Fish from the Gulf Stream have found themselves up the Loxahatchee River to the delight and surprise of local fishermen, and the outgoing tides have cleansed the river of any debris it had collected.

Among the shipwrecks that might have occurred near Jupiter Inlet was that of the son of Pedro Menéndez de Avilés, the great Spanish explorer who founded St. Augustine. One of the reasons Pedro Menéndez sailed to Florida in the 16th century was to look for his shipwrecked son — but in vain. The father may have stopped at Jupiter Inlet to look for the boy and seen the gold ornaments the Indians had taken from shipwrecks along the coast there. He may have wondered if any of the gold was from his son's expedition.

Many vessels continued to wreck along Jupiter Inlet in subsequent centuries. One particularly bad day for such ships was October 20, 1870. On that day, the steamer *Varuna*, on her way from New York to Galveston, Texas, sank about 35 miles off the coast from Jupiter. Fifty-two persons lost their lives in that accident, including all the passengers and most of the crew. Although only one year old and supplied with excellent engines and boiler, the steamer could not withstand the force of a severe hurricane and a sudden change of wind direction, which caused the ship

to swamp and sink.

Exactly two years later the steamer SS *Victor* was heading from New York to New Orleans when she broke her shaft near Jupiter Inlet during a northeaster. The captain at first ordered the crew to anchor the vessel, but, as the ship began filling with water and threatened to sink, they slipped the cable and allowed the ship to drift toward shore. The $150,000 cargo was a complete loss, but everyone on board survived. The only passengers were the wife of a ship captain in New Orleans (Mrs. Libby), her seven-year-old daughter, and a New York merchant. The three-decked, round-sterned steamer, which had been built in 1863 in Mystic, Connecticut, was 205 feet long, 36 feet wide, 19 feet deep, and weighed 1,326 gross tons. The steamer had two masts, brig-rigged, and was commanded by Captain Gurdon Gates when she wrecked.

The keeper on duty that night in Jupiter Lighthouse, H. D. Pierce, noticed the glow of a ship's lights south of the inlet during the storm and woke the other two keepers, Captain Armour and Charles Carlin. The three men loaded the *Almeada*, Captain Armour's sailboat, with ropes and other rescue equipment and sailed down before daybreak to the south side of the inlet.

At daybreak they saw the steamer lying broadside with the ocean breaking over her and the people huddling in the middle of the vessel. The site of the shipwreck was fortunate since no other white settlers who could come to the passengers' rescue lived within a hundred miles of the site. The ship's crew lowered a large buoy from the stern and watched while it slowly made its way to shore. The three lighthouse keepers on the beach buried a large timber in the sand, retrieved the ship's buoy from the surf, and hauled the heavy cable attached to the buoy up to the buried timber, to which they attached the cable. The steamer's crew then took up the cable's slack and launched three boats, pulling them to land by the cable. The third boat was swamped by a large wave, but the lighthouse keepers on shore succeeded in pulling the capsized crew to safety.

The pigs and sheep on board the steamer all drowned, but three dogs managed to swim to shore. The lighthouse families adopted the collies and named them "Vic," "Surf," and "Wreck." From then on the dog named Wreck hated storms so much that he would hide under the nearest bed during gales and hurricanes. The keepers took Mrs. Libby, her daughter, and the ship's stewardess back to the lighthouse for food and shelter, while the captain and crew pitched tents made out of the ship's sails and camped on the beach. The passengers told their rescuers how relieved they were when they saw the gleaming light from the lighthouse or the lantern as the lighthouse keepers walked along the beach to the wreck. With the wind roaring, the sea crashing onto unseen rocks, the rain drenching everything, and panicky passengers screaming for help, the sight of a steady light on shore usually indicates that the ship's passengers can be saved if they just make it to shore.

Meanwhile seven canoes full of Seminoles appeared on the scene, ready to claim their share of the beach-strewn cargo washing ashore from the wreck. Before the Indians could seize a sewing machine, keeper Pierce quickly claimed it, something that his wife used for years afterwards. The salvage claimed by the Pierces replaced much of what they had lost in a fire just before they had come to Jupiter. A case of 50 men's suits washed up along with bolts of muslin and a case of Plantation Bitters; the Indians retrieved the latter and much of the foodstuffs and proceeded to have a noisy party. The Indians eventually salvaged what they could from what washed ashore and returned home with their booty. Such shipwrecks provided the Indians living along the coast with much-needed supplies.

Four days later the lighthouse keepers signaled the steamer *General Meade* to stop, and it took on the *Victor*'s crew and passengers. The crew eventually returned to New York, and the passengers went on to New Orleans. The ship's two rusty boilers, which remained in place at the shipwreck site, were why local fishermen used the name "The Boilers" for the place. Grouper and snapper made their home in and around the wreck, and gradually people forgot the details of the *Victor*'s demise.

In 1957, two young men flying along the coast near Jupiter Inlet in a small plane noticed that an ocean current had swept the sand from what appeared to be the remains of a shipwreck. After landing their plane, they made their way to the Inlet and obtained permission from a local dock owner to keep their barge and equipment at the dock while they attempted to salvage the metal from the steamer's engines. Over the

next few days they brought up silverware, china plates, a clock, and personal possessions, as well as the scrap metal that had corroded over the years. In time researchers discovered the story of the *Victor* and added another chapter to the history of the area.

Other episodes in the maritime history of Jupiter Inlet have included blockade runners and rum runners. During the Civil War southern sympathizers darkened the lighthouse there in order to allow blockade runners to sneak in and out of Indian River with provisions for the Confederacy. Local residents have occasionally found Civil War cannonballs, which suggests that federal patrol boats fired on the fleeing blockade runners.

In the 1920s rum runners often made the short trip to West End in the Bahamas and returned with cases of liquor to help satisfy the thirsts of Palm Beach socialites. Once inside Jupiter Inlet the boats could disappear up branches of the Loxahatchee, the Indian River, or the Inland Waterway. Whenever a rum-running boat would wreck at the inlet, the word would quickly spread and locals would descend on the site to scoop up the burlap sacks of liquor, called "hams" by the knowledgeable, and take them home. Different kinds of shipwrecks hold a different kind of "treasure" for different people.

REFERENCES

DuBois, Bessie Wilson. *Shipwrecks in the Vicinity of Jupiter Inlet*. DuBois, 1975: 7-8.

DuBois, Bessie Wilson. "The Wreck of the Victor." *Tequesta*. 23 (1963): 15-22.

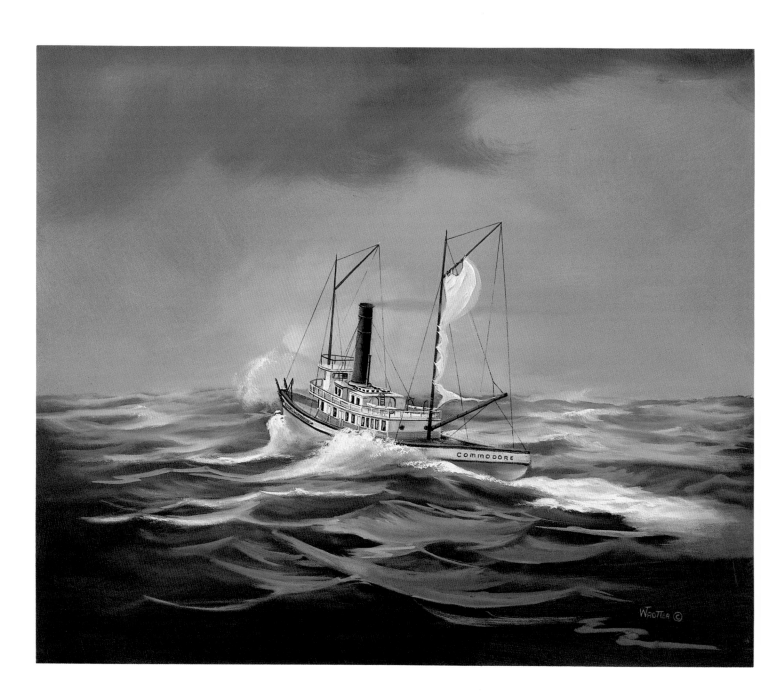

COMMODORE, 1897

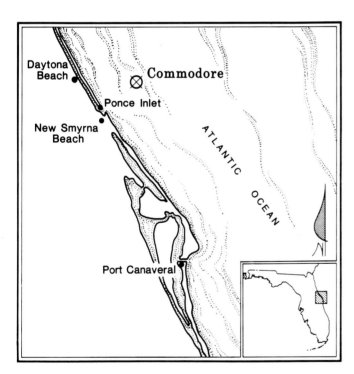

Location: The Commodore *lies in 80 feet of water about 12 miles east of Ponce de Leon Inlet between New Smyrna Beach and Daytona Beach. The ten-foot dinghy washed up on the beach at the site of the Main Street Pier in Daytona Beach.*

S hipwrecks and other near-death experiences affect survivors differently. Some stoically proclaim that it was not their time to die and sign on for other trips. Others give up the sea and head for the safety of inland towns. One, author Stephen Crane, used his harrowing brush with death off Daytona Beach to write one of our country's most acclaimed short stories, an account that has enabled readers to experience a shipwreck and 30 hours on an angry sea in a little dinghy.

When the 25-year-old Crane, author of *The Red Badge of Courage* (1895), decided to write newspaper articles about Cuba's struggle for independence from Spain, he signed on the *Commodore* as an able seaman at $20 a month. The 178-ton steamship, built in Philadelphia in 1882 and based out of New York, was 122.5 feet long, 21 feet wide, and nine feet deep; she had a single, coal-fired engine. When the *Commodore* left Jacksonville for Cuba on December 31, 1896, she carried a cache of arms, including ammunition, dynamite, and machetes for those insurgents fighting for independence from Spain. Because America would not be officially at war with Spain for another 16 months, gunrunning was illegal, but that did not stop arms merchants. The *Commodore* had already made two successful gunrunning trips to Cuba, although revenue cutters had intercepted her on two other occasions and turned her back.

Soon after the ship left the Jacksonville harbor headed for Mayport and the open sea, she struck a

sandbar at Commodore's Point in the St. Johns River and had to wait until a revenue cutter could tow her off. The captain of the *Commodore* failed to have divers check for damage to the hull, which had probably been weakened from the grounding. Later at sea the heavy pounding from the waves weakened her further and she sprang a leak. The engine room eventually flooded, and the pumps could not keep up with the inrushing water. About 18 miles off Mosquito Inlet (now Ponce de Leon Inlet) the captain ordered the crew to bail with buckets and to stoke up the furnace one last time in an effort to build up enough steam to reach the shore. The incoming water soon doused the furnace, and the captain ordered all hands to abandon ship. Later there were rumors of sabotage.

An imminent shipwreck with the possibility of death looming over them affects people differently. One man on the *Commodore* suggested that the captain use dynamite to blow up the ship and not prolong the agony. Another tried to jump overboard, but the mate restrained him. A third knelt at the captain's feet and begged to be thrown into the sea. Crane kept his calm demeanor and, when the crew discovered the leak, was the first to volunteer in any way the captain could use him. Before getting into the dinghy, Crane stood on the bridge scanning the horizon with glasses and trying to figure out the best direction to go.

The first lifeboat with 12 Cubans aboard reached shore at 10 a.m., January 2, 1897, several miles north of the Mosquito Inlet Lighthouse. The second lifeboat with six Cubans reached shore near Port Orange at noon that day. Seven Americans boarded the third lifeboat, but it smashed and sank; the men quickly put together three rafts, but only three of the men made it aboard. The others, including first mate Frank P. Grain, went down with the ship. Captain Murphy, novelist Crane, cook C.B. Montgomery, and oiler William Higgins scampered aboard a ten-foot dinghy just before the *Commodore* sank and headed for shore, confident they would reach the safety of the beach before they tired and lost strength. Little did they know they would spend the next 30 hours bobbing on the stormy Atlantic.

Several problems contributed to their plight. The wind threatened to capsize the tiny dinghy, the waves often seemed about to sink it, and a huge shark hovered nearby, occasionally bumping the boat in an attempt to hasten their imminent demise. The erratic wind pushed the boat south toward New Smyrna Beach, then north to the lighthouse, then inland toward Daytona Beach. Crane did his share of rowing and holding up the oar mast that held the sail made from an overcoat. The Captain had hesitated for several reasons to have the men row the boat toward land and risk capsizing. First of all, he had a broken arm, but also the cook could not swim, the dinghy was frail, the undertow seemed treacherous, and sharks threatened in the area. Finally, realizing that the men were losing strength and hope, Captain Murphy ordered them to take the boat as far toward shore as possible before the surf would capsize it. In the confusion that resulted, oiler Higgins was struck on the head by the overturned dinghy or the loose oars and died soon after reaching shore. At one point Crane, thinking he might not make it to shore, dropped into the sea his chamois-skin belt containing $700 of Spanish gold. Crane later wrote in a newspaper account of the rescue how one rescuer caught sight of the men and "came running down the beach and as he ran the air was filled with clothes. If he had pulled a single lever and undressed, even as the fire horses harness, he could not seem to me to have stripped with more speed. He dashed into the water and dragged the Cook. Then he went after the Captain, but the Captain sent him to me, and then it was that he saw Billy Higgins lying with his forehead on sand that was clear of the water and that he was dead."

The first reports of the accident indicated that Crane had drowned, but later headlines announced "Stephen Crane Safe." His lady friend, Cora, was so relieved that she wanted to hire a special train to take him back to Jacksonville, but Crane refused. The two lovers were reunited in the Daytona railroad-station before heading back to Jacksonville. Crane spent the next few months writing his story about the shipwreck, checking with Captain Murphy for details about the sinking and subsequent rescue. The cold he contracted in that harrowing experience may have weakened him and led to his death from tuberculosis three years later.

"The Open Boat" tells the story of that shipwreck, emphasizing how mortal man is before the forces of an uncaring nature. In 1986, a Jacksonville University English professor, Elizabeth Friedmann, enlisted the aid of veteran diver Don Serbousek of

Ormond Beach to help her locate the wreck of the *Commodore*. Using "The Open Boat" story, newspaper accounts of the time, and other historical documents, they found the remains of a ship which they believe to be the *Commodore*. Serbousek has filed an admiralty claim in federal court which gives him exclusive rights to the wreck. Divers hope to find the ship's pumps to attempt to determine if they had been sabotaged by loyalist Cubans intent on preventing gunrunners from reaching Cuba.

The depth of the wreck, between 70 and 80 feet, allows divers only 30 minutes of bottom time before they have to replenish their air supply and spend two hours decompressing aboard the dive boat. The water is often murky, with strong currents, and sharks are a constant danger. The ship's manifest, printed in Jacksonville's *Florida Times-Union* (Jan. 1, 1897), indicated the steamer was carrying 203,000 cartridges, 40 bundles of rifles, two electric batteries, 30 machetes, 14 cases of drugs, and much clothing.

In the end Cuba won her independence from Spain, Crane wrote a classic American short story about his harrowing experience in the dinghy, and Florida gained a shipwreck that may provide more information about gunrunning a hundred years ago.

REFERENCES

Barada, Bill. "Commodore." *Skin Diver*. May 1987: 128-32.

"Found: Crane's 'Open Boat.'" *Newsweek*. Jan. 5, 1987: 52.

Friedmann, Peggy. "The Raiders of the Lost Commodore." *Jacksonville*. Oct. 1985: 7-11.

Friedmann, Peggy. "Search II." *Jacksonville*. Nov. 1986: 112-14.

Friedmann, Peggy. "Showcase." *Jacksonville*. March 1987: 93-94.

Stallman, R.W. "Journalist Crane in that Dinghy." *Bulletin of the New York Public Library*. April 1968: 261-77.

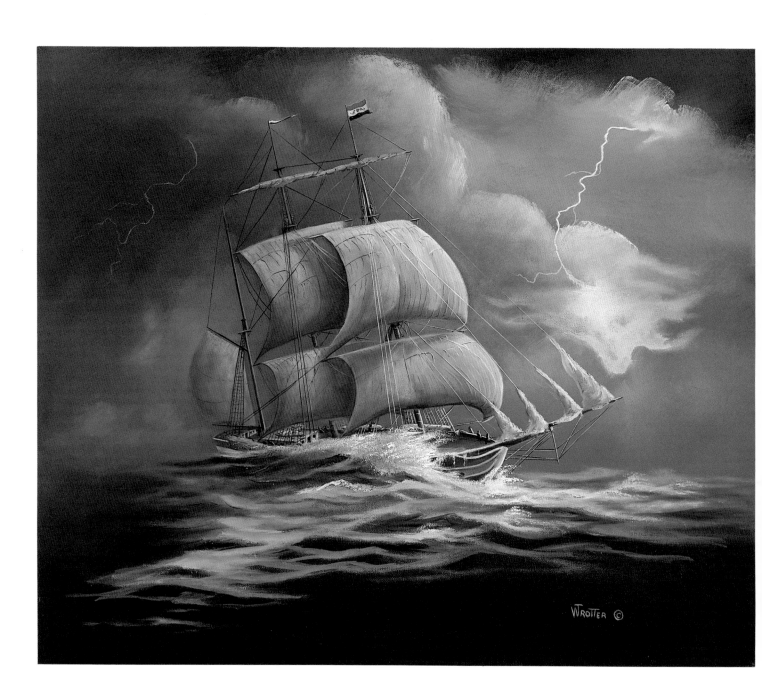

DROT, 1899

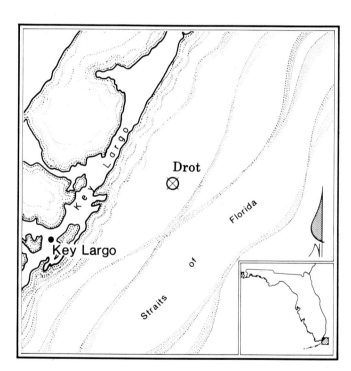

Location: No trace of the Drot *has been conclusively identified.*

Those who survive a shipwreck may sometimes not survive the hunger and thirst that follow. Horrible tales have reached civilized peoples over the years that describe great hardships, deprivations, even cannibalism. What follows is an article from *The Jasper News*, a newspaper from Jasper, Florida, that recounted a terrible Florida shipwreck tale on Friday, September 8, 1899:

ATE FLESH OF DEAD MEN
Horrible Story of Two Survivors
of Storm-Wrecked Bark
Drifted for Days Without Food or Water
Drew Lots to See Who Should Die and
Furnish Blood and Flesh to Survivors

The British steamer Woodruff from Hamburg, arrived at Charleston, S.C., Saturday with two half starved, half wild devils who had lived for two days on a raft at sea on a feast of blood and human flesh. They were Morrison Anderson and Goodman Thomas, members of the crew of the Norwegian bark *Drot*, which was wrecked in the hurricane off the straits of Florida on August 11th.

The bark carried a crew of seventeen. When the storm came down, the vessel was smashed into, the captain and eight men being swept overboard and drowned. Eight men clung to a raft, a part of the bark's deck, and drifted out. The waves, however, smashed this in two, and left six men swinging to the

larger part. The two men on the smaller raft were driven away, and one [was] saved by a passing ship and landed at Baltimore.

When the storm had passed the six men were left drifting about, with no help in sight and without food or water. Some of the bark's trappings were found on the raft and among these was a fishing hook and line. The fish caught were devoured raw by the starving crew. The thirst was fierce. While one of the sailors was fishing with his line staying far out, he drew in a fish, but in an instant he went mad, "I am saved!" he shrieked as he lunged for the fish, and he went over and was lost. With his death, the last means of obtaining food was gone.

Soon after the man was drowned, two members of the crew were taken deathly sick from eating the raw meat. Signs of death were falling over them, and the three fellows, still strong through all the suffering, stood by them with a knife ready to cut for the heart blood as soon as that organ failed to beat. The sick man's feet were cold and clammy when his heart was cut, and the half fiends scrambled for the trickling blood.

Cast Lots For Victim

While they were sucking this, the second sick man died and there was the same rush for the weak blood from his heart and veins. Parts of the filthy, sickly flesh were eaten, but the thirst for hot blood came over the three men left and they agreed to cast lots to see who should die.

The unlucky man was a German, a big sailor, thirty-five years of age. He lost and surrendered manfully, baring his breast that his heart might be struck good and clear. The German was stabbed. Anderson and Thomas stuck their lips to his breast and drained the blood.

Afterwards the heart was chopped out and particles of the warm flesh eaten with a relish. All the time the men were on the raft a stench to heaven had arisen and scores of sharks came straggling up. They fought to overturn the craft and find the human prey, but they were driven off and parts of the German's

body was tossed over to them. The survivors were weak and thirsty and had agreed among themselves to cast another lot by Friday morning at sun rise if no help was in sight, but the steamer Woodruff sighted the raft Thursday afternoon at 6 o'clock.

The small boats sent out to rescue the men had to fight away the sharks. Anderson and Thomas were picked off weak, demented and emaciated, with ulcers and sores steaming over their bodies. Both men were in a dreadful condition and when landed at Charleston were sent to a hospital for treatment.

Thomas was the cabin boy and was only seventeen years of age. Thomas's face and breast was bitten fiercely. He claims that it was done by Anderson.

No intimation of what the couple will do, if anything, is given. The Drot sailed from Pascagoula for Buenos Aires on August 8.

The Drot was a wooden, three-masted sailing barque that weighed 1,198 tons gross and was 185 feet in length. Built in Maine in 1874, she first sailed under the name Almira Robinson before being sold in 1883 to E. Berentsen of Norway, who renamed her Drot, an old Norse word for "king" or "leader." Berentsen had had another ship by the same name, a ship destroyed in an earthquake, but he had no premonition that the name might bring bad luck. For many years the new Drot sailed between ports in the East Indies, China, Australia, and South America. As she aged, she worked in the petroleum trade between the United States and France and then in the lumber trade between Florida and Britain. In August 1899, she left Ship Island near Pascagoula, Mississippi, with a cargo of lumber bound for Buenos Aires.

The hurricane that struck her on August 11 off Florida killed the captain and eight sailors. The rest of the crew escaped on a raft, but, when it broke in two, two of the men on one part began drifting away. One of those men jumped overboard and drowned; the other was later rescued by a German steamship and landed in Baltimore. The other part with six men on board saw one of the men drown after jumping overboard with the survivors' only fishing line; soon afterwards two of the men died and had their blood drunk by the three remaining

men. Then those men cast lots to see which of them would have to sacrifice himself that the others might live.

When the *Woodruff* arrived on the scene and rescued the two shipwreck survivors and later landed in Charleston, officials placed the men in the city hospital, where Thomas slowly recovered on a diet of dry crackers and beef tea. The man who handled consular business for several European countries secured a warrant for their arrest on a charge of murder and tried to have them extradited to stand trial. The Charleston *News and Courier* debated the issue of whether the men should be indicted for murder or whether they were merely following self-preservation. The newspaper noted that the men would have deserved much credit if they had withstood the pangs of hunger and thirst and died rather than give in to their animal instincts of survival, but it raised the question as to their legal right to survive at all costs. One U.S. Department of Justice official thought that the two survivors had suffered enough and that the men should not be prosecuted.

Researchers have found no record of the extradition of the two men and have concluded that the whole matter was dropped. Anderson apparently never recovered his sanity. Thus ended one episode among several that had elements of cannibalism among shipwreck survivors. One can only wonder how many instances of cannibalism among shipwreck survivors have taken place but never been reported.

REFERENCES

"Ate Flesh of Dead Men." *The Jasper News* [Jasper, Florida]. Sept. 8, 1899: 1.

Simpson, A. W. Brian. *Cannibalism and the Common Law.* Univ. of Chicago Press, 1984: 266-70.

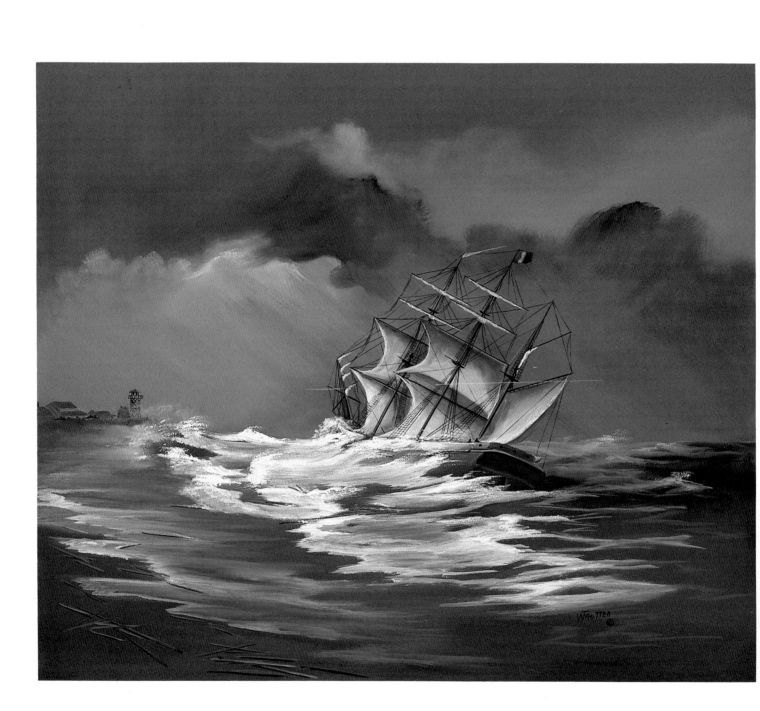

CHAPTER 20

GEORGES VALENTINE, 1904

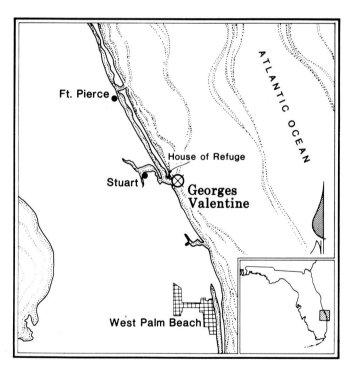

Location: Divers should proceed five steps south of the wall in front of the museum and then swim about 100 ft. offshore to see the remnants of the Georges Valentine *in 15 ft. of water. Guides at the museum can point out the exact spot of the wreck, much of which has been washed away in storms. The house of refuge is at 301 S.E. MacArthur Boulevard on Hutchinson Island about four miles east of Stuart, Florida, off State A1A.*

For most of the 19th century Florida's east coast from Indian River Inlet to Cape Florida was largely uninhabited by white settlers. Survivors of shipwrecks along that coast had to contend with sand flies, mosquitoes, thirst, and starvation once they made it to shore. Those stranded along the coast, i.e. on the east side of Indian River, had great difficulty finding fresh water and a means to reach the mainland, where they might find small settlements. Panthers, wildcats, and alligators in the area also increased the danger.

The perilous situation of stranded sailors along that coast led to an 1873 report to Congress from the United States Life-Saving Service which recommended that houses of refuge be built to shelter and feed 25 persons for up to ten days. The lack of settlers along that coast precluded the practice of using volunteers to man a lifeboat station, and so each of the five shelters to be built was to have a single keeper to provide shipwreck survivors with food, shelter, clothing, and transportation to safety. He might have his family with him, but not many people could stand the loneliness of life there for very long.

After receiving a government contract to build five houses of refuge, Albert Blaisdell of Massachusetts arrived in Florida and had crews build all five in 1876, each one identical and costing about $3,000. He finished the house two miles north of Gilbert's Bar Inlet, the present St. Lucie Inlet, on Hutchinson Island near Stuart in March, and the government

stationed a man there. Workers put directional markers each mile along the beach to direct ship-wreck survivors to the nearest refuge. The houses of refuge were usually two-storied, wooden struc-tures rectangular in shape with clapboard siding and a porch encircling the whole building, all under a broad, sloping roof that kept the porch and house relatively cool in the summer. The keeper and his family lived in the four downstairs rooms, while the large dormitory room upstairs had cots and bed-ding for 20 or 30 men. A large brick cistern caught the rainwater from the sloping roof. Dried provis-ions, salted meats, and medicine chests were kept sealed and were to be used only by shipwreck vic-tims, not the keeper's family. Clothing supplied by the Women's National Relief Corps was warm and sturdy. Gilbert's Bar House, unlike the other houses, which were built on sand dunes, was built on a rocky point of land; in 1930, workers moved it back from the shore and built a protecting seawall.

The Wreck Reports that each keeper kept testify to the great service they performed, including risk-ing their own lives to save shipwreck survivors, all for the meager salary of $400 a year plus provisions. One such rescue occurred at Gilbert's Bar in Octo-ber 1904, when keeper William A. Rea discovered the wreck of an 822-ton Italian bark near his beach. The *Georges Valentine* was carrying a $7,000 cargo of lumber to Buenos Aires, Argentina, when a strong gale drove her toward the beach off Gilbert's Bar. The captain had his 11-man crew throw the deck load overboard to lighten the ship, but the incessant pounding of the waves continued driving the ship to shore, eventually toppling her three masts. The ship's hull broke open, and the sea began rushing through her, tossing the crew into the seething water and scattering the timbers in all directions. A falling spar killed one of the men, and the surging waters drowned others, but seven made it to shore. As described in the *History of Martin County* (p. 60), Keeper Rea, who kept lights burning on the shore to guide the survivors, described what happened next in his report:

> A terrible gale was raging, accompanied with torrents of rain. There was a high sea. The night was dark and the storm so severe it was impossible to see anything. The keeper kept light burning which attracted

the sailors to the station and fortunately caused them to land nearer than otherwise. One man came ashore on the floating lumber and got to the station cold, hungry and naked. After given clothing, he assisted in rescuing six others of a crew of twelve. All were more or less injured and some severely. All totally exhausted and would have died before morn-ing but for the timely assistance, as none of the six were able to stand when brought into the station, being chilled through from expo-sure to the elements, without clothing and exhaustion from hanging onto the riggings, battling the waves that were one mass of lum-ber. Many were dashed against the rocks many times before the Keeper could rescue them. The Keeper worked all night on the beach hunting through the lumber for disabled sea-men, the air full of flying lumber, the breaking of which sounded like a report of thousands of rifles.

Mr. Rae tended to the immediate needs of the survivors, supplied them with food and clothing, summoned a doctor from the mainland to care for them, and wired the Italian ambassador in Washington, D.C., and the Maritime Exchange in New York City to let them know of the wreck. The very next day that same storm drove a 1,200-ton Spanish vessel, the *Cosme Colzado*, into the beach three miles above the house of refuge. One of the crew swam to shore with a rope attached to his body and then used it to drag 14 others ashore from the ship. One man drowned when he got tangled in the rigging. A local resident took the survivors in for the night until they could make it the next day to the house of refuge. Keeper Rae took care of all 22 men until they were well enough to proceed on their way.

The house of refuge at Gilbert's Bar, the only surviving one, continued operating into this cen-tury and served during World War II as a patrol base for boats looking for enemy intruders and submarines — hence the 35-foot watchtower in front of the house of refuge. More recently the site was used for raising turtles rescued from poachers and animals in their nearby nesting grounds by volunteers; the hatchlings were taken care of in large tanks until they were released into

the ocean. The Martin County Historical Society manages the house of refuge and the museum there. Visitors driving along the beautiful A1A highway with its many condominiums and resorts may find it difficult to believe how desolate the coast was just 150 years ago. Photographs and life-saving equipment at the museum there help visitors visualize how the keepers rescued sailors from 33 shipwrecks. One photograph shows the immense amount of lumber strewn up on the beach from the *Georges Valentine* wreck; local residents used much of that wood in the building of their homes in Stuart.

REFERENCES

Hutchinson, Janet. *History of Martin County*. Hutchinson Island, Florida: Martin County Historical Society, 1975: 60-61.

Kerber, Stephen. "The Florida Houses of Refuge." *Fiesta*. Boca Raton, Florida. May, 1975: 26-27+.

Lonsdale, Adrian L. and H.R. Kaplan. *A Guide to Sunken Ships in American Waters*. Arlington, Virginia: Compass Publications, 1964: 62-64.

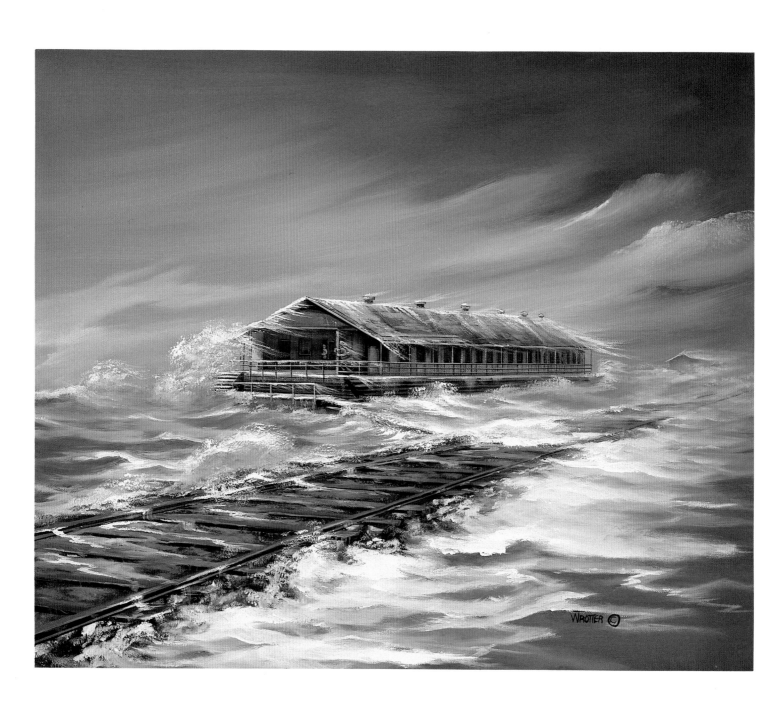

CHAPTER 21

\mathcal{H}OUSEBOAT NO. 4, 1906

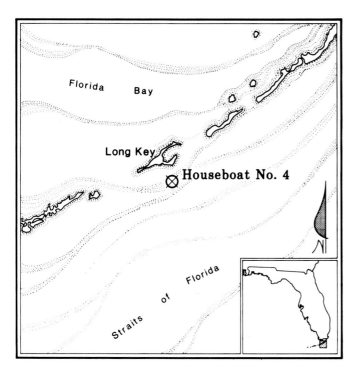

Location: Long Key is at Mile Marker 67.5

"Weed's rising in the glass!" Those ominous words used to warn local inhabitants of the Florida Keys that a storm was coming. Barometers in those days often consisted of glass tubes with weeds in the bottom. As a storm grew in intensity, the pressure of the surrounding air increased, and the weed rose in the tube. That is what happened on the afternoon of October 17, 1906, in Long Key, a small village in the northern Keys. The small-craft warnings from Miami and the statement in that day's *Daily Miami Metropolis* that "boatmen have begun to predict that the storm is moving some other way" belied the seriousness of the storm as it bore down on the little island. The barometer at Miami fell to 28.55 inches, but it was too late to warn the workers at Long Key to head for the mainland.

The scene on Long Key was perilous. Hundreds of workmen were building Henry Flagler's Overseas Highway to Key West, extending the Florida East Coast Railroad to link formerly isolated fishing villages with the rest of the nation. Called "Flagler's Folly" or a technological miracle, depending on who was speaking, the railroad had to span large, open sections of water as it skipped from island to island on its way to Key West. The Long Key section was particularly difficult to build because of the depth of the water there and the length of the bridge needed to reach Conch Key. The logistics of the whole operation, including ferrying in hundreds of workers and supplies, setting up base camps along the way, and

building temporary trestles, seemed impossible to some engineers, but not to Flagler. He was determined to press on and to reach Key West, which he did in 1912, one year before he died.

In 1906, when the construction of the railroad reached Long Key, Flagler had crews build screened cottages for his workers while they worked on the Long Key Viaduct. For other workers railroad officials used an old Mississippi River barge, called a houseboat or a quarterboat, to house between 150 and 175 men just offshore. Carpenters converted the below-deck area into a kitchen and dining room and built a one-story frame house on the deck to house the men. The railroad crews labored mightily around the clock to set the piles in the seabed, build the forms, set the reinforcing steel, and pour the cement for the viaduct. Newspaper warnings of the approaching storm brought a halt to the work and forced the workers on Long Key to retire to the old barge, Houseboat No. 4. The local Conchs who were working on the railroad and who knew the force of hurricanes disappeared, but the other workers, many of whom had never experienced a Florida hurricane, hunkered down in the barge and tried to sleep. The wet spray kicked up by the winds that preceded the hurricane on the morning of October 18 disabled the gasoline-powered boats and prevented the men from reaching the safer ground at Long Key.

By 7:30 a.m. the cables holding the boat in place snapped, causing the boat to drift across Hawk's Channel toward the Gulf Stream. 100 mile-per-hour winds from the north battered the boat, which began to leak badly. The men dropped two anchors overboard to try to hold the vessel fast, but they could not stop the boat's drifting toward the deadly reef. By 9 a.m. the winds tore off the top of the boat and threw a number of men into the stormy sea, where they met their death. Soon after, the rest of the houseboat began to come apart. The men clinging to the separated planks of the barge were battered by other planks and knocked unconscious into the water. One survivor of the hurricane, William Saunders, described in "The Wreck of Houseboat No. 4 October 1906" (p. 17) the sounds he heard: "I had been told when I first arrived in Florida, that there never was any thunder and lightning with a hurricane. As far as I had known in the four storms I had been through that was a true saying. This storm disproved all old

sayings. I have heard some terrific loud cracks of thunder along the Florida East Coast, but none of them surpassed the loud explosions that we heard that morning."

Two men saw the water tank break loose from the barge and swam for it, confident that its buoyancy would keep them afloat. What they had not planned on was the constant spinning of the tank as the waves tossed her about. As survivor William Saunders described the scene, "They were like two squirrels on the outside of the cage, and every shift of wave or wind would start the cage to turning, and those two trying to stop its turning, by one climbing up on one side, and the other sliding down on the other side." Other men managed to find intact pieces of the boat and clung to them as the waves crashed over them until around 4 p.m., when the wind and waves died down. After almost 12 hours in the water the men who were still alive but far out at sea saw some ships in the distance; one of the men used his shirt on a stick to attract the attention of the ship, the passing Austrian steamer, *Jenny*, which saw them and began picking them up, 49 of them, and took them to Key West. The ship's crew divided their own clothing among the survivors and did their best to tend to injuries. The steamer *Miami*, which belonged to Flagler's system, took the survivors back to Miami to their grateful families. Other passing ships searched the waters for survivors and picked up whomever they found before proceeding on to ports like Cape Henry, Virginia, and Mobile, Alabama; the men then made their way back to Florida. The final tally of dead was approximately 164 people killed, although some of their bodies were never found.

The Daily Miami Metropolis used such bold headlines as "Miami Does Not Need Sympathy — It Needs More Strong Substantial Citizens to Assist Its Developments" and "Don't Let Storm Afflictions Disturb You — The Like May Never Occur Again" to encourage its citizens to stay in the area. The paper criticized those out-of-state newspapers that gloated over Miami's misfortune and pointed out that the storm center was at Long Key, nearly 100 miles from Miami. The *Metropolis* noted that Miami, although cut off from the outside world for 36 hours, was relatively unscathed from the storm and "is as good or better than it ever was." With some exaggeration, especially in light of later hurricanes, the paper boasted that

"human life and property are safer here than anywhere else in the country."

Workers eventually completed the Long Key Viaduct and continued the railroad to Key West. Flagler had the construction camp at Long Key converted into a fishing camp, the Long Key Fishing Club, complete with a narrow-gauge railroad running through a tunnel underneath the main railroad tracks. The wealthy and the famous, including writer Zane Grey, came by train and yacht to take advantage of the excellent area fishing, especially sailfish and tarpon.

Despite warnings from native Keys people and from Miami editor Frank Stoneman, the father of environmentalist Marjory Stoneman Douglas, that the solid rock embankments Flagler was building would not stand up to strong hurricanes, engineers kept on with their work. The 1935 Labor Day hurricane, which occurred 23 years after the railroad reached Key West and 22 years after Flagler died, fulfilled the warnings of Stoneman and washed away much of the solid rock causeways, convincing railroad officials to abandon the line and sell the remaining bridges to the federal government for highway bridges. That hurricane also destroyed the Long Key Fishing Club that Flagler had established near the Long Key Viaduct.

REFERENCES
The Daily Miami Metropolis. Oct. 19-22, 1906.

Saunders, William H. "The Wreck of Houseboat No. 4 October 1906." *Tequesta*. 19 (1959): 15-21.

Smiley, Nora K. and Louise V. White. *Hurricane Road, A Novel of a Railroad That Went to Sea*. New York: Exposition Press, 1954: 49+.

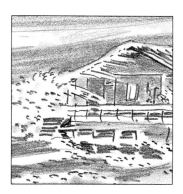

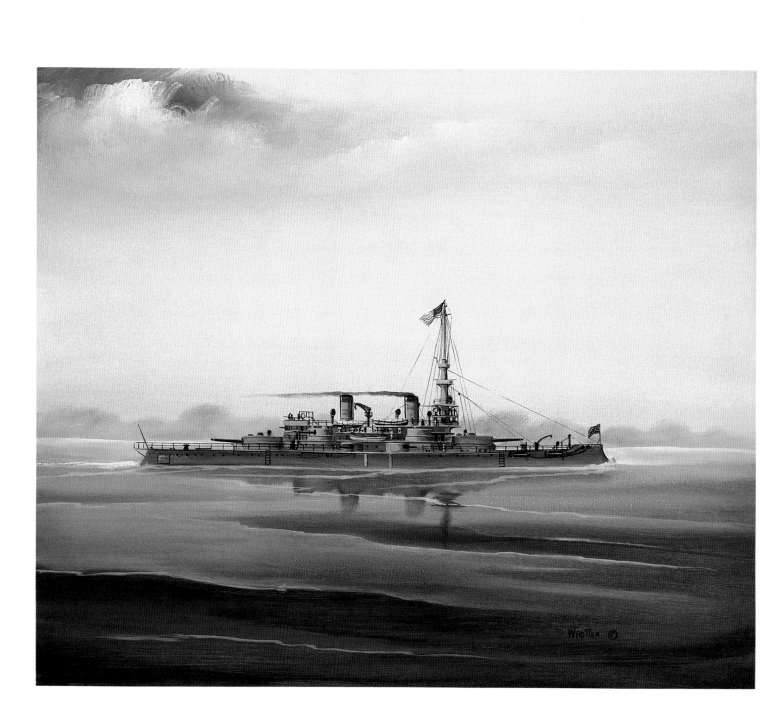

CHAPTER 22

ℳASSACHUSETTS, 1921

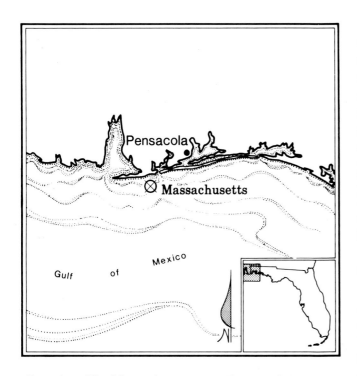

Location: The Massachusetts, *easily located from the gun turrets rising above the water, lies in 20 feet of water just west of the pass that leads into Pensacola Bay from the Gulf of Mexico.*

Florida's Emerald Coast, so called because of the color of the Gulf of Mexico there, attracts fewer divers than the more glamorous Keys and east coast of the state, but one shipwreck off Pensacola deserves more visitors: the 350-foot-long USS *Massachusetts*. Its name honors a state, as do most battleships, a practice that has encouraged the respective states to furnish their naval namesakes with silver service, recruits, etc., in return for which the states often received ownership of the battleships to be preserved as memorials instead of being scrapped. Beginning in 1920, the Navy also gave its battleships letter designations and numbers; thus the Pensacola ship was designated *BB2* as the second battleship of its kind.

The keel of the ship lying in shallow water near the entrance to Pensacola Bay was laid in Philadelphia in 1891. Built at a cost of $3,000,000, it joined the *Indiana* and the *Oregon* as the three members of the *Indiana*-class of battleship, all of them launched in 1893. Each displaced 10,000 tons of water and had formidable armaments of four 13-inch, eight 8-inch, and four 6-inch guns, along with a crew of between 473 and 636.

These three battleships were the result of a U.S. Navy policy board's recommendation in 1889 that the U.S. build 192 warships over 15 years at a cost of $281,550,000, including ten first-class battleships "of great endurance" with a range of 5,400 miles at 10 knots; the board also recommended the building of

25 battleships for use primarily as coastal defense ships. An anti-militarist attitude in the U.S. Congress that conjured up thoughts of imperialism and aggression greatly diminished the end results; the Act of June 30, 1890, authorized only three "sea-going, coastline battleships." The resulting ships had very heavy armaments and armor on a restricted displacement; the crowded design led to low freeboard and only moderate speed, characteristics that emphasized the Congressional mandate that the three battleships be coastline defenders rather than offensive warships.

The *Massachusetts*, like the *Indiana* and *Oregon*, had twin turrets fore and aft on the centerline that housed the four 13-inch guns. Eight 8-inch guns were in twin turrets, two on either beam at the upper-deck level, and four 6-inch guns were in casements amidships on the main deck. The crowded placement of the big guns on the decks resulted in the 13-inch guns' crews being affected by the blast from the 8-inch and 6-inch guns. All three ships in the *Indiana*-battleship class served in the Spanish-American War, but became obsolete by World War I.

The *Massachusetts* operated along the Atlantic coast and participated in training maneuvers off Florida. She helped blockade Cuba in 1898 during the Spanish-American War, warding off intruders with her huge guns. After that she cruised along the Atlantic coast and eastern Caribbean as part of the North Atlantic Squadron. In 1900, the battleship steamed into Pensacola with the flagship *Kearsarge* for repairs and caused a great outpouring of welcome from the townspeople that reminded old-timers of the days when the West India Squadron frequented the harbor. The local Pensacola *Daily News*, reminding people how profitable such visits could be to the town, drummed up much support. After the *Massachusetts* left Pensacola and cruised the Gulf, she returned to Pensacola in 1901 but ran aground in the harbor. The official navigational charts of the channel there indicated sufficient depth for the battleship, but shoaling reduced that depth in several places. Even though the local newspaper had a daily headline declaring that the channel was 33 feet deep, the battleship ran aground in water that was only 25 feet deep.

In 1903, the *Massachusetts* had the first major casualty for an American battleship since the 1898 sinking of the *Maine* in Havana harbor. What happened aboard the *Massachusetts* was a misfiring of one of her 8-inch guns because of improper safety procedures; nine crew members were killed. After authorities tightened up the procedures, she served in 1904 as a training ship for Naval Academy midshipmen off New England. In 1909-10, workers added a cage mainmast to the ship for a searchlight platform and for gunnery spotting. In World War I she served as a heavy-gun target practice ship in Chesapeake Bay and in the Atlantic. She was decommissioned in 1919, renamed the *Coast Battleship No. 2*, struck from the Navy list in 1920, and loaned to the War Department as a target ship.

In the early 1920s, the Navy turned over the *Massachusetts* to the Army, after which a tugboat towed her from Norfolk to shallow water near Pensacola, where engineers opened up the ship's sea valves, flooded the compartments, and sank her south of Fort Pickens and east of the channel that led into Pensacola Bay. Because too much superstructure protruded from the water at that site, engineers pumped the water out of the compartments and moved the battleship to deeper water on the west side of the channel. At the same time engineers were converting two unfinished battle cruisers, *Saratoga* and *Lexington*, to aircraft carriers, the second of which arrived in Pensacola in 1928 to undergo several experiments involving carriers, including the use of airplanes launched from the carrier to bomb the partially submerged *Massachusetts*. In order not to destroy the ship with a few well-placed bombs and therefore deprive future pilots of the chance to use her for target practice, military instructors had student pilots use fake bombs that had blank shotgun shells with small plungers in the nose of the bombs; when the bomb hit the ship, a little puff of smoke activated by the plunger would indicate how accurate the student bomber was.

The *Massachusetts* also served as a target for large army coastal guns. A flatcar in the freight yard at Brent outside Pensacola had a gun mounted on her that would fire projectiles over the city onto the ship. In 1925, authorities returned her to the Navy, which put her up for sale for scrap but received no acceptable bids.

Over the years fishermen discovered what a rich fishing ground the hulk provides, attracting schools of small and large fish. In 1955, the Corps of Engineers, ignoring the pleas of fishermen, gave the Mas-

sachusetts Company a permit to begin salvage operations on the ship. The company proceeded to fence off the watery area of the *Massachusetts* with buoys, which angered such groups as the Pensacola Anglers and Hunters Club and the Sports Association. Groups like the Pensacola City Council and the Warrington Kiwanis Club passed resolutions urging authorities to save their favorite watery landmark.

A lower court ruled in favor of the salvage company, but in 1956 the Florida Supreme Court reversed that ruling, citing English common law and ancient British admiralty statutes adopted as Florida laws that gave ownership of such ships to the state in its sovereign capacity. The Supreme Court noted that under old English law any shipwreck that remains unclaimed by its owner for a year and a day becomes the property of the crown. The State has succeeded to the sovereignty of the crown; since the Navy abandoned its claim to the *Massachusetts*, the State of Florida could claim it. Today the stately *Massachusetts* is a reminder of the days when battleships began to come into their own. In spite of her bulky size and ungainly appearance, she has served this country well and may continue to do so as an underwater park.

REFERENCES

Gibbons, Tony. *The Complete Encyclopedia of Battleships*. New York: Crescent Books, 1983: 134-35. pp. 113-15, 174-79.

Pearce. *U.S. Navy*, pp. 113-15, 174-79.

Pensacola Journal. Nov. 17, 1956: 1.

Reilly, John C., Jr. and Robert L. Scheina. *American Battleships, 1886-1923*. Annapolis, Md.: Naval Institute Press, 1980: 50-69.

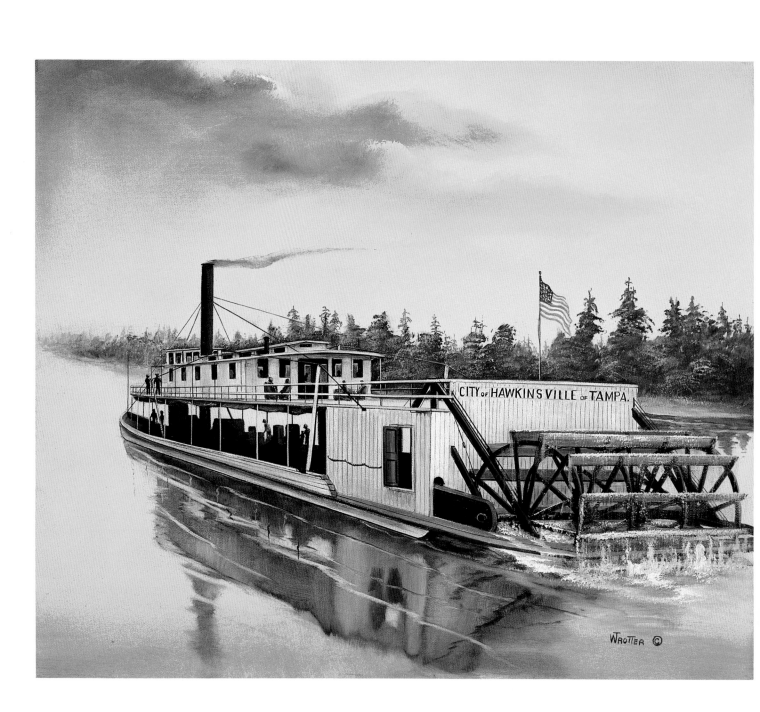

CITY OF HAWKINSVILLE, 1922

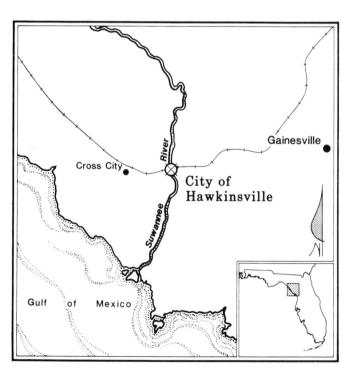

Location: The City of Hawkinsville *lies two-and-a-half miles upriver from where U.S. 19 crosses the Suwannee at Fanning Springs. The vessel lies approximately 200 yards downstream from the railroad trestle crossing near Old Town.*

Of all the rivers in Florida the most famous and most romantic is the Suwannee, made famous in Stephen Foster's "Old Folks at Home" song, which the state of Florida adopted as its official state song in 1935. The 1851 version was originally created to commemorate South Carolina's Pee Dee River, but somehow "Way down upon the Pee Dee River" did not sound right. According to legend, Foster, who probably never saw the Florida river, then took out an atlas, found the Suwannee River, changed it to the two-syllable "Swanee" to fit the melody, and immortalized the river forever.

The Suwannee begins its 250-mile meandering to the Gulf of Mexico in Georgia's Okefenokee Swamp, 120 feet above sea level. Despite the influx of clear waters from hundreds of springs along the way the Suwannee has a brownish color from the many cypress, palmettos, and pines along the riverbank. Those springs, especially White Springs, Suwannee Springs, and Fanning Springs, as well as Suwannee's tributary, the Santa Fe River, add 10 billion gallons a day into the river and then into the Gulf. Heavy rains will cause the river to flood its banks occasionally, but it continues to be one of the few unspoiled rivers in the southeastern United States.

Before railroads began to inch their way down and across Florida in the 19th century, merchants and travelers relied on steamboats to reach the more inaccessible parts of the peninsula, especially those on inland waterways. The fact that the St. Johns,

Suwannee, and Apalachicola rivers ran north-south enabled steamboats to cover much of the state. Beginning in 1834, steamboats began navigating the Suwannee, at first sticking to the lower river below Branford, but later venturing as far north as Columbus, now a ghost town in Suwannee River State Park. One enterprising pilot, Captain James Tucker, once used the swollen Suwannee to take his steamboat, *Madison*, up as far as White Springs, a feat that helped establish the Suwannee as a navigable river from its mouth to White Springs.

The river had several forts and camps that steamboats serviced during the Second Seminole War (1835-1842) as well as sawmills and turpentine camps that sprang up along the banks and which needed groceries, hardware, and clothing from Cedar Key. As markets grew upriver, especially in cotton, steamboats made the trip from Cedar Key, where they would unload cargo from ocean-going vessels for the trip up the Suwannee. River pilots had to exercise caution when they approached the river's rocky shoals upstream, and the wrecks along the way testify to those pilots who were careless. When farmers and woodsmen heard the welcome whistle of an approaching steamboat, they hurried down to the nearest landing to load and unload cargo. Children would scramble after the nickels that the crew would throw around the dock, and everyone would join in the festivities associated with the steamboats. Captains would steer their paddlewheelers up the river as far as the depth of the water would permit.

During the 1860s, when the Confederacy needed Florida's cotton, Union troops captured Cedar Key and forced blockade runners to use the shallow waters of rivers like the Suwannee to load cotton for another trip. The most famous steamboat wreck of the Suwannee is the *Madison*, a Civil War steamboat which was scuttled in Troy Springs above Branford in 1863 to keep her out of Union hands. In the following years local residents cannibalized the wreck for lumber to rebuild their homes and farms, and workers took her boilers to Cedar Key to help make salt. Divers can see the remains of the *Madison* in the spring about five miles above Branford on the southwest side of the Suwannee.

After the Civil War, steamboats continued using the Suwannee until the 1896 hurricane severely damaged Cedar Key and sealed the fate of steamboating on the river. The last and largest steamboat to run on the river was the *City of Hawkinsville*, a 319-ton stern-wheeler that served Cedar Key, Old Town, Clays Landing, and Branford. Built in Abbeville, Georgia, in 1896, the ship stretched 141 feet and had two decks, a single stack, a square stern, and a molded bow. She was supposed to have served several years in Georgia waters for the Hawkinsville Deepwater Boat Lines carrying naval stores, but in June 1900 the Gulf Transportation Company bought her to transport cedar for pencil factories at Cedar Key, lumber, and other goods on the Suwannee. Her official name became *City of Hawkinsville*. "*Of Tampa*" was also lettered on her hull because she was registered at the Port of Tampa, but she spent most of her time on the Suwannee. One of her jobs may have been to help in the building of the rail bridge at Old Town, a task that hastened her own obsolescence. She served until May 1922, at which time steamboating on the Suwannee ended. She rests in the river near Old Town minus her top deck, which was removed because it presented an above-water traffic hazard.

Bronson High School principal Michael McCaskill, who discovered the shipwreck when he was a teenager growing up in the area, has taken students from Bronson's Marine Science course to the site to learn more about it. Such trips are part of what the state calls education through recreation. The fresh water of the river has helped preserve the wood and metal parts of the ship, but river currents and occasional fluctuations in the river's depth have eroded exposed timbers. The Suwannee there is often clear enough for divers to have a good view of the ship's main deck, hull, and mechanical and propulsion equipment, although the river's tannic acid color, caused by decaying plant life and the cypress trees along the banks, can also make visibility quite poor below the surface.

In 1991, the Florida Department of State dedicated the site near Old Town on the Dixie side of the Suwannee River as an underwater shipwreck park to instruct visitors about Suwannee River steamboating through the *City of Hawkinsville*. It was the third such park, after the Urca de Lima Preserve near Fort Pierce and the San Pedro Preserve near Indian Key. The criteria for such under-

water sites are that they have good public access and diving conditions, interesting features to explore and photograph, available service from local dive shops, and a local community willing to support it.

The Suwannee River offers different challenges to divers than do the ocean waters around the state. Divers in the river should be on the lookout for alligators, alligator gars (a freshwater version of the barracuda), and alligator snapping turtles that can bite off a finger of an unsuspecting swimmer. Boaters should be careful not to anchor on or cruise over the wreck and should park in the mooring area only, and divers should not hold on to or move parts of the wreck and should not collect artifacts within the proposed park. While not as glamorous as the Spanish treasure galleons of the Florida Keys, the *City of Hawkinsville* offers a glimpse into a hard-working steamboat that served the Suwannee River towns well for several decades.

REFERENCES

Bulger, Peggy, "Steamboating on the Suwannee: Folk Culture at Work." *Proceedings of a Conference on the Steamboat Era in Florida*. Edited by Edward A. Mueller and Barbara A.Purdy. Univ. of Florida, 1984, pp. 21-26.

"City of Hawkinsville: Recommendations for the establishment of a state underwater archaeological preserve in the Suwannee River near Old Town, Florida." Tallahassee: Florida Dept. of State, [n.d.].

Dunn, Hampton. "Steamboats Was A-Comin' on the Suwannee." *Florida Trend*. June 1968, pp. 36-37.

Kaucher, Dorothy. *The Suwannee*. Lake Wales, Florida: Kaucher, 1972, pp. 11-17.

Mueller, Edward A. "Suwanee River Steamboating." *Steamboat Bill, Journal of the Steamship Historical Society of America*. 21 (Winter 1964): 107-11, 127; (Spring 1965): 11-16.

Voyles, Karen. "Paddlewheeler may become next underwater park." *The Gainesville Sun*. June 24, 1990, p. 1-2B.

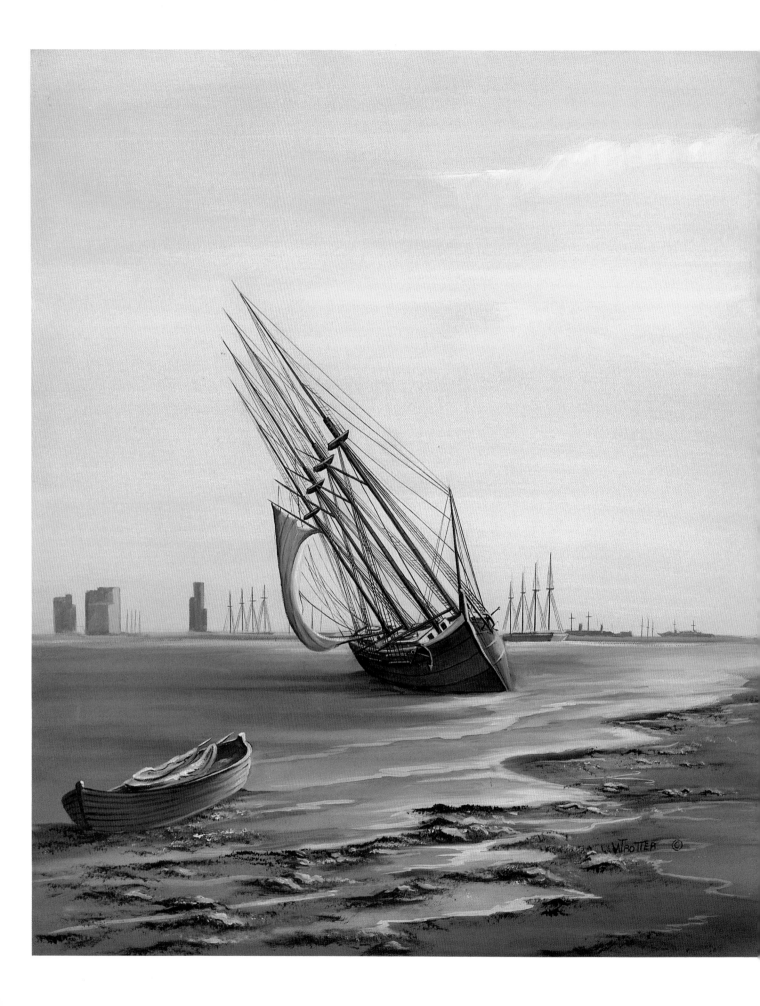

PRINZ VALDEMAR, 1926

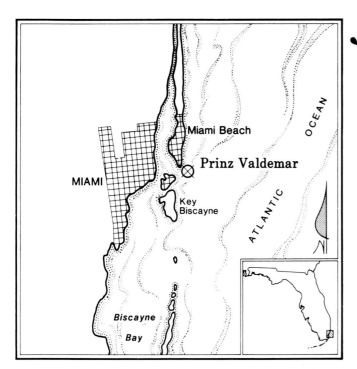

Location: The Valdemar *is no longer intact.*

January 10, 1926, dawned bright and clear in Miami. Everything seemed to bode well for the building boom that was making the city a real estate developer's dream. Even when a northeast wind sprang up and tipped over the barkentine *Prinz Valdemar* that night, city officials thought they could right the ship in a short time and proceed with the many construction projects in the area. Little did they realize how serious that capsizing was, that it would effectively bring Miami's rapid development to a stop.

Florida's Dade County in 1925 was undergoing a land boom seldom seen in this country. People were flocking to South Florida and speculating in land at a frenzied pace that saw the price of land double and triple. What contributed to the state's unprecedented growth in the early 1920s were the state's road-building projects and the increasing popularity of the automobile which enabled thousands to make the trip south. The end of World War I and great confidence in President Coolidge's administration gave Americans a sense of optimism and daring, and Florida's climate and frontier-like newness beckoned more and more people away from the crowded, industrialized cities of the Northeast. Lack of state income and inheritance taxes, as well as reports of early got-rich-quick speculators added to the flood of people. The *Miami Herald*'s extensive and extravagant advertisements gave it the largest advertising lineage of any American newspaper, and the 1925 announcement that a university would be built in Coral Gables gave

Miami more credibility and permanence. The value of property soared from $63,000,000 in 1921 to $421,000,000 in 1926, an increase of 560 percent.

One ominous sign that the boom could not sustain its breakneck pace was a 1925 freight embargo that the Florida East Coast Railroad imposed to allow workers time to repair the overburdened tracks. A few farsighted developers took their profits and departed the city, convinced that the building frenzy could not last. Others ignored the signs and continued to speculate. The National Better Business Bureau's investigation into dishonest land promotions dampened the enthusiasm of many would-be buyers, as did the decline of the stock market. Banks elsewhere cautioned their investors against withdrawing large sums for speculation in Florida, and northern newspapers began giving the state a bad press.

Meanwhile, several developers made plans to install the *Prinz Valdemar* as Miami Beach's first floating hotel. After developers had bought her in New York and while they piloted her to Miami with a load of building materials, she weathered a gale that sank a half-dozen large ships. She finally arrived in Miami on October 31, 1925. In early January 1926, the ship's crew of 14 and a large group of workers were preparing to convert the former Danish naval training ship into a floating hotel. On January 10, she was resting on the north bank of the ship channel and was so light in the water and high on the bank that the receding tide threatened to unbalance her. The northeast wind that came up was just strong enough to topple the stately ship.

As the ship began to tip, those below decks scurried topside and gathered on the port side, hoping their combined weight would stabilize her. It didn't work, but the crew was able to remain out of water as the ship toppled over to rest on her starboard side. The four-minute interval between the time the *Prinz Valdemar* started to tilt and when it came to rest on its side enabled everyone on board to reach safety.

At the first sign of the tilting, ship's officers had directed crew members to take lines to shore in order to keep her upright; two sailors jumped overboard and swam to shore with a line but could not handle the heavy rope. The officers also tried to attract the attention of the nearby Coast Guard station to have them make a line fast on shore, but no one in the station responded. When the officers saw a tug passing by, they called over to it, but it continued on its way. At that point the "all-hands-on-deck" order made everyone realize how precarious their position was. The Coast Guard was finally alerted and rushed to the scene with a cutter to take the men on board off the capsized vessel. Six men remained on the site to guard her from looters.

The Coast Guardsmen who arrived on the scene realized how serious the situation was when they saw that the 241-foot steel hull completely blocked the channel, preventing ships from delivering the building material necessary to complete the city's many projects. The *Valdemar's* four tall masts, stretching more than 100 feet across the channel to the south bank, sealed the harbor. The nearby Cape Florida Channel was an alternate route out of the harbor, but it admitted only vessels like small yachts and flat-bottom houseboats with a maximum eight-foot draft.

City commissioners met in emergency session and made plans to remove the disabled *Valdemar* from the channel or, as a temporary solution when they realized how difficult that would be, of dredging a new channel around her. They declared the present harbor master incompetent and asked Florida Governor John Martin to appoint a new one. They made plans to lash two schooners together by the side of the capsized *Valdemar*, run lines from the mastheads to the masthead of the barkentine, and then block and tackle the ship to an upright position; they moved the *Rose Mahoney*, a five-masted sailing vessel, next to the *Valdemar*, but it did not succeed in raising the vessel. The *Valdemar's* owners estimated the value of the ship, its cargo, and the labor that had been used in converting her into a floating hotel as $200,000, a large enough figure that may have discouraged city officials from using dynamite to blow her out of the harbor, which is something they might have done if they had known then just how much the city would lose over the next month from the inability of ships to deliver building supplies and fuel oil.

Meanwhile some 100 vessels with a combined cargo of 45 million board feet of lumber languished offshore, unable to discharge their much-needed cargo, and 11 ships that had unloaded their material lay trapped in the harbor. The dozens of passengers stranded on boats in the port had harsh words for Miami and its inability to solve the problem of the capsized ship. Even when engineers succeeded in

removing the *Valdemar*'s masts with torch and ax and allowed freighters to enter the port to unload their cargo, the steamer *Lakevort* grounded across the outer channel, forcing another 50 ships to remain off the coast. A few impatient captains tried to ease their vessels close to the mainland and ended up grounding on the reef. Two dredges digging a channel around the *Valdemar* broke down, further exasperating a desperate situation. Eventually engineers refloated the *Valdemar* and took her to the foot of Biscayne Boulevard and Sixth Street where they made her into an aquarium.

The month that the *Valdemar* bottled up Miami's harbor effectively brought an end to the city's building boom. A fierce hurricane in September 1926 was yet another blow to Miami's hopes for a quick recovery. Despite newspaper headlines elsewhere of "South Florida Wiped Out in Storm" enough people remained in Miami to start anew. In a twist of irony, the *Valdemar* was the only ship to ride out the hurricane. The ship lasted until the 1950s, when workers dismantled her to make room for an auditorium. She had played an unwitting part in the collapse of Miami's boom, but she probably also saved some investors from throwing their money into yet one more unneeded get-rich-quick scheme.

REFERENCES

Miami Herald. Jan. 11-17, 1926.

Muir, Helen. *Miami, U.S.A.* New York: Henry Holt, 1953: 159-66, 286.

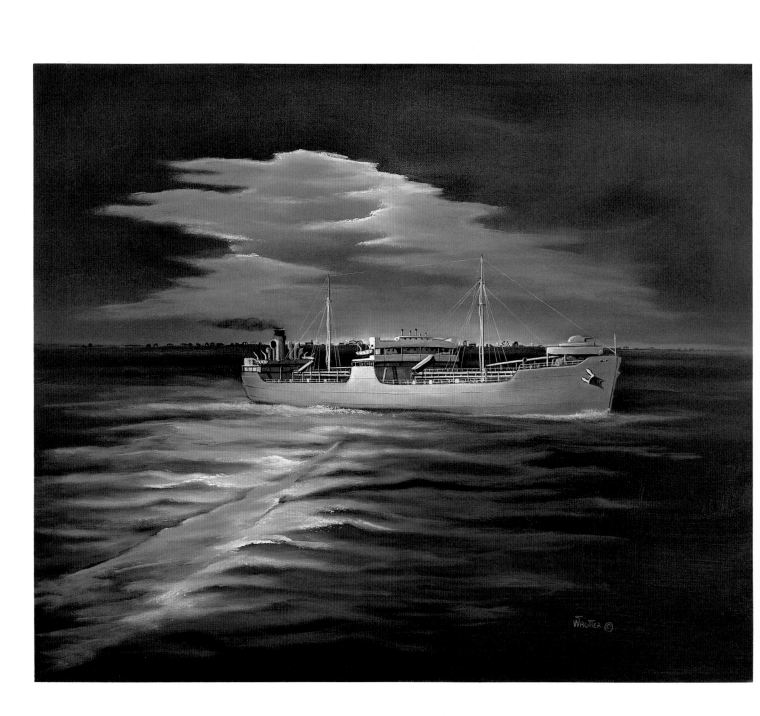

\mathcal{G}ULFAMERICA, 1942

Location: The wreck lies 11 miles off Jacksonville Beach.

The night skies of April 10, 1942, suddenly exploded in a fiery flash off Jacksonville Beach as a German submarine torpedoed the oil tanker *Gulfamerica* and began moving in to finish her off with deck guns. The Friday night crowd in the bars and restaurants along the beach streamed out when they heard the explosion and stood in awe as they saw the ominous German submarine, popularly called a U-boat, silhouetted against the blazing ship. The explosion shattered the oil tanker as well as the complacency of many Floridians who thought World War II was a European conflict that had little to do with them. It made them realize that Florida waters were part of the world's busiest sea-lanes and that they had better be more alert to the danger.

That sinking, just one of many that German U-boats began to inflict on the relatively defenseless shipping that plied the waters along the nation's east coast, beginning two months earlier, was part of Nazi Germany's plan to intimidate American forces, disrupt the vital lifeline of goods from America to her European allies, and punish American efforts to help England, for example in reporting the whereabouts of U-boats to British destroyers. If Americans in general and Floridians in particular thought the busy Florida Straits were too distant for German U-boats, they soon found out that the 1,051-ton Type IX boat could reach American shores in three weeks, spend a week or more attacking the merchant ships that traveled alone, and still have enough fuel to return home.

Gulf Oil Corporation's SS *Gulfamerica* had begun her maiden voyage in early April 1942, by loading 90,000 barrels of fuel oil at Port Arthur, Texas. The 8,081 GRT (gross register tonnage) ship had a four-inch gun and two .50-caliber machine guns manned by a U.S. Navy Armed Guard as part of a new plan to provide some protection for the usually unarmed vessels plying American waters. Little did her 41 crew members or seven Navy men know what lay ahead off the northeast coast of Florida on the evening of April 10. When the U-boat commander, 28-year-old Lieutenant Commander Reinhard Hardegen, sighted the *Gulfamerica* that evening after surfacing from a day spent on the bottom of the sea three miles offshore, the tanker was proceeding north off St. Augustine. Despite the tanker's blackout, no lights, four lookouts, and a good speed of 14 knots, the U-boat, named U-*123*, easily followed it up the coast. The boat chased the large ship for over an hour until it was four miles off Jacksonville Beach, at which point Commander Hardegan gave the order to launch a torpedo, one of only two that he had left from a successful foray along America's east coast. At 10:24 p.m. the torpedo scored a direct hit, and the tanker exploded.

Gulfamerica's captain ordered the engines stopped, lifeboats lowered, and everyone to abandon ship. He quickly stuffed important papers like confidential codes in a weighted bag and threw it overboard. In order to finish off the burning tanker and sink it, Commander Hardegan ordered U-*123* to close in and open fire with its deck gun. When he approached the ship from the seaward side and was about to order his gunners to open fire on the listing ship, he noticed how many people were milling around on the shore four miles away, people who might be hit by stray shells from his artillery. He then ordered the submarine to position itself between the ship and the shore, which put his own vessel in danger from coastal guns, if there were any, but there were none. The *Gulfamerica*'s Armed Guard could not reach its gun position because of the flames. Thus U-*123* was able to fire at will on the *Gulfamerica* and finish her off. The Navy stated later, "The crew had no opportunity to fire at the attacking submarine."

Rescue boats from Mayport sped to the blazing tanker and saved 29 survivors from the crew and armed guard, as well as what bodies they could find. Local resident Townsend Hawkes quickly telephoned the Jacksonville Naval Base during the shelling, but learned that the base did not have any live bombs, only practice ones. The real bombs would have to come from the Army Air Force Base near Tampa. Hawkes telephoned the city electrician to turn off all the lights along the beaches to prevent the submarine crew from firing on the town. He then ran about a mile to the Red Cross lifesaving station, recruited one, slightly inebriated man there, commandeered a surf-boat, and began rowing out to the tanker. The burning oil almost claimed the lives of the two men who had to row madly for over an hour to keep the strong wind from sweeping them into the flames. A blacked-out patrol boat, already loaded with survivors and bodies from the tanker, eventually picked them up.

Some time after the attack, PBY-3s from the Jacksonville Naval Air Station flew over the area and dropped magnesium flares to pinpoint the U-boat. B-25 bombers later flew over the area and dropped their depth bombs at random, but they could not locate the U-boat, which had headed south after the attack. When a search plane reached the area southeast of St. Augustine, it dropped a parachute flare that illuminated the U-boat and forced it to dive rapidly. A nearby American destroyer, USS *Dahlgren*, moved in for what seemed like a certain kill. It dropped six depth charges which severely damaged the boat, but the destroyer did not finish the kill probably because its commander concluded that air bubbles rising to the surface were a sign that the U-boat had been destroyed. U-*123* inched its way out to deep water and eventually made its way to its home port in occupied France. That foray along Florida's east coast was one of several on which Commander Hardegan led his crew during World War II. He managed to sink 25 ships, including *Gulfamerica*, and, although he came close to being captured or sunk several times, he escaped each time and returned to Europe.

The day after the *Gulfamerica* explosion local governmental bodies issued rules to try to dim coastal lights so as to hinder the sighting of ships by offshore submarines. Nighttime driving on the beach was forbidden, and cars east of the Intracoastal Waterway were to use only parking lights. Neon lights were banned, and ocean-front houses

and buildings were to be blacked out or heavily curtained. Local defense councils, fully aware how important tourism was to Florida, stressed that the new regulations were to be in effect at night only. Lighthouse keepers had a dilemma of how to keep their towers beaming light to ships passing offshore but not aid the U-boats that lurked beneath the beams, waiting to torpedo passing freighters. Authorities finally diminished the intensity of the light beamed from the lighthouses along the coast.

On April 16 the *Gulfamerica* finally sank to the bottom of the sea. That voyage, her first and last, also led to an order that halted other oil tanker traffic on the east coast. As part of Operation Paukenschlag ("Operation Drumbeat") in the spring of 1942, German U-boats sank almost 400 ships along America's eastern, Gulf, and Caribbean shores. German boats had much success along Florida's coast, often averaging one "kill" a day. Those kills still affect our beaches today, since many of the tar balls that wash ashore come from the slow leakage of tankers sunk almost 50 years ago by German U-boats, a grim reminder of how vulnerable Florida shipping lanes were.

REFERENCES

Florida Times-Union. [Jacksonville] April 11-15, 1942.

Gannon, Michael. *Operation Drumbeat.* New York: Harper & Row, 1990: 343, 364-66.

Moore, Captain Arthur R. *"A Careless Word...A Needless Sinking."* Kings Point, NY: American Merchant Marine Museum, 1983: 112-13, 534.

New York Times. April 15, 1942: 5.

St. Augustine Record. April 14, 1942: 1.

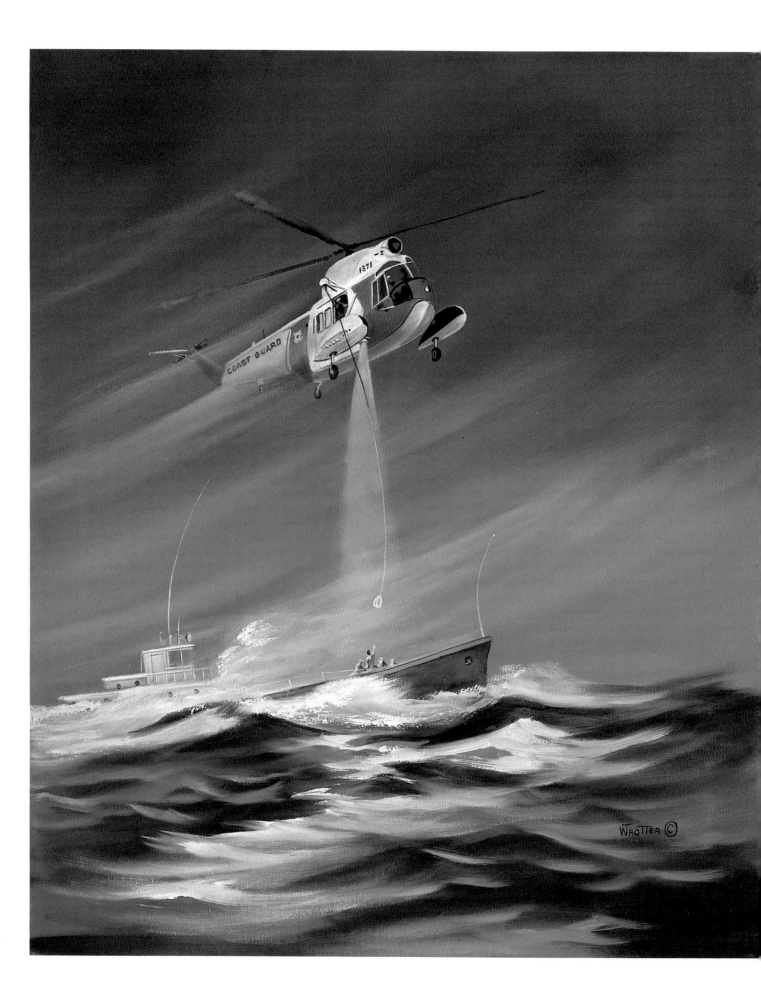

CHAPTER 26

\mathcal{C}ECIL ANNE, 1967

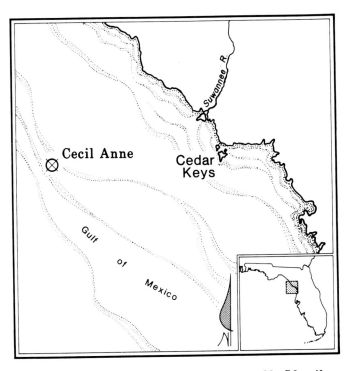

Location: The Cecil Anne *ran into trouble 50 miles southeast, 146° from Carabelle, Florida, and 120 miles northwest of St. Petersburg. It was later recovered by Captain McDowell.*

The headline in the January 29, 1967, issue of *The St. Petersburg Times* said simply "Copter Rescues Six From Gulf." The story behind that rescue and the dangerous situation for the six on the boat and the helicopter crew is typical of what the Coast Guard goes through countless times each year. The crews stationed at the Coast Guard station in the St. Petersburg-Clearwater area save over 100 lives and over $1 million of property each year; claiming that its 500 people make it the largest Coast Guard air station in the nation, the crews work around the clock to maintain the half-dozen Hercules airplanes and the dozen helicopters so that they will be ready for any emergency at sea. Its station motto, "Anytime, Anywhere," represents a commitment to Search and Rescue missions that has earned it high praise from Coast Guard authorities and from the thousands of persons it has rescued over the years, including six people on a sinking boat off Florida's west coast in 1967.

The *Cecil Anne* was a 62-foot U.S. Army cargo boat converted into a pleasure craft. Captain Henry Mc-Dowell had five others with him on their way to their home port of Savannah, Georgia. About 50 miles west of Cedar Key the boat developed engine trouble and began sinking; the captain radioed his distress call at 1:10 a.m., January 28. The force of the winds and seas prevented the captain from taking his boat to Cedar Key, especially after one of his two engines stopped because of flooding. The situation was desperate, especially because the boat had no rafts or flares

aboard, and there were no other ships in the area to aid in the rescue. Ten- to twelve-foot waves and strong winds added to the danger.

Within minutes of receiving the distress call, a Coast Guard crew was airborne and carried two pumps to help the boat remain afloat. By 2:30 a.m. the helicopter — near the limit of its fuel range — found the sinking boat and dropped the pumps and several rafts to the stricken boat before heading back to shore. More trouble developed as the first pump malfunctioned, and the second one's parachute became entangled with the boat's screw and could not be used. Captain McDowell decided that he and the other three adults would have to abandon ship, but radioed the Coast Guard to evacuate the two children, one of whom had a broken leg. The adults would take their chances with the rafts dropped by the helicopter, but the severe wind and sea conditions made it doubtful whether the adults in the water or on the sinking boat could recover and use the rafts.

At 4:55 a.m. another helicopter arrived on the scene piloted by Coast Guard Lt. Robert Workman. By that time the *Cecil Anne*'s stern was submerged, and only the bow area could be used to hoist the boat's passengers, but a 24-foot antenna and a 12-foot jack staff obstructed that area and hindered the hoist operations. The boat's second engine had stopped because of flooding, and the vessel began to yaw 60 degrees in the heavy seas. The helicopter had to make all hoists cross-wind, which hindered its lift ability. Lt. Workman later recalled what happened:

We had no time to fool around. We were at the limit of our flying range when we came in over the boat. We had to fly on instruments because it was too dark to see the horizon. Below, the seas were banging the boat around and it was difficult to keep the helicopter in position. My hoist operator, First Class Petty Officer John Chassereau was busy in the back lowering the basket — trying to get it in the right spot. And then one person would dart out onto the deck and dive into the basket. Chassereau would lift the man up just as the boat would toss out from underneath us. The boat had a long radio antenna which whipped in the wind and almost got caught in the rotor blades a couple of times.

Beside me, Lt. Norman Huff, co-pilot, was making calculations. They couldn't be off by a gnat's eyebrow. The gas we had left, the wind, the added weight of six persons. He also was radio man. We had one guy left to pick up and were operating at 95 per cent full power. I had to decide whether to pick this guy up or hope another plane could make it to him. Waves were washing over the boat. He weighed about 310 pounds. I decided to try. It was one of those decisions.

Chassereau lowered the basket and the man dashed and got in. We had to pick him up on the run. When I felt the strain of the basket, I lifted clear of the boat about 10 feet and headed into the wind. The wind helped us because the more air that goes through the blades the easier it is on the engine and we didn't have any gas to spare. We made it away from the boat and brought the man up. The rest was a piece of cake.

Because of the total weight of those rescued, 961 pounds, the rescue was particularly difficult. The last hoist had to be made with the helicopter going forward using 100% torque to remain airborne. The chopper settled eight feet during that last rescue, but it completed the rescue of all six in 30 minutes. The helicopter then headed for the Crystal River Airport, where another Coast Guard plane took two of the survivors to the Coast Guard Air Station in St. Petersburg. The helicopter, which landed at the Crystal River Airport with 350 pounds of fuel in its tanks, refueled and returned to its home base in St. Petersburg with the other four survivors and had medical staff there treat them. The Coast Guard cutter *Point Swift* sped to the scene but could not find the *Cecil Anne* after a three-hour search. The Coast Guard concluded that the boat had sunk.

For their efforts in the rescue of the six people, Lt. Huff and First Class Petty Officer Chassereau received Air Medals, and Lt. Workman received the Distinguished Flying Cross. The citation for Lt. Workman ended with high praise: "His skill, courage, sound judgment and unwavering devotion to duty reflect the highest credit upon himself and the United States Coast Guard." The commander of the Coast Guard at St. Petersburg concluded his report by noting that "the Aircraft Commander, LT WORKMAN, and the Co-pilot LT HUFF by outstanding performance and airmanship and the hoist operator,

AM1 CHASSEREAU by his outstanding performance in guiding the pilot during hover and operating the hoist probably saved all six of the crew of the ill fated Cecil Anne under extremely difficult conditions of weather and darkness."

The U.S. Coast Guard has more than 38,000 personnel on active duty. Of those, 1,000 officers and 3,000 enlisted personnel maintain and fly the 170+ Coast Guard planes involved in Search and Rescue missions, drug interdiction, oil spill surveil lance, and the guarding of our coasts. They have successfully carried out the motto of the Coast Guard: *Semper Paratus* (Always Ready).

REFERENCES

St. Petersburg Times. Jan. 29, 1967: B1.

Wrecks, Rescues & Investigations. Edited by Bernard C. Nalty, Dennis L. Noble, and Truman R. Strobridge. Wilmington, Del.: Scholarly Resources Inc., 1978: 295-309.

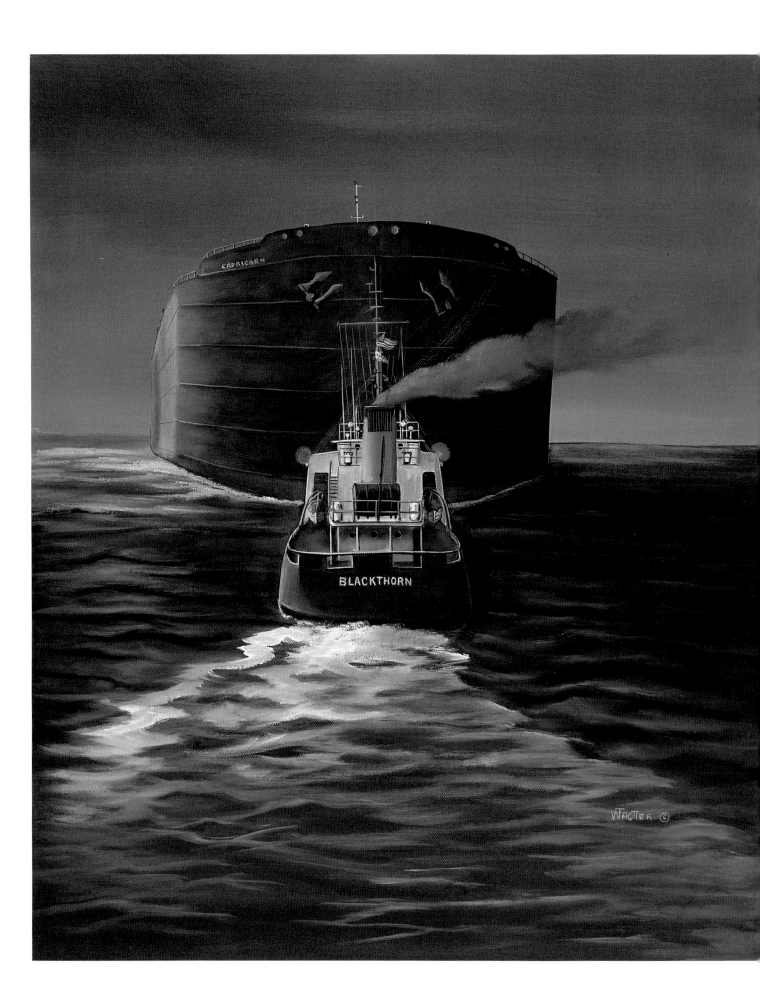

\mathscr{B}LACKTHORN, 1980

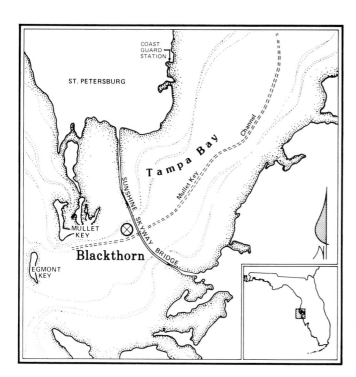

Location: The collision took place just west of the Sunshine Skyway Bridge. Today the Blackthorn, *renamed the* Florida Angler, *lies 20 miles off Clearwater in 80 feet of water.*

At 8:22 p.m. on January 28, 1980, a "Mayday" sounding over channel 16 to the Coast Guard Group in St. Petersburg indicated that the *Blackthorn*, a U.S. Coast Guard cutter on its way out of Tampa Bay to the Gulf of Mexico, was in deep trouble. The radio receiver did not realize that what was about to happen would be the Coast Guard's worst peacetime disaster, one that could and should have been avoided.

Tampa Bay, which connects St. Petersburg and Tampa with the Gulf of Mexico and eventually the Atlantic Ocean, is a busy port with ships of all sizes entering and leaving throughout the day and night. The port ranks seventh in the United States in total tonnage handled and third in tonnage of foreign export. Just before the collision took place that January night, the USSR cruise ship *Kazakhstan* sped out ahead of the *Blackthorn*, and other vessels like the outbound tugboat *Ocean Star* and the inbound tugboat *Pat-B* were using the channels.

The *Blackthorn*, a 180-foot *Iris*-class Coast Guard cutter, had been built for $876,000 in Duluth, Minnesota, in 1943 and commissioned in 1944. Its crew of six officers and 74 men had served in ice-breaking on the Great Lakes before having general duty off California in 1944. Her home port in 1979 was Galveston, Texas, her destination after spending four months in a Tampa dry-dock undergoing repairs. That long four-month layover might have made the crew a little rusty in terms of readiness. The 605-foot-long U.S.

113

tanker *Capricorn*, more than three times longer than the *Blackthorn*, had just spent four days steaming up from St. Croix with 152,000 barrels of oil for Florida Power Corporation's Weedon Island generator, and its crew might have been tired. Conditions were ripe for a major tragedy.

Maritime regulations require that all foreign vessels, all U.S. vessels in foreign trade, most domestic-trade U.S. vessels that draw more than six feet, and U.S. Naval vessels crossing Tampa Bay use local pilots to maneuver through the channels and under the Skyway Bridge. The *Blackthorn* did not do so, even though that trip was the first night transit of Tampa Bay for any officer on board and even though the crew and officers had not been to sea for months. Local pilots know the Bay well, are aware of any temporary lights that are out, and keep themselves well informed about inbound and outbound traffic. Compounding the problem was the fact that the skipper of the *Blackthorn* did not notify the Tampa Bay pilots about his exiting and did not inquire about any other traffic in the harbor that night.

As the two ships approached each other less than a mile west of the Sunshine Skyway Bridge, the *Blackthorn* began turning right to head for the Gulf, and the *Capricorn* was turning left to go up Tampa Bay. The eastern end of Mullet Key Channel, where the collision took place, is 600 feet wide and 34 feet deep at mean low water, but ships have to exercise great caution when meeting oncoming vessels. Outgoing ships like the *Blackthorn* have to make an 18-degree turn to the right from Cut A Channel to Mullet Key Channel. Engineers have dredged a widener at the intersection of Cut A Channel and Mullet Key Channel to help outbound ships make the turn, but deep-draft vessels like the *Capricorn* do not have much margin of error in their maneuvering. When the commanding officer of the *Blackthorn* saw the oncoming *Capricorn* tanker, he should have used his bridge-to-bridge radiotelephone or whistle signals to determine with the pilot of the other ship how the two ships would pass each other, normally port-side to port-side. Both ships were going full speed with a combined speed of 30 miles per hour. Just before the impact, the *Blackthorn*'s commanding officer ordered, "Sound the collision alarm," and the assistant navigator called out "Stand by for collision" over the cutter's public-address system.

When the ships collided almost head-on, the *Blackthorn* heeled five to ten degrees to starboard as the *Capricorn* scraped alongside the cutter. The head-on collision might have turned out better than a broadside because neither ship was sliced open below the water line, and the smaller ship was not cut in half; at first it looked as if the cutter might bounce off the tanker injured but not mortally. However, the larger ship's seven-ton port anchor became entangled in the cutter's superstructure, which caused the anchor chain to be pulled out as the *Capricorn* dragged the smaller *Blackthorn* back up Tampa Bay. The cutter's commanding officer asked the navigator for the location of the nearest shoal water to see if they could beach their disabled vessel, had the assistant navigator broadcast a "Mayday," and stopped the engines. When the cutter suddenly heeled sharply to port, the ship's commanding officer yelled "Abandon ship," but it was too late. The ship capsized and floated upside down until it sank to the bottom in midchannel 800 yards northeast of the collision site and only 600 yards west of the Sunshine Skyway Bridge. Twenty-three Coast Guardsmen were drowned, most of them trapped below. The tanker ran aground near the Skyway Bridge, but none of its crew was injured and none of its oil spilled.

The accident closed the shipping channel for three weeks as U.S. Navy salvage divers made extensive, systematic survey dives on and in the *Blackthorn*, which was resting on its port side 48 feet deep. The divers determined what channel the radio dial was set to, if the radar was energized (it was) and what range it was set to (six miles), what the engine order telegraph indicated ("All Stop"), and what the rudder angle indicator read ("right full"). The tanker, which sustained some $600,000 in repairs, was mothballed soon after as the oil shipping business declined in the early 1980s; four years after the collision the ship's owners had the *Capricorn* broken up for scrap. When workers raised the *Blackthorn* from the bottom of the channel two weeks after the collision, the Coast Guard estimated it would cost $7 million to repair her and therefore decided to decommission her rather than make the repairs. The closing of the channel cost the ships waiting to enter or leave between $5,000 and $20,000 per ship for each day's delay; the closing also cost the Port of Tampa millions of dollars. The *Blackthorn* was renamed the *Florida Angler* and sunk in 1982

to become a fishing reef 80 feet down about 20 miles offshore from Clearwater.

The investigations begun soon after the accident had to determine if the collision took place on the north side of the channel (which meant the *Blackthorn* had been at fault) or the south side (which meant the *Capricorn* deserved the blame). The Coast Guard Marine Board of Investigation blamed both ships for poaching on the centerline of the channel, but the National Transportation Safety Board put most of the blame on the *Blackthorn* for not keeping on its side of the channel when meeting another vessel in a bend, and it blamed the commanding officer for not adequately supervising the actions of an inexperienced officer-of-the-deck. In the settlement of damage suits a federal judge agreed with the Coast Guard that both ships shared the blame. Other questions raised dealt with why the crews had not seen each other sooner (the brightly lit Russian cruise ship *Kazakhstan* might have obscured the two ships as it passed by the *Capricorn* ahead of the *Blackthorn*) and why the two skippers had not made radio contact to arrange for a normal port-side-to-port-side passing (possibly because the radio transmissions of a tug with the *Kazakhstan* interfered with the communication between the Coast Guard cutter and the tanker).

REFERENCES

Scheina, Robert L. *U.S. Coast Guard Cutters & Craft of World War II*. Annapolis, Md.: Naval Institute Press, 1982: 92-95.

National Transportation Safety Board. *Marine Accident Report: Collision of U.S. Coast Guard Cutter Blackthorn, and U.S. Tankship Capricorn, Tampa Bay, Florida, January 28, 1980*. Washington, D.C., 1980.

Tampa Tribune. Jan. 28, 1990: 1A.

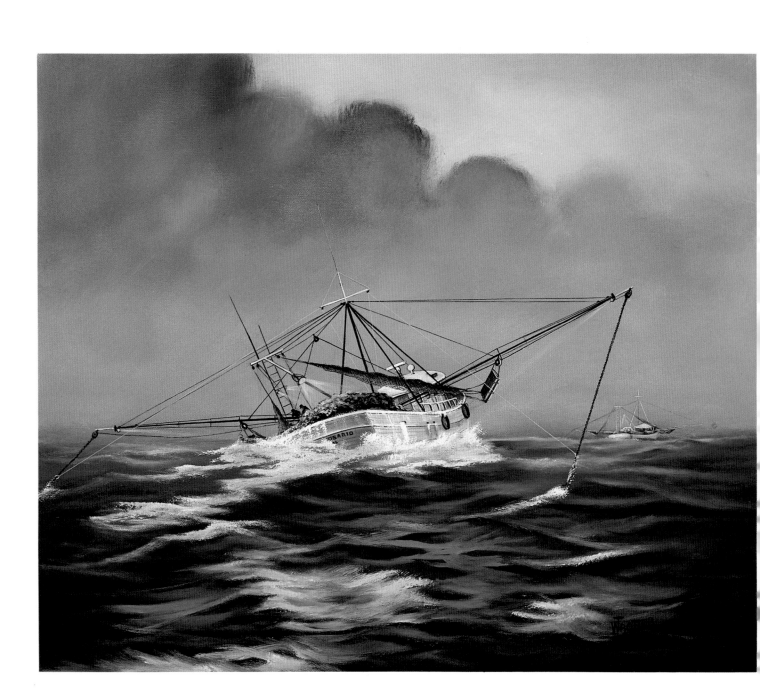

ᘓANTO ROSARIO, 1984

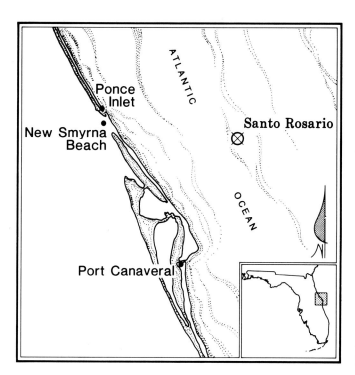

Location: The vessel sank in 150 feet of water 30 miles east of New Smyrna Beach.

A little calico scallop may weigh several ounces and seem harmless enough if left on a boat deck to dry. But multiply that little scallop by several thousand and mix it with huge quantities of grit from the ocean bottom and you can have a serious problem of balance. How serious became clear on the morning of July 23, 1984, 30 miles east of New Smyrna Beach.

Like many scallop ships out of Florida, the *Santo Rosario* was a converted shrimp trawler outfitted with heavier nets and rigging than it had used for catching shrimp. Built in Larose, Louisiana in 1973, the steel-hulled ship was 70.5 feet long, 20 feet wide, and 11.4 feet deep. The conversion to scallop ship added sturdier rigging, nets, and heavier equipment over and on the deck, all of which raised the vessel's center of gravity and therefore decreased the ability of the ship to right itself if it began to list to one side.

The crew, all experienced fishermen, consisted of a captain, winch operator, tail bagman, and crew member. The captain had operated the *Santo Rosario* for five years and held a Coast Guard license. The vessel was part of a 20-ship fleet of converted shrimp trawlers that supplied calico scallops to a Port Canaveral seafood company. Each vessel was on a tight schedule that required five 18-hour round trips a week during the summer harvest season to and from the fishing grounds.

Three weeks before the accident the captains of the fishing fleet had agreed to a fixed unloading time

of 1.5 hours at the pier for each vessel regardless of its size. If a captain was not able to maintain that 1.5-hour unloading time, he would lose his contract. If a captain put too much of a load on his deck and therefore required a longer unloading time, the scallops might spoil in the hot sun. If he had a small load on deck, the shorter time he would require for the unloading would make the automatic shucking machine on the dock less efficient and more costly. However, the 1.5-hour unloading time, which the captains had been using for three weeks before the accident, necessitated an overload on the ships.

Deep-sea scallop trawlers that operate in colder waters use larger crews to shuck the scallops by hand and stow them on ice in the hold. The Florida trawlers had been designed to stow shrimp on ice in the below-deck hold, but the converted trawlers usually had the scallops piled on top of the deck to enable a mechanical shovel at the pier to scoop them off for the automatic shucking machine.

On July 22, 1984, the Santo Rosario left Port Canaveral and met up the next day with another fishing vessel, the Captain Ed, 30 miles east of New Smyrna Beach. The weather conditions — 10-15-knot winds from the southeast, 70° air temperature, 70-80° water temperature, three-foot swells from the south, and overcast sky — were suitable for fishing.

At 4:30 a.m. Captain Gaede had the Santo Rosario on automatic pilot and was helping the two deck hands bring in the last load of scallops before returning to Port Canaveral. The boat, which was carrying the equivalent of 700 gallons of shucked scallops when the accident occurred, had two submarine-shaped paravanes or stabilizers lowered about 30 feet into the water to steady the vessel. When the raised bag full of scallops unexpectedly slid to the port side, the deck load of 8-foot-high scallops also shifted to port, which caused the ship to roll several times from side to side before assuming a 45° port list. One minute later the ship rolled over on its port side and overturned.

Meantime, the Captain Ed was about one nautical mile north of the Santo Rosario. When the Captain Ed's skipper looked back to the Santo Rosario and could not find the vessel's lights, he called the boat on his radiotelephone, but received no answer. When he could not find the Santo Rosario on his radarscope, he moved his vessel toward where he had last seen his companion boat, stopping occasionally to listen and use his searchlight. Ten minutes later he found the three survivors clinging to the Santo Rosario and had his crew toss life preservers and a line to the three men, who were safely brought aboard. As the Captain Ed backed away with the rescued crew, the Santo Rosario sank bow first at about 4:45 a.m. As soon as he was aboard the Captain Ed, Captain Gaede of the Santo Rosario informed the other captain that a third deck hand had been asleep in a berth below decks and did not escape.

When Coast Guard officers learned that the missing crew member had gone down with the Santo Rosario in 150 feet of water, they decided not to send a helicopter from the nearest available base, Clearwater, since it would have taken two hours of flying time to reach the scene. Nor did Coast Guard personnel dispatch a rescue boat from Port Canaveral since that also would have taken two hours to reach the scene.

The rescued members of the Santo Rosario were taken to Cape Canaveral Hospital in Cocoa Beach and treated for minor injuries. The captain suffered from shock and nerve damage to his left arm; the winch operator developed pneumonia and had to be hospitalized; the deck hand had bruises from trying to climb aboard the bottom of the ship as it rolled. All recovered in time. A week after the sinking a diver hired by the insurance company of the vessel surveyed the wreck and found no structural damage to the hull, but no attempt was made to raise the vessel, valued at $250,000.

On the day after the sinking a fisherman told the captain of the Santo Rosario that he had seen oil surfacing at the spot where the ship sank. After he gave the captain the loran readings, the latter had a professional scuba diver search the sunken ship for the missing crew member. On the next day the diver located the ship 146 feet below the surface and found the body of the drowned man at the steps leading up to the deck. The water temperature on the sea floor was 57°. A Coast Guard manual indicated that a person in water that cold could last from one to six hours. If the crew member had been able to surface, he could have lasted in the 70° water an indefinite time.

The subsequent investigation by the National Transportation Safety Board and the U.S. Coast Guard led to recommendations that the scallop ves-

sels not overload their catch, that seafood companies use more prudence in establishing unloading times at docks, and that engineers design a vessel more suitable for that kind of work. Authorities also suggested that ships operate in pairs to keep watch on each other, that such boats have life rafts that can float freely in a sinking, that boats have speakers or alarms in the crew berthing areas so that persons on deck can alert those below when danger strikes, and that captains learn more about the stability of their vessels. Some of the loaded boats were so limited in stability that they actually rolled over when their outriggers were raised. Between 1979 and 1981 19 shrimping or scallop vessels sank or capsized off Florida, resulting in the deaths of three fishermen and losses of over $1 million. In 1982 and 1983 five scallop trawlers capsized in the Port Canaveral harbor so overloaded and unstable were they. Fortunately for the three rescued crew members of the *Santo Rosario*, the captain of their companion boat, the *Captain Ed*, had a keen eye in the early morning of that day in 1984 or they might not have been rescued.

REFERENCES

National Transportation Safety Board. *Marine Accident Report: Sinking of the U.S. Fishing Vessel Santo Rosario About 35 Nautical Miles East of New Smyrna Beach, Florida, July 23, 1984.* Washington, D.C., 1984.

The Orlando Sentinel. July 24, 1984: B-2.

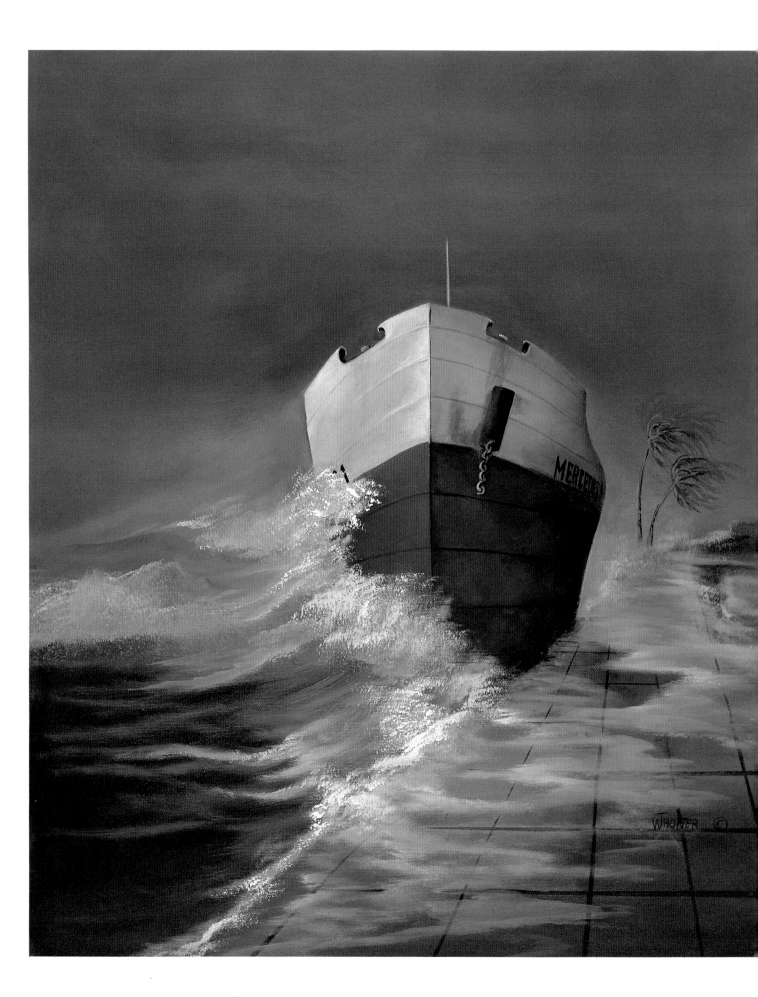

MERCEDES I, 1984

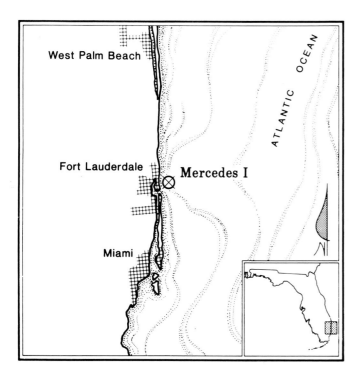

Location: The Mercedes I *lies 1.2 miles north of the intersection of Route A1A and Sunrise Boulevard right off Fort Lauderdale's sandy beach. The ship sits upright in 97 feet of water on a sand and coral bottom just east of the coral reef line. Snorkelers can see her from the surface on a clear day.*

If a 190-foot, 500-ton freighter crashes into your yard and you're inside the house, chances are you will hear it, but not necessarily. Palm Beach socialite Mollie Wilmot was asleep when the Venezuelan ship crashed into her seawall off North Ocean Boulevard just south of the Kennedy family compound in November 1984. As she reported, "I didn't hear the crash; there was a storm raging that night, and, besides, my bedroom doesn't face the ocean. My maid came in to wake me around nine that morning and told me there was a barge outside." Having a monstrous ship sitting in the backyard interfered with the photograph session a fashion magazine had scheduled that morning, but brought a certain notoriety to a town better known for its elegant parties and exquisite mansions than for a rusty old barge sitting in Mollie Wilmot's pool. At least it provided much conversation for the next few months as party-goers talked about the largest Mercedes ever parked on the island.

The *Mercedes I* had been built in Hamburg, Germany, in 1952 and had sailed the North Sea for years as the *Jacob Rusch, Rosita Maria*, and *Rita Voge* before another name change and a move to the Caribbean. In November 1984, while she sailed from Margarita Island, Venezuela, to the port of Palm Beach, Florida, her engines failed four times. On the night of November 22, 1984, while waiting to enter the Port of Palm Beach to pick up cargo, she broke loose from her anchor during a storm and drifted onto Mollie

Wilmot's property while the crew tried desperately to start the engines.

When governmental officials first arrived on the scene, they would not allow the 12-man crew, who claimed that they had not been paid or fed in some time, to disembark because they did not have proper visas. Ms. Wilmot provided water and food to the sailors and had some Cuban friends translate for them. City officials eventually allowed them to stay in a local hotel before flying back to Venezuela on November 29. Meanwhile the ship's owner inspected the *Mercedes* but decided to abandon it rather than pay for its refloating. For months, while the media spent much time detailing the ship's fate, salvage crews tried to inch the ship back into the water, but without much luck. A spiritualist had similar luck in trying to use psychic power to remove the ship. Authorities were forced to declare the vessel a derelict, and the state of Florida had the unenviable task of trying to remove her with as little damage to the beach and Ms. Wilmot's property as possible.

The state hired Donjon Marine Co. of New Jersey to refloat the ship for $223,000, but the lack of a strong sea to loosen the sand under the ship stretched the one-month job into a two-month ordeal. The money came from a state fund for oil spill prevention and control; federal tariffs on petroleum shippers and port terminals created the fund. With much trouble crews finally winched her off the property on March 6, 1985, and towed her 48 miles to Port Everglades at Fort Lauderdale. Two dozen community sponsors contributed to the *Mercedes* Reef, and hundreds of divers helped the Create-a-Reef Fund that worked with Broward County's Environmental Quality Control Board to obtain matching government funds to establish artificial reefs from derelict ships. Broward County bought the ship for $29,450 with receipts from boat registration permits. In the spring of 1985, members of the South Florida Divers Scuba Club cleaned up the ship, removed her doors and hatchways and other safety hazards, and cut large exit holes in her sides and interior bulkheads. The Broward Sheriff's Office, Bomb and Arson Unit, placed 360 pounds of TNT aboard the vessel.

On March 30, 1985, 20,000 spectators watched as the bomb squad set off the TNT and the ship quickly sank into the depths, landing upright and intact at 97 feet below the surface. Ms. Wilmot, the Palm Beach socialite who had played hostess to the beached freighter for 104 days, watched the sinking from a Goodyear blimp 800 feet above. The ship's plight inspired a drink named "Mollie's Follies" (rum, papaya, and orange and cranberry juice) and a Mollie Wilmot look-alike contest, generated $12,840 in parking fines for those who illegally parked to look at the ship, and inspired two local singers to write "Donjon," a song sung to the tune of Jimmy Dean's "Big John" and containing lyrics like "Well, nobody really knew how to move that barge. They pulled it and they pushed but it was just too large." The local newspaper summed up the feeling of many residents when it stated: "The Mercedes, however, was a good guest. It came, it entertained and it knew when to leave."

The sunken ship quickly became one of the most popular sites for divers, as evidenced by the dive boats often anchored over the ship on clear days. In the year after the sinking of the *Mercedes*, one local dive shop with one boat took 10,000 divers out to the ship; "I dove the *Mercedes*" t-shirts proliferated in the area. The large hole at the bow of the ship, caused by the dynamite explosion, allows experienced divers to examine the hold. The nearby Gulf Stream, while providing good visibility around the ship, also generates strong surface currents, and divers have to be careful. Tropical fish and barracuda now inhabit the wreck, but spearfishing is not allowed there.

The sinking of the *Mercedes I*, Florida's most famous east-coast wreck, did much to generate public interest in the artificial reef program and brought thousands of divers to the Fort Lauderdale area. Broward County has built over 50 different artificial reefs along its 24 miles of coastline since the artificial reef project was begun in 1982. The many divers who flocked to the area discovered that the warm waters of the Gulf Stream mix well with the cooler, clear waters of the Atlantic Ocean.

Three reefs ring the shore at Fort Lauderdale: an inner reef close to shore that snorkelers use; a middle reef of 30 feet depth further offshore; and an outer reef of 60 to 80 feet a mile offshore that experienced divers explore. Popular diving sites include the Barracuda Reef, Hammerhead Reef, Fisher's Pedestal, Lobster Ledge, the Houseboat Wreck, *Rebel* (a former pot-smuggling freighter), and Tenneco Towers (a former Gulf of Mexico oil-drilling platform). Divers should be alert for moray eels and amberjacks that

make their homes in the wrecks.

Palm Beach lost out on sinking the *Mercedes I* for an artificial reef, much to the dismay of local dive groups who saw how popular the sunken ship would be, but the locals tried to make up for their loss by sinking a car in September 1985 to help form an artificial reef off Palm Beach. The car they chose was not a Chevy or a Ford, but a Rolls Royce Silver Shadow, valued at more than $25,000; workers welded on the hood ornament, grill, emblems, and hub caps to prevent vandalism, and local authorities pointed out that removing anything from an artificial reef is a federal offense. The car was sunk about one mile offshore and one-half mile south of the Palm Beach/Lake Worth Inlet in 80 feet of water.

REFERENCES

Dean, James. "Shipwrecks of Broward County." *Broward Legacy*. Winter/Spring 1983: 11-26.

Murphy, Geri. "The Mercedes I." *Skin Diver*. Dec. 1985: 86-89.

New Yorker. March 18, 1985: 36-37.

Palm Beach Post. Nov. 1984-March 1985.

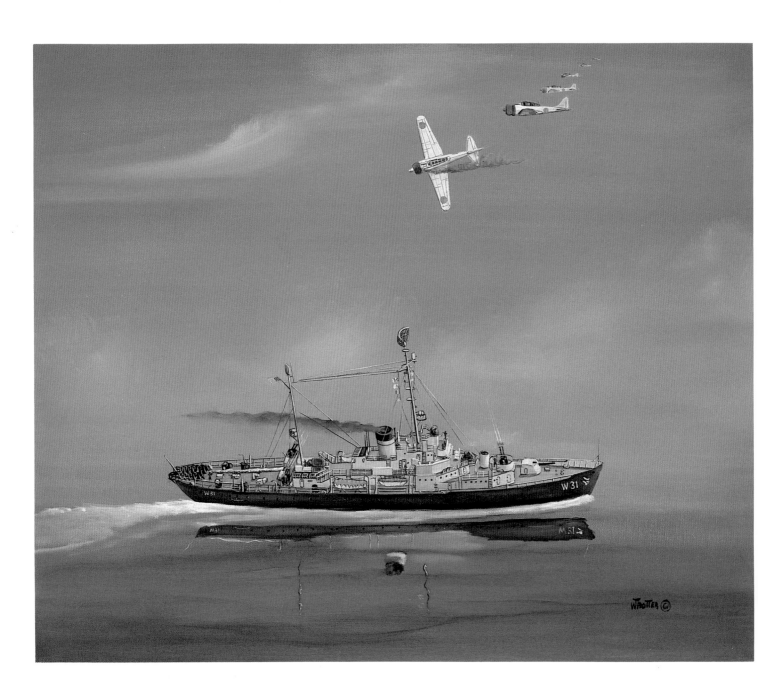

CHAPTER 30

\mathscr{B}IBB, 1987

Location: The Bibb and Duane *lie seven miles offshore in the Key Largo National Marine Sanctuary.*

Two ships that lie near each other on the bottom of the sea off Key Largo had over 100 years of active service between them, years that included daring rescues of shipwrecked sailors and even airplane passengers. Today those two ships, the U.S. Coast Guard cutters *Bibb* and *Duane*, continue to serve divers in the Florida Keys and illustrate the importance of artificial reefs in preserving natural reefs.

After Prohibition ended in 1933, the U.S. Coast Guard needed a new type of cutter for high-seas search and rescue and also to track down narcotics, especially opium, which was being smuggled from the Orient to west coast ports. Transatlantic flight was becoming more important then, and the Coast Guard needed speedy ships to be in position for search and rescue in the event of a downed airplane. The *Bibb* was one of seven 327-foot, 20-knot cutters capable of carrying an airplane in a hangar. Named after Secretary of the Treasury George Bibb, who held office in 1844 and 1845, the *Bibb* was launched in January 1937; at that time the Coast Guard reported to the Treasury Department, hence the custom of naming the cutters after former Secretaries of the Treasury. After three years of trials and routine assignments, the 2,200-ton ship took up its position in the North Atlantic, launched instrument-carrying balloons, and reported on the weather conditions for the large seaplanes and lend-lease warplanes crossing the ocean.

When World War II began, the *Bibb* began escorting Atlantic convoys. Her great endurance — 8,000

125

nautical miles at 10.5 knots — allowed her to accompany the slow-moving cargo ships, while at the same time her 20-knot speed enabled her to hunt down submarines detected along the route. An even greater contribution to the war effort came in her rescue of sailors. In September 1942 she rescued 61 survivors from the torpedoed freighter *Penmar*; in February 1943 she rescued 202 survivors from the troop transport *Henry S. Mallory* and 33 survivors from the Greek merchantman *Kalliopi* (or *Kaliope*). The roominess and hospital accommodations on the cutter allowed her to handle the 235 survivors better than a destroyer could.

In 1945, the *Bibb*, after being converted into a command ship for amphibious operations, joined the Okinawa invasion in the Pacific and repelled some 55 aerial attacks by Japanese kamikazes, conventional bombers, and torpedo planes. After the war the *Bibb* resumed weather patrols in the Atlantic. In 1947, the ship rescued 69 passengers from a four-engine airplane that had been forced to ditch in the ocean just before it ran out of fuel. After 21 more years of weather reporting and rescue operations, the *Bibb* reported for duty in the Vietnam conflict in 1968 and spent almost eight months patrolling the South Vietnamese coast to prevent smuggling of weapons from North Vietnam into South Vietnam. Afterward she returned to the Atlantic to continue her duties.

Like the *Bibb*, the *Duane* was a 327-foot cutter that operated in the North Atlantic after her 1936 launch. She rescued dozens of survivors of torpedoed ships, helped sink a German U-Boat, rescued crew members from the submarine, later served off Vietnam, and helped in the 1980 Mariel Boat Lift that brought hundreds of Cubans to South Florida. Each ship, which cost $2.5 million in the 1930s, would need a similar amount for routine maintenance today. Lack of spare parts and the high repair costs for the ships sealed their doom, and both were decommissioned in 1985 and turned over to the U.S. Maritime Administration for disposal.

In the mid-1980s divers in the Florida Keys began trying to obtain a ship for sinking off Key Largo. The Key Largo National Marine Sanctuary and the nearby John Pennekamp Coral Reef State Park were popular dive sites, but lacked an intact shipwreck that divers could explore. Historical shipwrecks in the area were in such shallow waters that officials had to remove their superstructures to avoid hazards to navigation.

Local divers learned from the Maritime Administration that the *Bibb* and the *Duane* were available and made plans to try to obtain them.

Florida Senator (later Governor) Lawton Chiles convinced the federal government to donate the *Bibb* and the *Duane* to the Florida Department of Natural Resources, which released the two ships to the Florida Keys Artificial Reef Association. The Monroe County Tourist Development Council and local dive shops, restaurants, hotels, and individuals raised $160,000 to clean and prepare the vessels for divers. Workers took the portholes and other brass artifacts off the ships and sold them to raise money for the project. In November 1987, the U.S. Navy Experimental Diving Unit flooded the cutters' bilges and engine compartments evenly with three powerful pumps rather than dynamite the ships in order to maintain better control in the scuttling operation. George Kranz, a 1941 veteran of the *Bibb*, joined other crew members to watch the sinking of the ships and, as reported in *The Key West Citizen* (Nov. 30, 1987, p. 8), remarked to a reporter: "I'm a sailor and I don't like to see any ship sunk, but this is a dignified and useful way for both cutters to be retired."

The *Duane* sits in 120 feet of water with her bow pointing south. Her crow's nest is within 50 feet of the surface and allows a relatively shallow dive for the less experienced. The *Bibb* did not sink as smoothly and now rests on her side in 132 feet of water. Because she has a 42-foot beam, divers will first encounter the *Bibb* at the 90-foot depth; a controlled dive to 120 feet will allow divers to see much of the ship. The many compartments, rooms, and stairways on the ships provide even experienced divers many hours of exploration. The nearby Gulf Stream, while sometimes causing strong currents around the ships, also provides clear visibility that often exceeds 100 feet.

Each ship has four subsurface mooring buoys that allow boat anchoring and diver descent and allow boat pilots to avoid using the coral reef for their anchors. Within days of their sinking the ships began attracting barracudas and amberjacks as well as the start of algae that attracts baitfish. The two sister ships should continue to serve hundreds of divers at Key Largo just as the ships served hundreds of shipwreck and plane wreck survivors during their long distinguished careers.

Those who object to establishing artificial reefs like the *Bibb* and *Duane* fail to realize that such reefs actually preserve the natural coral reefs by taking pressure off them that divers and fishermen exert in their determination to exploit our maritime resources. Sport fishermen in the United States built artificial reefs from old car bodies in the 1950s, eventually switching to the larger ships that became available from the federal government. Materials like concrete, fiberglass, and synthetic rubber, which do not deteriorate in salt water, form long-lasting artificial reefs that have attracted huge schools of fish.

Authorities should place such reefs at least one-half mile from a natural reef in order to attract divers away from the more fragile coral and allow nature to replenish the natural reef. Careful planning will enable the reefs, natural and artificial, to survive for hundreds of years.

REFERENCES

Frink, Stephen. "Bibb and Duane." *Skin Diver.* April 1988: 144-48.

Key West Citizen. Nov. 30, 1987: 8.

Nalty, Bernard and Dennis Noble. "The Good Ship Bibb." *Sea Classics.* 15 (1982): 27-31.

Scheina. *Coast Guard Cutters*: 13+.

INDEX